Paint with the Watercolor Masters

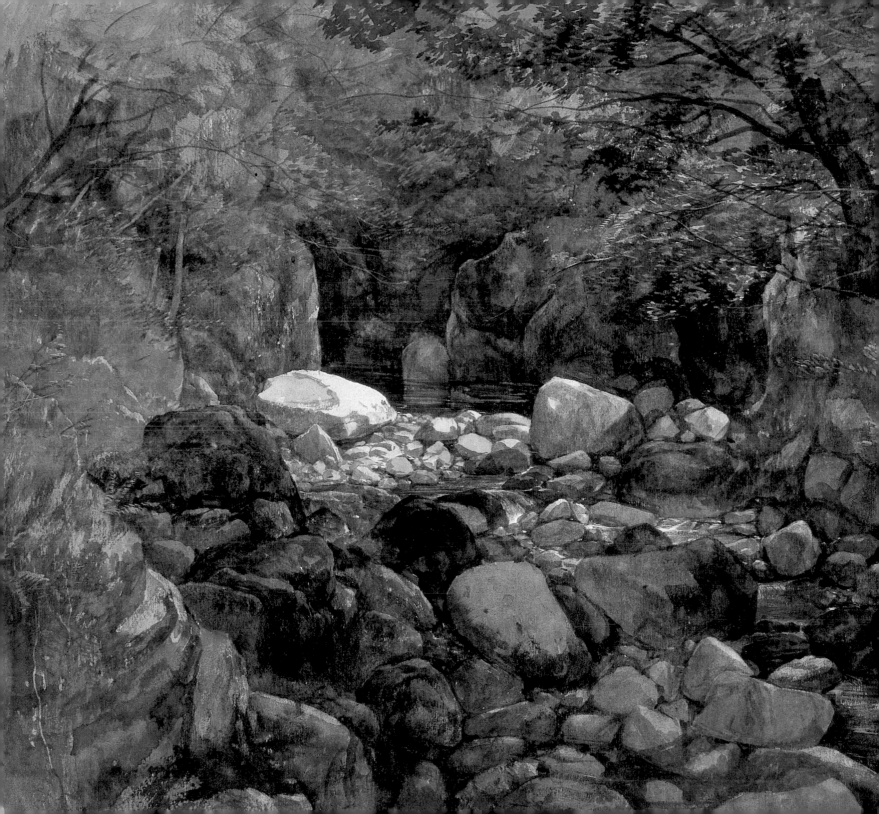

Jonathan Stephenson

Paint with the Watercolor Masters
A step-by-step guide to materials and techniques for today's artists

With 324 illustrations, 304 in color

Thames & Hudson

For Trish, Amy and Sophie

CONTENTS

INTRODUCTION

WHAT IS WATERCOLOUR? *Pages 7–14*

- Defining watercolour
- Methods and materials
- The permanence of watercolours

PART 2

WATERCOLOURISTS AT WORK *Pages 45–72*

- Dürer and the miniaturists
- Turner and the Golden Age
- Sargent and the Impressionist legacy

PART 1

MATERIALS *Pages 15–44*

- The early use of watercolour
- The 18th and 19th centuries
- Watercolour paints
- Watercolour brushes
- Watercolour papers
- Alternative surfaces and supports

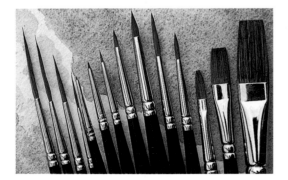

PART 3

DEMONSTRATIONS *Pages 73–157*

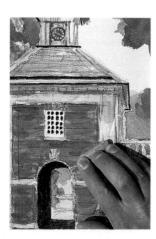

INFORMATION *Pages 158–60*

INTRODUCTION

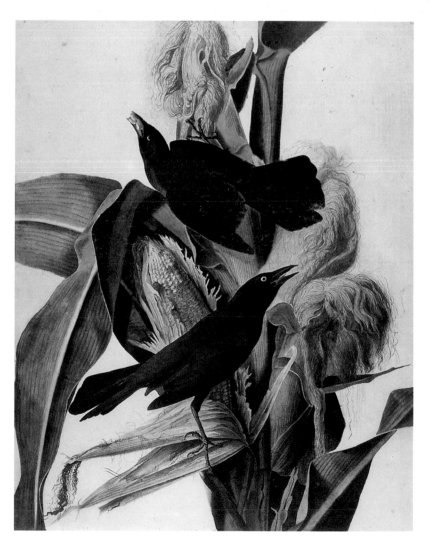

Common Grackles
*(1822) by John James
Audubon. Watercolour
on paper.*

WHAT IS WATERCOLOUR?

The history of watercolour painting can be traced back over 3000 years and across four continents. The subject of this book is the materials and techniques of watercolours in Europe and America during the last 500 years, but it also touches very occasionally and briefly on matters beyond this theme – for the sake of completeness.

About 200 years ago the watercolourist Edward Dayes (1763–1804) wrote: 'We need not wonder at that want of information in the higher walks of art which at present pervades society, if we consider the want of knowledge in those who make a trade of teaching, and the effect of the number of drawing books poured on the public.' This remark can also be applied to the situation today and underlies the purpose of this volume.

Here, I have attempted to provide a clear, comprehensive, well-informed, easy-to-follow and up-to-date account of the materials and techniques of traditional watercolour painting. Primarily intended as a practical manual for painters, it is also an unconventional art history book, which draws not only on my own experiences as a painter, but also on thorough research into historical practices and therefore on the knowledge of some of the greatest – and lesser-known, but also very able – watercolourists of the past. This is a book about how watercolours can be used that takes its information from a detailed consideration of how watercolours have been used.

Defining watercolour

All artists' colours that contain or are diluted or manipulated with water are watercolours – this would include the ancient temperas, bound with egg, casein or glue, and the modern acrylics and vinyls bound with plastics. Both groups are discussed at relevant places in the text, though not in great detail. However, in the context of this book none of these are as important as colours bound with gum.

It is often argued that only paintings done exclusively with transparent washes are true watercolours, but having studied the use of the medium in some depth I am bound to disagree with this. Opaque and transparent watercolour are in fact very similar in terms of their composition – it is the techniques that differ, but even these have common territory so I have included both in my definition of watercolour.

The narrow definition, based on transparent washes, was an impractical and elitist idea that did not emerge until quite late in the history of watercolours. None of the major painters featured in Part 2, for example, have ever taken this supposed rule very seriously. In fact, as you will see, the combination of opaque and transparent watercolours is certainly not avoided by these painters and is sometimes at the very heart of their methods.

In attempting to define watercolour, another technical factor should be considered: watercolours are always painted on a thin, flexible sheet of material – generally but not necessarily of paper. As an additional benchmark I have also used the rather vague concept of 'traditional watercolour' – the application of the techniques that have been used with watercolour materials for the last 500 years.

This leads to my definition of watercolour painting for the purposes of this book as the use of watercolour paints, or gouache, or similar or related materials, in techniques involving transparent washes or opaque painting, or both, on paper or some other thin, flexible sheet material, for any purpose for which such combinations of materials have been used historically.

Methods and materials

This book will make most sense if first read in the order presented, but you can also use it as a reference work. As far as the materials of watercolour are concerned, Part 1 covers them in depth, including information on historical materials and their relationship with techniques. In Parts 2 and 3 there are also references to materials, but always specifically related to the techniques discussed. The primary function of Part 2 is to support the demonstrations in Part 3 with historical information. Its purpose is also to provide additional insights into methods and materials and in particular to account for those techniques that have not found their place in Part 3.

The historical illustrations serve a purpose beyond that of complementing their surrounding text. They have been deliberately chosen as varied

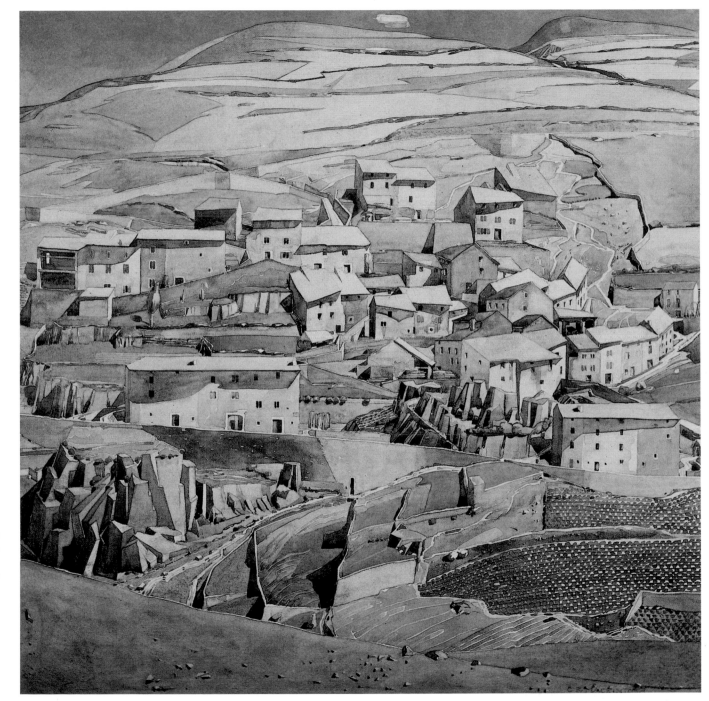

Fetges (c. *1923–26*)
by Charles Rennie Mackintosh. Watercolour on smooth paper. Mackintosh reduced this village and its fields to a complex jigsaw of angular shapes. He delineated each area in pencil in a careful preparatory drawing on what appears to be hot-pressed watercolour paper. Then, probably with the work laid flat, he added the washes space by space, allowing each wash to flood generously onto the dry paper. Thin white gaps of reserved paper separate the washes and represent paths and the tops of walls. These add to the pattern-like quality of this landscape.

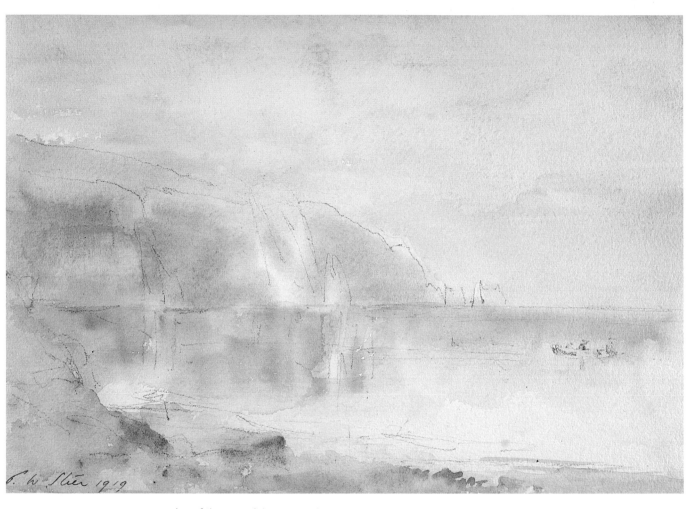

The Needles *(1919)*
by Philip Wilson Steer.
Watercolour over pencil
on paper. This vaporous
use of watercolour is in
complete contrast to the
effects sought in An Old
Hulk at Teignmouth. *This*
is a rapid sketch that
relies on the slight pencil
drawing for its definition.
It was probably done
onto wet paper – the soft
atmospheric shadows of
the cliffside were certainly
achieved by wet-into-wet
painting.

examples of the use of the watercolour medium. This makes them an additional reference source on methods and materials and provides opportunities to compare and contrast the wide-ranging possibilities of painting in watercolour. The illustrations in this introduction, for example, show very different watercolours in terms of their styles and techniques.

In selecting the techniques to be included and the materials to demonstrate with, my aim throughout has been to give a comprehensive and balanced representation of watercolour painting, but in Part 3 there were some practical issues to be considered.

To begin with, watercolours are to a substantial degree unpredictable and unforgiving. Also, in practice watercolour methods frequently rely on instinctive actions or reactions that depend on the circumstances and a time factor is usually involved. This obviously makes it difficult to record watercolours as they actually happen and, of course, to predict what will happen once watercolour paintings are begun. In addition, there are technical difficulties involved in photographing watercolours, especially as they progress. It is common to overcome these problems by using step-by-step demonstrations that are faked for the camera, but I do not think that such an approach illustrates the true nature of watercolour or for that matter any process of painting, so the watercolour demonstrations in this book are shown as they actually happened. The final selection has

therefore had to depend, at least in part, on how successfully each attempted demonstration has illustrated its technique.

In demonstrating watercolour methods, I felt it appropriate to work in a modern context. The materials used are therefore the closest or most practical modern equivalents to those originally employed and they should be relatively easy to obtain.

Because the behaviour of the paper is often a critical factor, I have made a point of specifying my choice in each case. Where aspects of the performance or quality of other materials are also relevant, I have pointed this out. You will notice that I have employed good-quality materials throughout. My brushes, for example, are often relatively large and comparatively expensive; the smallest tend to be of the highest quality. The same applies to my choices of paper and paint. Cheap, inferior materials will not produce great watercolours.

In your own paintings you do not have to follow me exactly, but your results will be related to

An Old Hulk at Teignmouth (1851; reworked 1891) by Samuel Phillips Jackson. Watercolour and gouache on paper. This painting's remarkable effects make it the equal of a work in oil.

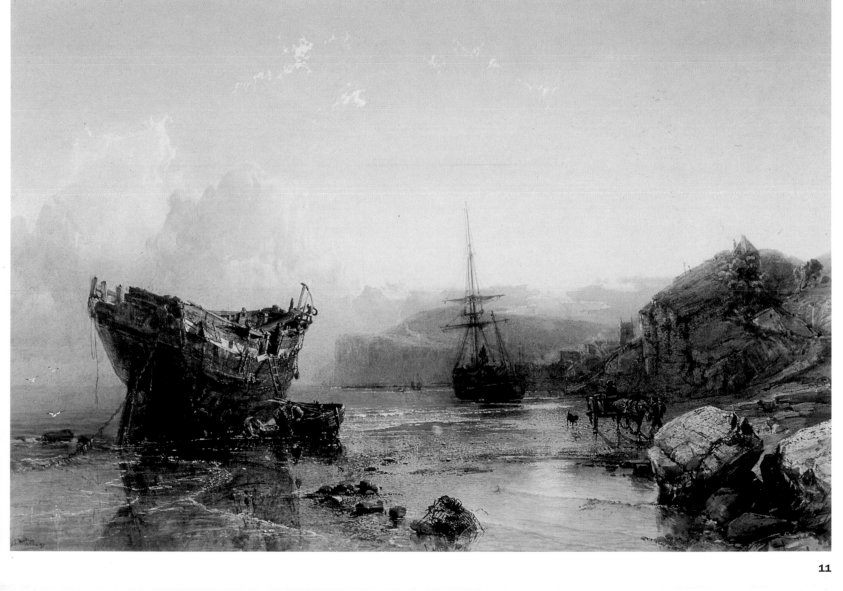

your materials and if you do not have the right materials, you may not achieve what you want. Watercolour can be pursued at modest cost – there is a lot of information and advice in this book that will help you do that – but it is an inescapable fact that leisure painters' materials produce amateur paintings. Good-quality materials and equipment – not necessarily the most expensive or the very best – are needed to make the most of the medium.

The permanence of watercolours

The selection of colours and the exact manner in which they are applied is often at the heart of a technique, especially where it is directly linked to a particular individual, so I have had to think carefully about my choice of colours. However, from today's point of view there are two other very important considerations. Firstly, pigments have increased in number, so what were perhaps the only choices at a certain time and place in history, may not be any longer. They may now be obsolete or simply inappropriate. Secondly, permanence and in particular the pigment's fastness to light are relevant.

Some of the pigments that found favour as watercolours in the past were fugitive. This was known, but until quite late in the 18th century, the normal uses of watercolour made it less of a problem. For example, Cennino d'Andrea Cennini (b. *c.* 1370–d. *c.* 1440) said of saffron yellow: 'It is good on parchment. And see that it is not exposed to the air, for it soon loses its colour.' In effect, he was showing an awareness of its lack of permanence, but also an understanding that if it is used as a watercolour on parchment – in a book or on a document – its exposure will be limited and therefore it may preserve quite well. When watercolours began to acquire the same sort of

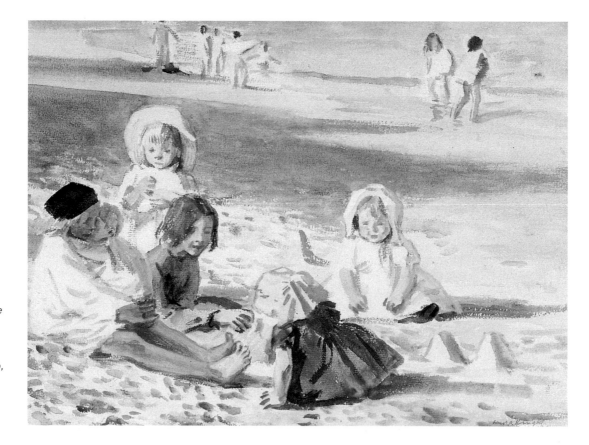

Children on the Sands *(1908) by Laura Knight. Watercolour corrected with gouache on white not surfaced (cold-pressed) watercolour paper. This has been painted quickly and directly from life and so has both the roughness and vitality of a sketch. Contrast it with the figure group in* The Star of Bethlehem *(opposite), which was composed and painted in the studio, is about 100 times larger and does not use watercolours in a typical manner.*

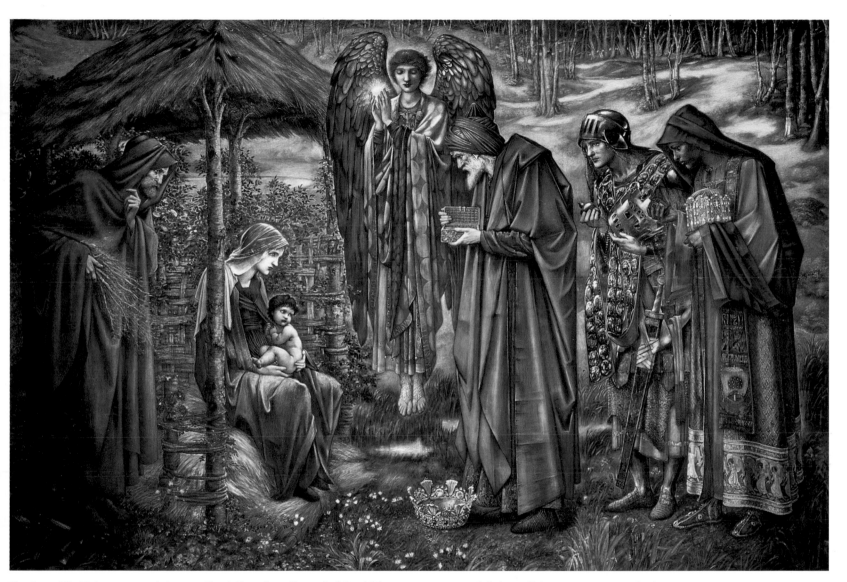

The Star of Bethlehem by Edward Burne-Jones (dated 1890, but worked on between 1881 and 1887). It is on ten large sheets of paper, pasted together and measures 101" x 152" (256.5cm x 386cm). The technique probably involves a glue or gum medium.

status as oil paintings from the end of the 18th century onwards their conditions of storage and display altered and the fastness to light of watercolour pigments became more relevant.

Painters by then had lost much of their traditional knowledge and the methods being used were quite new, so it was not until the 19th century that the full consequences of using impermanent materials for watercolours became apparent. Painters have always had to use whatever was available and there has always been a temptation to use colours that

are especially beautiful or transparent, or both, when applied as watercolours, even though their fastness to light may be poor. The situation is aggravated by the fact that when pigments are used as watercolours they are especially vulnerable, since they are exposed in thin layers with virtually no protection from the binding medium. There have also been unforeseen circumstances, like the unfortunate effects of the original Indian Red pigment on the blues and mixed greys that it was used with.

To complicate matters still further, watercolour painting has attracted a large amateur following ever since the 18th century, thus providing a ready market for materials that had been made without addressing such considerations. In consequence, far less than ideal standards of permanence have been tolerated and a range of watercolour colours has become accepted by tradition that partly derives from some rather doubtful pigments.

A few misguided painters still seek these out for their supposed authenticity, but more importantly modern watercolour paint ranges have been influenced by this history and continue to reflect the accepted tradition. So if permanence is considered paramount, colours still have to be selected with care, although manufacturers are presently moving towards improved permanence across their ranges.

Personally, I do not see the point of putting a great deal of effort into a painting that will not last. In choosing colours for use in the step-by-step demonstrations, I have for the most part opted to use modern reliable equivalents to or improvements on the original colour values. Take note, though, that not all manufacturers offer the same colours under the same names. My colour lists are therefore only a guide and you must satisfy yourself that the watercolours that you actually use are suitable.

Ultimately the choice and the responsibility lies with the individual painter, but I think it has to be accepted that however much effort you put into securing the long-term survival of your paintings, there is, by its very nature, an element of fragility about watercolour that in no way detracts from its value. The point was nicely made by the influential critic John Ruskin (1819–1900) in a letter to *The Times* in 1886, when the permanence of watercolours had previously been under public discussion. He said: 'Properly taken care off – as a well-educated man takes care also of his books and furniture – a water-colour drawing is safe for centuries; out of direct sunlight it will show no failing on your room-wall till you need it no more; and even though in the ordinary sense of property it may seem less valuable to your heir, is it for your heir that you buy your horses or lay out your garden? We may wisely spend our money for true pleasures that will last our time, or last even a very little part of it; and the highest price of a drawing which contains in it the continuous delight of years cannot be thought extravagant as compared to what we are willing to give for a melody that expires in an hour.'

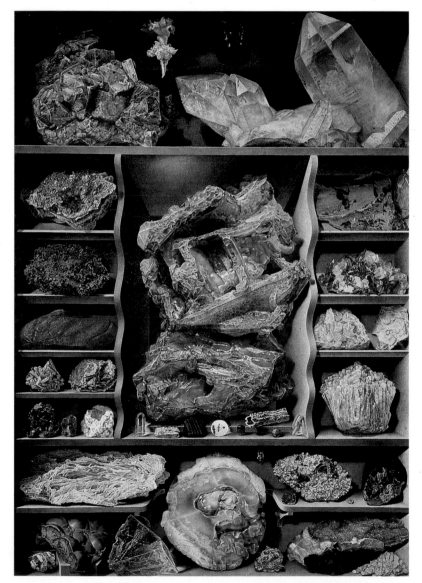

Minerals in Chrystallization (1813) by Alexandre-Isidore Leroy de Barde. *De Barde was an amateur painter with an interest in natural history. This is one of six paintings he did of exhibits displayed at the Bullock Museum, London, at the beginning of the 19th century. It is painted with watercolour and gouache and was minutely worked with fine brushstrokes. De Barde's trompe-l'oeil effects anticipate photo realism.*

PART 1 MATERIALS

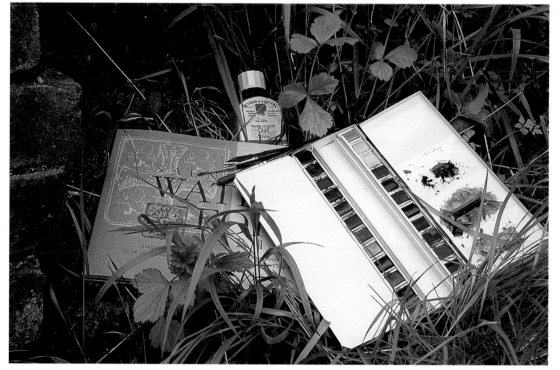

THE EARLY USE OF WATERCOLOUR

The use of watercolour can be traced back to the ancient Egyptians. Their paint was probably bound with a plant gum – possibly gum arabic, which has always been associated with watercolours, or an animal glue. The ancient Egyptians used their watercolours opaquely – as gouache on papyrus, a paper-like substance made from the pith of a reed.

In the tomb of Tutankhamum, who reigned in Egypt from *c.* 1361 to 1352 BC, there was a small ivory palette inscribed with the name of Princess Merytaten. In the British Museum there are two similar-looking wooden palettes – one dated to *c.* 1450 BC and the other to *c.* 1420 BC. In ancient Egypt scribes wrote with two colours, black and red, but these palettes were made for six, eleven and fourteen colours respectively, so they must have been used for painting. Merytaten's palette still has the colours in it – probably gypsum for white, Orpiment for yellow, Red Ochre, Malachite Green, Blue Frit and a Carbon Black.

One use which the ancient Egyptians had for their water-based paints was illustrating and decorating documents – for example, their Books of the Dead. This probably continued in the Classical era of the Greeks and Romans and the Moorish cultures of North Africa and Arabia, and became the art of illumination in the West. From the Byzantine era until the end of the Renaissance – that is from the 4th century to the 17th century – watercolour materials were used continuously for this purpose. This was not, however, the only way in which watercolours were applied: 'On Tuesday, the 11th of February, 1410, I caused a copy to be made in Bologna of certain recipes leant to me by Theodoric of Flanders, an embroider accustomed to work at Pavia ... which recipes the same Theodoric said he had obtained in London, in England, from the artists who used the watercolours hereinafter described. ... The painters work with these watercolours on closely woven linen saturated with gum water. This, when dry, is stretched on the floor over coarse woollen and frieze cloths; and the artists, working over the linen with clean feet, proceed to design and colour historical figures and other subjects. And because the linen is laid quite flat on the woollen cloths, the watercolours do not flow and spread, but remain where they are placed; the moisture sinking through into the woollen cloths underneath, which

absorb it. In like manner, the outlines of the brush remain defined, for the gum in the linen prevents the spreading of such lines. Yet, after this linen is painted, its thinness is no more obscured than if it was not painted at all, as the colours have no body.'

The implication here is that the watercolours were used transparently, a suggestion apparently confirmed by Giorgio Vasari's (1511–74) description of a self-portrait given by Albrecht Dürer (1471–1528) to Raphael (1483–1520). 'This was a head executed in watercolours on a fine linen cloth, so that the design appeared the same on both sides; he used watercolours for the ground and colouring, while the cloth was left for the lights.' It seems that this method was known both in England and in Germany.

The term 'without white' appears in an early translation of Vasari's words, but the precise meaning is ambiguous. Clearly, white highlights

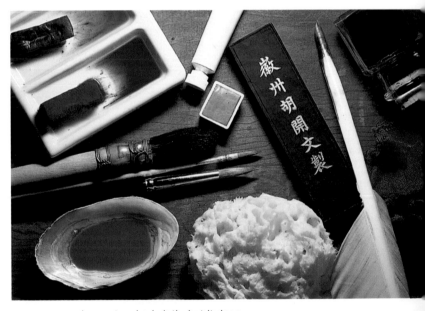

Some early watercolours were kept as pieces of dyed cloth, others were prepared in the shells of freshwater mussels. Later, cakes of watercolour paint had to be dipped in water and rubbed against a china slab, just as Chinese ink sticks were. Modern moist watercolours are contained in pans or tubes.

were reserved as untouched cloth, but it does not follow that the paint itself was completely free from white. For illumination, watercolours were used opaquely, though there seems to have been some local variation in methods that caused some to be done with more 'body' than others.

Until the 18th century artists had to make watercolour paints for themselves. Edward

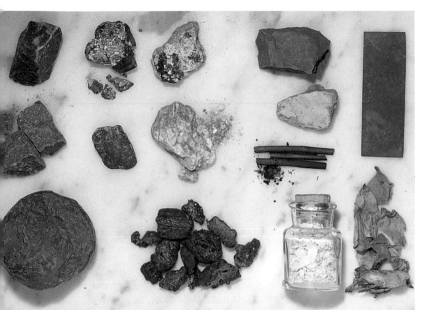

in watercolours as well. The most extraordinary advice on this subject comes again from Norgate: 'If your colour crackle or peel, which is usual with Lake, Pink, and Umber, temper them with a little earwax, then will they lie fast and work well.'

THE 18TH AND 19TH CENTURIES

The trade of the artists' colourman was established gradually during the 18th century. There are references to the commercial supply of artists' materials prior to this, but it seems to have become an actual business at about this time. In 1766 William Reeves began trading near St Paul's Cathedral in London. He is credited with the invention of the watercolour cake, but it also seems that the artist Paul Sandby (1731–1809) was responsible for the development of a manufactured product. This account is from two years after Sandby's death: 'For many years after Mr Sandby commenced landscape drawing, no

Pigment had to be crushed, extracted or refined by various means to be prepared as paint. It was then worked to a fine quality by wet grinding on a stone slab. Here you see tempera paint being made, but the same equipment was used for all types of paint including watercolours. Watercolour was still ground by hand until well into the 19th century and even when machines were introduced pigments continued to be ground on stone. Even today, the best paint mills have stone rollers.

Early pigments included brightly coloured natural minerals: top row, from left to right, Cinnabar, Malachite, Azurite; middle row, from left to right, Realgar, Lapis Lazuli and Orpiment. Below these in the bottom row, from left to right, Gamboge, a natural yellow-coloured gum, Sticlac, a resinous mass of insects and their eggs which gives a brilliant purple-red, White Lead in a glass bottle and some rose petals from which a pale yellowish green pigment can be obtained. Top row, second from right and below it, two samples of coloured earth, charcoal and to the right, a piece of copper covered in Green Verdigris.

Norgate (d. 1650) explained how the pigments were first prepared by grinding and washing and then: 'Your colour being dried, reserve it in clean papers and boxes for your use, and when you will fall to work take as much as will lie in a mussel shell (which of all others are fittest for limning, or otherwise those of mother pearl) and with a little gum water temper it with your finger till it comes to a fitting consistency or stiffness, observing that your proportion of gum arabic must be so as neither to make the colour shiny, which it will do if it be too much gummed, nor when dry in the shell to come off with a touch of your finger, which is a sign that it is gummed too little.'

It is possible that other gums, such as cherry gum, were used from time to time and glair – beaten and strained egg-white – was certainly employed with some colours. To prevent the colour cracking materials that tended to absorb or retain moisture were incorporated. Norgate continued: 'For you must endeavour to make all your colours lie even and fast, without peeling or cracking, and this is done by adding a little white sugar candy in fine powder and with a few drops of fair water temper the colour with your finger till it be thoroughly mixed and dissolved, and then it will be smooth and even.'

Honey was already used as a plasticiser for water-based materials and may have been used

colours were in general use except such as were peculiarly adapted for the staining of maps and plans, and indeed it was he himself who set Middleton the colourmaker to prepare them in somewhat like their present state, and which are now brought to so great perfection by Reeves, Newman and others.'

Reeves was employed by the colourman Middleton and is said to have discovered, while

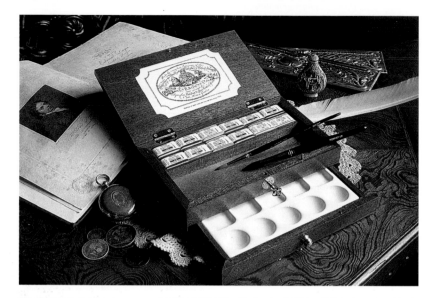

The Rowney replica watercolour box (above) *is a modern presentation set based on an original design from c. 1795. These 19th-century catalogue illustrations* (right) *show similar types of box. Note the china slab in the drawer of the watercolour box. Watercolour cakes* (far right) *did not yield wash as readily as modern watercolours and had a reputation for wearing down brushes. They were dipped in water and rubbed on a hard surface, hence the china slab. These cakes are shown smaller than life size, as are the whole and half pans opposite and the tubes on p. 20.*

working for him, that an addition of honey prevented cracking and allowed the formation of a watercolour cake. In fact, honey performs a similar function to sugar in this context and the essential ingredients of late 18th-century watercolours seem to differ very little from those listed by Norgate 200 years earlier. Another authority says that Reeves used virgin wax, which is again reminiscent of Norgate's recipes. Reeves' real commercial breakthrough was the realization that a watercolour containing sugar, honey, or some similar moisture-retaining agent, becomes toffee-like and malleable before it dries completely and can then be pressed into a mould which gives it a regular shape and an embossed pattern. A neat, standardized, professional-looking product – the hard watercolour cake – then became available and it is more likely to have been this rather than any technical development that stimulated the market.

The Reeves family and their partners and apprentices, George Blackman, John Inwood and James Newman, were prominent suppliers of watercolours during the late 18th and early 19th centuries, but other colourmen were quick to follow suit. In 1801, Robert Ackermann printed his recipes in *A Treatise on Superfine Watercolours*. His instructions on the 'Preparation of Colours for Painting in Miniature, Landscapes, Flowers, Shells, etc.' were as follows: 'The colours must be mixed upon the marble plate with the following different liquids, viz.: First composition – to 2 quarts of distilled water, add 12oz of gum senegal, and 5oz of sugar candy; let the whole be dissolved in a vapour bath, and filter it afterwards through blotting paper; Second composition – to a vessel, containing 2 quarts, pour in 1lb of distilled vinegar, 14oz of gum senegal, 6oz of sugar candy, 2oz of white honey, and fill it up with distilled water; let it dissolve and filter it; Third composition – take 2 quarts of distilled water, 5oz of gum arabic, and 2oz of sugar candy, dissolve and filter it; Fourth composition – dissolve 3oz of gum senegal and 1oz of sugar candy in 2 quarts of distilled water, and filter it.'

A list of colours accompanied these medium recipes, stating which should be used for which. The gum senegal referred to would have been a variety of gum arabic. The use of sugar candy and honey to prevent cracking and assist with the formation of wash was, as we have seen, a long-established practice. Vinegar was also a traditional additive, as were white wine and urine. These act as wetting agents; vinegar and wine also act as preservatives. Ackermann advised his readers against preparing their own colours, although at about the same time the watercolourist Edward Dayes suggested that artists should, but it seems unlikely that his view prevailed. The embossed watercolour cake continued to be used until the end of the 19th century, though it had by then been eclipsed by other innovations.

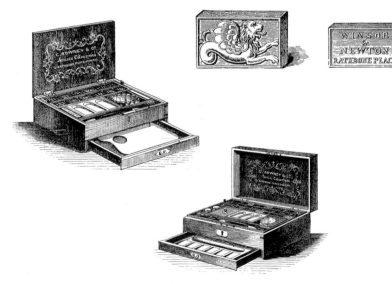

WATERCOLOUR PAINTS

Moist watercolours are used today and probably date from the early 1830s. The popular watercolourist and drawing master, James Duffield Harding (1797–1863), is quoted in the Winsor & Newton *Catalogue of Materials for Watercolour Painting, and Sketching, Pencil, and Chalk Drawing Etc.* of 1849 as saying: 'The art of painting in water colours has been greatly assisted by improvements in the preparations of the pigments: the greatest advantage, however, has been the introduction of moist colours, which, I believe, are a French

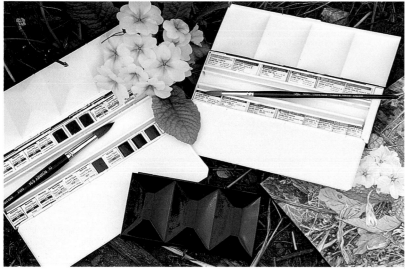

Metal boxes like these (above) were introduced with moist watercolours. If you compare these modern high-quality japanned metal sketch boxes by Daler-Rowney and Winsor & Newton with the 19th-century example shown on the right from a Winsor & Newton catalogue you can see that they are almost identical.

invention, but greatly improved by Messrs. Winsor & Newton.'

The pans and half pans into which moist watercolours are put were originally made of porcelain. A French colourmaker called Lambertye has claimed their earliest use, so perhaps Harding's assertion that they were a French invention is correct.

The composition of watercolours was changed with the replacement of sugar candy and honey by glycerine, itself a recent discovery. This thick, colourless liquid retains and absorbs moisture far more effectively than the earlier ingredients. Often the surface of a pan watercolour remains sticky and the slightest touch of a wet brush lifts it. As the moisture in the colour can cause mould growth, it is usual to add a preservative. This, in turn, could

explain the presence of ingredients such as oil of bergamot, an expensive perfume that would mask the odour of a preservative like phenol – carbolic acid.

Moist watercolours are seemingly much easier than cake watercolours to use, but their practical advantages may be overstated. Artists' cake watercolours continued to be sold for at least 50 years after the introduction of moist watercolours and since the prices were the same this must reflect customer preference. Painters such as J. M. W. Turner (1775–1851) and David Cox (1783–1859), for example, who began painting before the introduction of moist watercolours were not tempted to use them. Perhaps the first moist watercolours were technically less than perfect and maybe their advantages were only obvious in specific circumstances. Both these possibilities are hinted at in this description of George Rowney & Co's moist watercolours from their catalogue of 1864: 'For the sake of greater freedom and effect, this mode of preparing water colours possesses many advantages, more especially for sketching from nature, from their facility in washing up on a slight application of a wet brush, and from the depth of tone which may be produced with them. Those manufactured by Messrs. R. & Co. will be found free from the objections made to the moist colours generally, as they are not liable to harden

Whole and half pans of moist watercolour from Winsor & Newton's catalogue of 1888 (below). They were supplied wrapped in foil and labelled with the name of the colour, just as they are now.

Initially the moist watercolour pans were fixed to the boxes with pieces of wafer or gum, but soon clip or spring systems were devised to hold the pans in place (below).

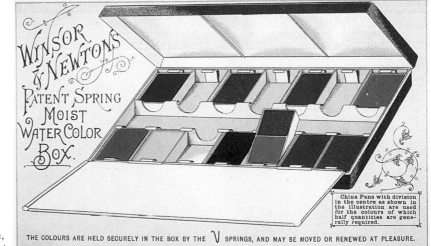

WINSOR & NEWTONS PATENT SPRING MOIST WATER COLOR BOX.

China Pans with division in the centre as shown in the illustration are used for the colours of which half quantities are generally required.

THE COLOURS ARE HELD SECURELY IN THE BOX BY THE V SPRINGS, AND MAY BE MOVED OR RENEWED AT PLEASURE.

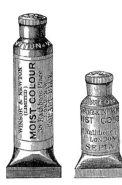

Nineteenth-century tube watercolours (above).

These tubes of water-colour (below) are in lightweight (right) and traditional japanned (left) sketch boxes similar to those used for pan colours. Tube watercolours can also be carried loose for use with a separate palette. Note the shaped handle on the brush – this is useful for cold weather and for painters with infirm hands.

in any climate, whether hot or cold, nor to ferment from the presence of saccharine matter (none being employed in their preparation), and they will dry perfectly on the paper, even when laid on with a thick body.'

In the studio, the advantages may have been less obvious, as once they become wet, watercolour cakes yield colour quite easily too. Here is a description of Cox using them: 'He was jealous of wearing his brush, and if any colour was obstinate from having been baked in the sun, he rubbed it with his finger.' What is not explained is that he would have dipped his finger in water so that rubbing the cake would convert its surface to a soft colour paste.

Interestingly, as late as 1857, John Ruskin (1819–1900) offered the following advice in *The Elements of Drawing*: 'And, first, of materials. Use hard cake colours, not moist colours: grind a sufficient quantity of each on your palette every morning, keeping a separate plate, large and deep, for colours to be used in broad washes, and wash both plate and palette every evening, so as to be able to get good and clear colour when you need it; and force yourself into cleanly and orderly habits about your colours.'

Paint in tubes

In 1841, John Goffe Rand, an American painter living in London, invented the collapsible metal

tube. The patent was sold to William Winsor of Winsor & Newton the following year and before long it was in common use. It obviously facilitated the storage of oil colour, and the manufacturers must have soon realized that it could also be used with a variant form of moist watercolour. In the 1849 Winsor & Newton catalogue previously referred to, they seem to be a recently introduced product and are described as follows: 'A new preparation of moist water colours, particularly adapted for large works, as any quantity of colour can be immediately

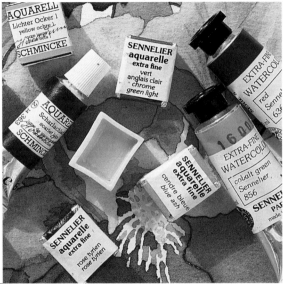

obtained, thus affording additional facilities for rapidity and increased power; they present a range of pigments which, in brilliancy and similarity of manipulation, much resemble oil colours.'

Machine grinding

By the second half of the 19th century machine grinding was well established and its supposed advantages were much trumpeted by the larger firms of artists' colourmen. The preparation of coarse pigments would have been improved, but there may also have been a tendency to overgrind – a feature sometimes encountered with modern watercolours. This eliminates the individual character of the pigment and can increase its opacity. However, the one undeniable benefit of

The French firm of Sennelier still use a porcelain half pan (left); other manufacturers also used them until comparatively recently. Watercolours are said to have been poured directly into the paint boxes prior to the introduction of the porcelain pan – it was first used in Britain in around 1836. Tube watercolours were available shortly afterwards.

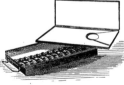

Japanned tin watercolour box with moist water-colours in collapsible metal tubes and a folding palette (above). This one was in a 19th-century Rowney catalogue.

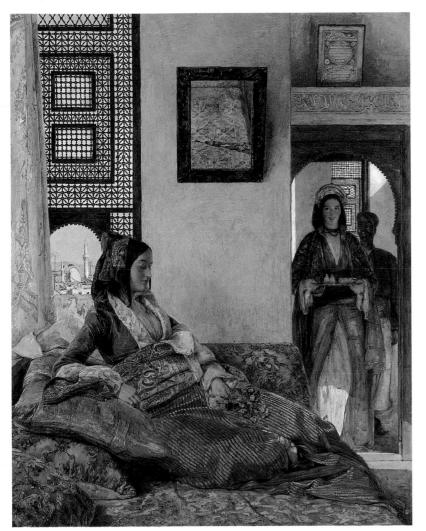

Life in the Hareem, Cairo *(1858) by John Frederick Lewis. The colour strength and fine finish of this watercolour resemble oil painting – Lewis eventually gave up watercolour in favour of oils, saying he could earn more money.*

pigments; or Barium Sulphate, which was sold as Constant White during the 19th century.

Zinc Oxide was available in the 18th century and by the beginning of the 19th century there is some evidence of it being used as a pigment. Ackermann's White, a watercolour listed in 1801, may well have included it as one of its components. For some years scientific and artistic opinion was divided over its merits – its advantages over White Lead in watercolour were confused by its disadvantages in oil. Moreover, Zinc White, prepared as a watercolour, is even now far from being as opaque as artists are led to believe.

The breakthrough came in around 1834, the year when Winsor & Newton are said to have introduced their special preparation of Zinc Oxide pigment, marketed under the name of Chinese White. Dispute and misinformation continued, which led them to publish 'Remarks on the White Pigments used by Water-Colour Painters' in 1837. Subsequently, Chinese White gained the public approval of some eminent painters and the tacit approval of at least one renowned scientist. By the second half of the 19th century, if not before, the name Chinese White was being used by the artists' colour trade for any watercolour preparations of Zinc Oxide.

The ways in which watercolour was used by 19th-century artists such as William Henry Hunt, Myles Birket Foster and John Frederick Lewis and the dashing manner of John Singer Sargent that so often requires correction would not have been possible without Chinese White. Arthur Melville coated his paper with it before painting and would then rinse off the excess. Some of it would remain, having penetrated the paper's surface, and the superimposed washes would take on a slightly milky, airy and atmospheric quality.

John Ruskin firmly believed in the use of Chinese White and, as an influential critic, must have encouraged its use. In the following extract from *The Elements of Drawing* (1857) he explains the term body colour and points out that with Chinese White watercolours can be made to resemble oil paintings: 'Use Chinese White, well ground, to mix with your colours in order to pale them, instead of a quantity of water. You will thus be able to shape your masses more quietly, and play the colours about with more ease; they will not damp your paper so much, and you will be able to go on continually, and lay forms of passing cloud and other fugitive or delicately shaped lights, otherwise unattainable except by

machine grinding that continues into the present day is that it makes artists' colours affordable and therefore accessible to a wide range of users.

Chinese White

The introduction of a stable watercolour white during the 19th century was a significant development. The White Lead that had been used by the Elizabethan miniaturists was liable to discolour when exposed to air. The alternatives had been varieties of chalk or gypsum that are neither particularly white nor suitable for use as

This 19th-century catalogue illustration shows a bottle of Chinese White.

time. This mixing of white with the pigments, so as to render them opaque, constitutes body-colour drawing as opposed to transparent-colour drawing and you will, perhaps, have it often said to you that this body colour is illegitimate. It is just as legitimate as oil-painting, being, so far as handling is concerned, the same process, only without its uncleanliness, its unwholesomeness or its inconvenience; for oil will not dry quickly, nor carry safely, nor give the same effects of atmosphere without ten fold labour.'

Chinese White in pans cannot be as opaque as that taken from a tube because it lifts from the pan in a dilute, wash-like state. The density of the tube colour can be adjusted more carefully. Nowadays, Titanium White is also used in watercolour and is sometimes sold as Chinese White. Titanium White is much more opaque than Zinc White, but unless it is a very carefully selected grade, it is less white and can be almost cream.

The colouring matter in watercolours is pigment – finely ground particles of colour that become enmeshed in the paper's surface as the wash dries (below). Nowadays there are more pigments than ever before and modern, highly specified manufactured colours are replacing traditional ones.

Modern watercolours

The watercolours of today owe a great deal to traditions that date from the 19th century. Now, only moist watercolours are made and large-scale manufacturing colourmen dominate the market place. Essentially, though, watercolours themselves are unchanged – they still consist, just as they did two hundred years ago, and before then, of finely divided pigments bound with a natural gum.

Gum arabic continues to be used for artists' quality watercolours and, while glycerine has displaced sugar and honey, the principle of adding an agent that plasticizes and aids solubility remains exactly the same. Modern recipes are, of course, fine tuned by colour chemists and the presence

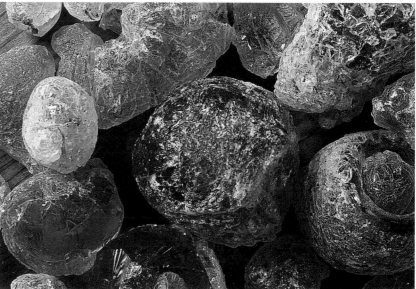

of other minor additives such as wetting agents and preservatives is likely, but watercolours are still fundamentally the same.

The range of pigments used has, however, altered. This began in the 19th century when new colours were discovered by the developing chemical industry. Some of the colours that we now think of as traditional originate from then – pigments like Cobalt Blue, Viridian, Cerulean Blue, French Ultramarine, Cadmium Red and Cadmium Yellow.

The traditional earth colours, such as Yellow Ochre and Raw Sienna, have also been replaced by manufactured versions, which are purer and stronger, or are improved by blending with modern pigments. Terre Verte, for example, may now be the natural earth made closer to the colour quality once obtainable by blending it with Viridian and Cobalt Blue. The original earth colours are either worked out or, for some other reason, are no longer practical to use.

Gum arabic, or gum acacia (above), is produced by the acacia tree, of which there are twelve species. Gum kordofan and gum senegal are traditional names for gum arabic that relate to its place of origin. Here you can see the natural gum in lump form. It is dissolved in water to make watercolours.

Modern watercolour paint ranges still have pigment names and colour values that have been used for a long time, but items such as Vandyke Brown, Indian Yellow, Indigo and Sepia are not the original colours. They are approximately matched by blends of more up-to-date and more reliable pigments.

Many new pigments have been discovered, particularly in the field of organic chemistry, and some have been added to the watercolourists' palette. All of these factors mean there is greater choice and improved permanence, but also that today's watercolour materials are specific to their time, so you should not expect a modern watercolour painting, however traditional its methods, to look exactly the same as one from another period. You should keep this in mind when studying the demonstrations of various techniques in Part 3 of this book.

Today, several manufacturers are changing the specifications of their watercolour ranges to make them more in keeping with the technical possibilities and expectations of the late 20th century. The American Society for Testing and Materials has set standards of performance for art materials. ASTM ratings are now given for many colours, though as yet not all are listed. Those rated at I or II are considered to be permanent enough for artistic use.

The Blue Wool Scale is also a valuable assessment of lightfastness. Its top score is 8 and those pigments that register 7 or 8 are usually very reliable. However, all standard tests relate to sets of specific conditions and a watercolour painting will, in practice, never reproduce them uniformly. For example, the ASTM tests measure lightfastness on wash samples that allow 40% of the light striking them to be reflected back from the paper. A real painting may use quite different and very varied degrees of reflectance. Similarly, a pigment that scores highly on the Blue Wool Scale at full strength may prove to be far less reliable in a dilute state. Because of this the manufacturers' own assessments of permanence, where offered, are also very useful. These are generally based on a variety of test methods, sometimes including a pragmatic evaluation of the materials in use.

Ultimately, the responsibility lies with the artists. Technical knowledge is not an end in itself, but it is the means to an end – better painting with lasting qualities. The information published by

A 19th-century japanned tin box with moist colours in china half pans (above).

manufacturers is widely available and periodically updated. In many instances, you will find all the information you need on the labels on your watercolour paints. Choose wisely, but select colours that you like. It is important to impress your own character on your work.

Choosing paints

Today, you can either get art materials that are of artists' quality or ones that are intended primarily for leisure painters. It is the artists' quality watercolour paints that are the true descendants of those used historically and they are the only ones that will give you the level of performance that serious professional watercolour painting requires. The techniques described and demonstrated in this book relate to this type of watercolour paint. You can have fun with cheap watercolours, but you would be hard pressed to achieve great things with them.

It is best to select your own palette of colours. Start with clean, sharp colour values, as they will be of most use to you: yellow, blue, green and red, although you may not need red so much, and add a few supporting colours to these, depending on your subject matter. Yellow and red earths and perhaps a dark brown are useful colours to have, as is a reliable crimson, rose or magenta.

Present-day moist watercolours in whole pans and half pans by Rowney (Britain), Winsor & Newton (Britain), Schmincke (Germany), St Petersburg (Russia), Maimeri (Italy), Sennelier (France), Talens (Holland) and Pébéo (France).

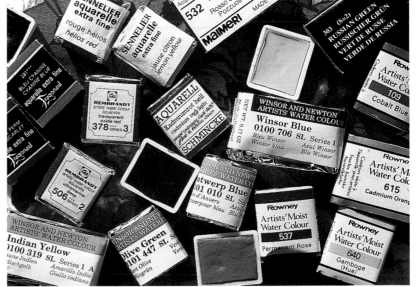

This miniature japanned sketch box from 1892 (above) is very like the modern one below.

Pocket sets (below) are convenient for impromptu sketching. Short, retractable and collapsible pocket brushes are also made for easy carrying. The set on the left holds standard half pans and the Rowney set uses quarter pans.

The colour selections that I have used in Part 3 will provide some guidance. Note also the number of colours used In each demonstration, typically less than 12. A modern range of watercolour paints could offer you a choice of around 90 colours. No one painter needs that many, and as Edward Dayes pointed out almost 200 years ago, the choice is potentially confusing: 'One great inconvenience the student labours under arises from the too great quantities of colours put into his hands; an evil so encouraged by the drawing master and colourman that it is not uncommon to give two or three dozen colours in a box, a thing quite unnecessary.'

It is, however, good to have a choice since different painters will want different selections of colours to suit their temperaments, but the important thing is not to be overwhelmed by it. Twelve well-chosen colours should be enough. Twenty-four carefully selected watercolours ought to allow any subject to be painted in any manner, as numerous combinations of, say eight to twelve colours – sufficient for any one painting – are possible. You can mix watercolours from different ranges in order to make up your ideal palette.

Whole pans, half pans and tubes

Today's watercolour paint ranges offer colours in whole pans, half pans and tubes, although the use of the whole pan seems to be in decline. Some manufacturers do not offer pans at all and only supply watercolour in tubes.

Whole and half-pan watercolours are good for painting out of doors and they are particularly suitable for sketching, as they are ready to be used instantly. They should yield colour easily, though different manufacturers' products vary considerably in this, and they ought to provide sufficient colour for use on a modest to reasonably large scale. Half pans are good for paintings of up to a Quarter Imperial Size – 11" x 15" (28cm x 38cm) or a little larger. For watercolours smaller than this they are in their element. Whole pans will work comfortably up to Half Imperial Size – 15" x 22" (38cm x 56cm).

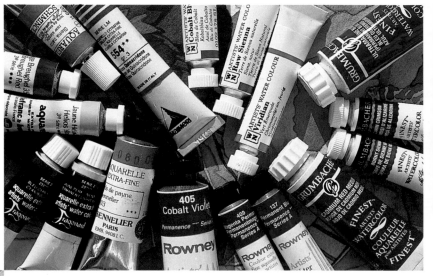

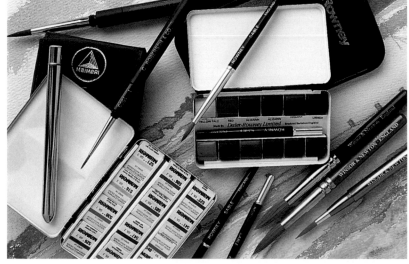

Typically, modern pan colours are extruded by machine and then chopped into blocks that are put into the pans. One or two manufacturers still claim to use more traditional methods – certainly the character of the different watercolour ranges varies and, depending on your subject matter and methods, you may find reasons to choose one over another. For example, I find some pan colours too hard and some too soft and am aware of marked differences in performance and colour strength. These last observations apply to tube colours as well as to watercolours in pans.

Tube watercolours are obviously suited to work on a large scale because generous quantities of wash are easily made up from them. They also allow colour to be used more intensely, closer to opaque gouache, if it is diluted less, but some tube colours carry an excess of gum and can

Present-day moist watercolours in tubes (above) by Grumbacher (America), Rowney (Britain), Winsor & Newton (Britain), Sennelier (France), Maimeri (Italy), Pébéo (France), Lefranc & Bourgeois (France) and Schmincke (Germany). 5ml and 14–16ml tubes are the standard sizes.

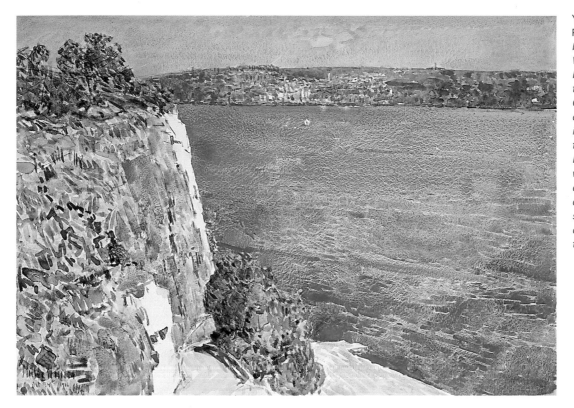

Yonkers from the Palisades *(1916)* by Childe Hassam. *Watercolour on paper. Here the blue-green of the sea may contain Cerulean Blue, an opaque and coarse inorganic pigment that tends to granulate. It may have been mixed with, or added to, a wash of lightweight pigment, deliberately causing the separation and collection of colour in the paper's texture that you can see.*

remain sticky on the surface of the paper if used too heavily. They take a little longer to set up with when painting and are well suited to work done in the studio, but are also practical enough for outdoor painting. An apparent advantage is that colours tend to stay clean with tubes, whereas many painters make a mess of their pans by using a dirty brush or mixing colours on their surface. The disadvantages are that the tops can get stuck on or they dry out if the tops are left off; also some pigments settle in tubes if they are stored too long. You can lay out tube colours and let them dry – thus using them like pan colours.

The character of colours

Whether you use pans or tubes, you must become familiar with the characteristics and behaviour of each individual pigment if you are to gain the command over them that traditional watercolour techniques so often require. There are two categories of pigment, inorganic (now manufactured, but originally from natural minerals), and organic (now manufactured, but originally animal or vegetable in origin). Two distinct types of chemistry lie behind them.

All watercolours are used so thinly that they are effectively transparent, but each separate pigment differs – some tend towards transparency and are either almost completely transparent or, at least, semi-transparent, while others tend towards being opaque and will produce a more obscured wash. The size, shape and weight of the pigment particles also varies, causing some colours to granulate and others to stain. Coarse particles granulate, settling quickly from the wash and giving a potentially attractive peppering of colour. The effect is exaggerated by rough paper and by sloping the work while wet. It can be reduced by painting with distilled water. Fine particles tend to stain, penetrating the paper so that they cannot be completely washed away. As a very rough guide, inorganic colours are more likely to be opaque and to granulate, while organic ones are very often transparent and tend to stain. There are many exceptions and it is important to know the colours that you use intimately.

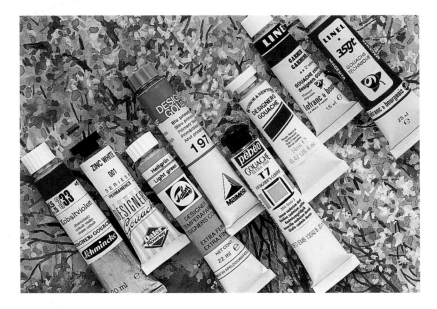

between watercolour made opaque by adding white to it, which I take to be true body colour, and a manufactured gouache that is intentionally opaque at the outset.

Using body colour

You need only add a white watercolour to your paint box in order to work in body colour. A set of artists' quality watercolours can be used either transparently or opaquely in this way. However, in practice you may find it desirable to use some ready-made gouache colours as well. This is because modern watercolours are sometimes so rich in gum that they cannot be used heavily and because the Chinese White in most watercolour ranges is not all that opaque – a tube of Zinc White gouache may be more effective. You should have no difficulties mixing this with ordinary watercolours. Alternatively, use Titanium White.

Tubes of modern gouache colour, from left to right, by Schmincke (Germany), Daler-Rowney (Britain), Talens (Holland), Maimeri (Italy), Pébéo (France), Winsor & Newton (Britain), and two ranges by Lefranc & Bourgeois (France). Schmincke also produce different ranges of gouache with specialized qualities.

Gouache

In very simple terms gouache is opaque watercolour. Historically, the term is confused with, and to a degree has the same meaning as, body colour, distemper and tempera, but it is now also the name of a type of manufactured paint – a ready-made opaque watercolour. Arguably, gouache is more correctly defined as a method of painting, one that uses opaque watercolours, rather than as the paint itself, since similar-looking effects can be achieved with materials that vary in composition.

Colours bound with a water-soluble gum, glue-size, casein, wax emulsion or egg may all produce the same sort of effects. These are the tempera paints, some of which are ancient in origin. Traditionally, they are used as thin, but solid, touches and as tints mixed with white. Such colours have body – a definite physical presence – hence the term body colour. All the terminology in this technical area is vague. Body colour in the context of watercolour painting is certainly opaque colour, usually the result of adding white to other colours, but it may also refer to the use of solidly opaque white on its own or to any colour applied so densely that it becomes opaque. I have chosen to use the description body colour, as well as gouache, throughout this book because firstly, it seems to be the term most often used and secondly, there is a real, but subtle, difference

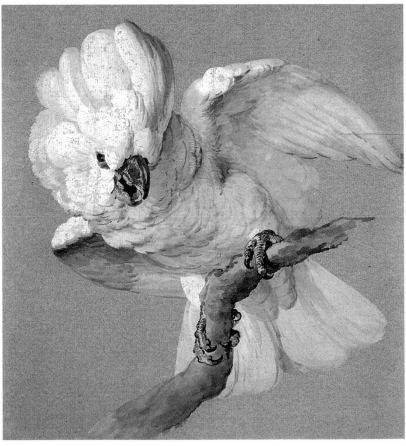

Large White-Crested Cockatoo, detail (c. 1750) by Aert Schouman. Gouache or body colour on blue paper.

Modern gouache

Modern gouache ranges vary enormously. Most were originally specified for designers – their flat matt colouring and their ease of use are advantageous – hence the presence of colours such as Cyan, Magenta, Primary Yellow and Trichromatic Black and several pretty, but fugitive, values in many ranges.

Manufactured gouache frequently contains an opaque base. This could be white pigment, chalk, powdered marble, or perhaps Barium Sulphate – sometimes more than one of these substances may be present, although the colour's opacity may depend entirely on an intense use of coloured pigments. In theory, the composition is otherwise very similar to watercolour, the binding medium being gum arabic with some glycerine, but this may not always be the case. It follows that painters must choose carefully when adding gouache paints to their artists' watercolours or when using them alone. Some gouache colours now carry their specifications on their labels, just as many artists' watercolours do.

Historical uses of gouache

In the 18th century a form of opaque watercolour painting enjoyed some popularity and success across Europe, as did pastel painting. Perhaps the term gouache was first used then. Both materials offer a light and airy colour quality and give quick results – they are sometimes used together. François Boucher (1703–70) sometimes used gouache and was, interestingly, involved in tapestry manufacture. The broad use of body colour is also evident in Raphael's (1483–1520) tapestry cartoons. They may be in distemper, a watercolour made with dilute glue-size, and typically associated with works of temporary importance.

Chalk and white marble dust seem to feature in 18th-century gouache paintings and in pastels, because the only white pigment of the time, White Lead, was unstable when exposed to the air. Perhaps this is the origin of some of the modern gouache formulations.

Paul Sandby, who helped develop watercolour painting in Britain, used body colour towards the end of the 18th century. There is a fascinating account which describes him using isinglass as a preliminary size and painting medium in 1802. There are specific references to colour mixtures that contain white and to the use of 'thick white

in the lights', but he also 'worked his design up a good deal with transparent colours'. Mixed techniques are not uncommon and, contrary to criticism, transparent watercolours and opaque body colours can co-exist happily in the same painting.

During the 1820s and 1830s, J. M. W. Turner used body colour very effectively on blue or blue-grey paper, applying it in a thin and wash-like state. Some of his pure watercolours also have a translucent, milky appearance, leading to speculation that he added a little white to his painting water before diluting the colours with it. The fluid use of gouache on a coloured background also features in the work of both Camille Pissarro (1830–1903) and Henri de Toulouse-Lautrec (1864–1901). It was used by Henri Matisse (1869–1954) in the early 20th century. Its present-day popularity with illustrators relates to Albrecht Dürer's early use of watercolour which is discussed in Part 2. Obviously since it is opaque you can correct and modify gouache in a way that is not possible with transparent watercolours.

Liquid colours

The earliest transparent colours used as watercolours were extracted from plants, insects or animals and were dyes, not solid pigments. You can only use a dye by staining something with it, so artists tinted the medium, gum solution or glair

Dye-based colours have a long history of use in watercolour. During the Middle Ages and the Renaissance they were kept as clothlets, shown here on the right. In the 18th century, bottles of liquid colour were used to stain maps and prints.

FW Acrylic Artists' Ink is a pigmented, liquid colour that is water-resistant when dry, though it can be mixed with water during application to achieve wash-like effects. Its lightfastness and permanence means that it is suitable for fine-art use and that it will adapt to many traditional methods. Liquid acrylic can be applied by brush, pen, technical pen or airbrush, making it popular with graphic artists and illustrators.

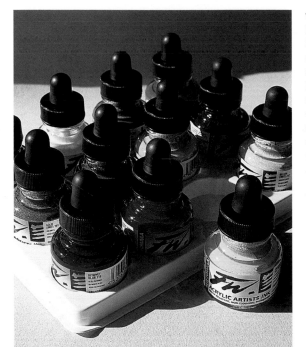

Liquid acrylics are versatile, but they are particularly suited to illustration. The ACP range, for example, is formulated so that its colours reproduce exactly in print – many artists' colours reproduce imperfectly.

(beaten egg-white) with the dye. These colours were stored as clothlets – small pieces of fabric, heavily impregnated with dye that was released when soaked. Cennino d'Andrea Cennini said: 'You can shade with colour, and by means of small pieces of cloth, according to the process of the illuminators; the colours tempered with gum, or with clear white of egg well beaten and liquified.' A Venetian manuscript compiled at around the same time gives a very similar account: 'When the aforesaid pieces of cloth are dried, put them in a book of cotton paper, and keep the book under your pillow, that it may take no damp; and, when you wish to use the colours, cut off a small portion and place it in a shell with a little water, the evening before. In the morning the tint will be ready, the colour being extracted from the linen.'

Liquid colours were also used during the 18th century – there are surviving examples in bottles and it is generally assumed that these were the transparent colours used to tint maps, prints and plans that are sometimes described.

It might also have been the practice to carry some made-up washes from pigment-based watercolours in bottles. Inks, of course, are also in effect liquid colours if painted with. Today, dye-based liquid colours are still used by designers and air-brush artists. They are often exceptionally bright and radiant, but like many dyes lack permanence. For serious painters, the more recently introduced alkali acrylics are a much better option. They are made of microfine pigments, which stay in suspension for some time when shaken, and a form of acrylic, which acts as a binder so they can be used with water, but become waterproof when dry. Some of you may find these modern liquid colours an interesting alternative to traditional watercolours. They are certainly suitable for calligraphy and illumination because of their similarity to inks. However, they can be disappointingly dull.

Acrylics

Artists' acrylic colours use acrylic polymer emulsions – the component parts of a plastic dispersed in water – as a binding medium. They were introduced in the 1950s and are now firmly established, having proved popular because of

their versatility and convenience. Acrylics thin with water and may be used like watercolours on paper, but they have the advantage of being waterproof when dry. This makes the use of superimposed layers very easy, but prevents 'subtractive' techniques like washing back. Acrylics tend to lack the subtlety and character of traditional watercolours when used transparently, but some painters find them sufficiently similar and are happy to use them in this way.

Acrylics are arguably better when employed as body colours. They suit working wet over

Artists' acrylic paints can be thinned and used like watercolour. They work well as body colour and since they are waterproof when dry they are easier than traditional transparent watercolours or gouache to work in thin, superimposed layers.

Sketching colours

Inexpensive watercolour ranges are made for leisure painters, amateurs and students. Their main attraction is the cost, but they are a false economy. To be fair to their manufacturers, they give a taste of the pleasure of painting at a very modest price, but they are no match for artists' quality watercolours. For the sort of painting that is discussed and demonstrated in this book, they are almost irrelevant.

Having said this, these secondary paint ranges do vary, some are better than others. However, sketching-quality watercolours in general are made of imitation pigments and are often noticeably duller and more opaque than the artists' quality ones. This may be due to the use of extenders or other types of binder.

Leisure painters' watercolours are intended for the amateur market. If you want to paint seriously, it is best not to use materials of sketching or student quality. The less expensive paper ranges that are generally used with leisure painters' watercolours are, however, suitable for some advanced methods.

Watercolour pencils produce wash-like effects, but they also have special characteristic qualities of their own. They can be used with ordinary watercolours to create additional effects and are also good for fast, on-the-spot sketching.

dry and their waterproof finish can give them distinct technical advantages over using gouache. However, artists' acrylics used as watercolours have drawbacks: they easily spoil brushes due to their rapid and irreversible drying and may give a plastic-looking surface finish. It is also possible to overthin them, though this is not really a problem on paper. Additionally acrylics tend – some ranges more than others – to have a residual surface tack, a very slight stickiness that does not go away, which can be disastrous in sketchbooks where it may cause pages to stick together.

Watercolour pencils

Watercolour pencils are not a traditional medium, nor do they do exactly the same things as watercolour paints, but they do lend speed, directness and convenience to sketching and allow you to combine aspects of drawing and painting easily in a single work. There are many ways to use them, but the easiest is to draw with the watercolour pencils dry, then wash out the colours by taking a wet brush over them, colour by colour. Some beginners will find this less intimidating than applying watercolour paints. You can draw with them onto wet paper as well. There are also water-soluble colour sticks – waxy pastel-sized crayons that can give wash-like effects. Both mediums have potential and it is possible to adapt some traditional watercolour methods to work with them.

The situation is much less clear-cut with papers and brushes. These too are made in specifications that allow low pricing, principally for leisure painters, but some of them offer a good basic standard and perform rather well, so in appropriate circumstances they can be a perfectly suitable choice.

WATERCOLOUR BRUSHES

For hundreds of years, watercolour brushes were made by fitting bundles of soft hair into lengths of quill from birds' feathers. Usually a quill stick was pushed into the other end to make a handle, but the largest sizes were sometimes sold in long quills where the whole quill, stripped of its feathering, was kept intact and served as a handle. Winslow Homer (1836–1910), for example, used such brushes.

Quill-mounted brushes were always round – since quills are round in section – and this is still the standard shape of an artists' watercolour brush today. The diameter of the quill determined the size of the brush and it was common for it to be referred to by the name of a bird that produced that size of feather: Lark, Crow, Duck; Small, Medium and Large Goose; and Small, Medium and Large Swan roughly correspond to the modern sizes 0–12.

Quill-mounted brushes are slightly flexible, which some think gives them a better stroke. The hair is less likely to break where it enters the mount than a modern brush with a metal ferrule. The smaller sizes are more fragile than the equivalent brushes today and must be carefully fitted to their quill sticks to prevent them coming off. Apart from these minor differences, modern watercolour brushes and the traditional quill-mounted ones are much the same in principle and in use.

By the middle of the 19th century and perhaps before then, watercolour brushes with metal ferrules were available in today's standard sizes. Brushes in quills may still, however, have been regarded as the superior product. They continued to be used throughout the 19th century and quill mounts are used to a modest extent today.

Hair types

The hair from miniver tails – probably the ermine or stoat, an animal once common in Europe and not unlike the sable, though smaller – was originally used to make soft, fine brushes. The tail hair of this animal is long and resilient, but perhaps softer than sable. To my surprise, I have not found specific references to sable prior to the 19th century, but the ambiguous term camel hair can be found in English sources from the 18th century onwards. The natural hair types used in watercolour brushes today are presumably very like those employed historically.

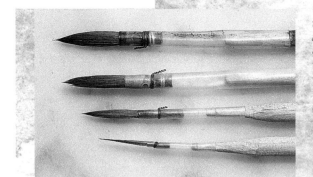

Watercolour brushes like these (left) consist of a bundle of soft hair tied off with thread and then fitted into a length of quill tightened around it by a wire. A wooden handle or quill stick is inserted into the other end of the quill.

Quill-mounted brushes from a 19th-century Winsor & Newton catalogue (right). These finest sable brushes were tied with different-coloured silks for the various sizes and the quills were tightened with gold wire. Note the length of hair inside the quill.

Natural hair makes the best watercolour brushes. These fine examples (left) are by the French brushmaker Raphael. Brushes in Kolinsky sable, Kazan squirrel and Canadian squirrel are shown. Quill and wire-bound mop-style watercolour brushes (centre) are a French speciality, although their accurate shaping is not typical of a mop brush.

The Pro Arte Series 100 'Connoisseur' (right) is a good-quality range of sable-synthetic mixed brushes. Sizes 14, 16 and 18 (centre) are rarely made in sable and would be prohibitively expensive for most painters.

A size 7, Series 7 brush by Winsor & Newton (left), shown life size. They are based on brushes made for Queen Victoria and are the benchmark of fine quality. Note the shape.

These sable watercolour brushes (below) are shown life size and are, from left to right, sizes 12, 7, 3 and 1. Size 14s are available in Kolinsky sable, when the hair quality is suitable. However, most sable ranges only extend to size 12.

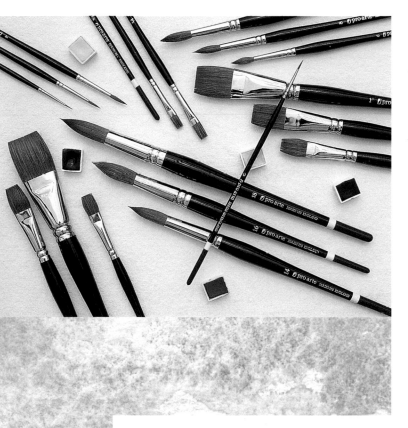

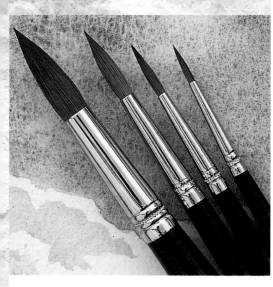

Sable

The sable-marten is a member of the mink family, native to Siberia and, I believe, parts of China. It is now bred for the fur trade, which still serves a demand in bitterly cold climates. Sables are not bred specifically for brush making and only the tails are used for this purpose. At one time they were classed as 'furriers' waste', but now sable is incredibly expensive. A very cold winter is required to produce hair of the finest quality so this can affect the supply of large brush sizes in ranges that aim for the highest standards.

Sable's unique properties relate to the length and strength of the hair, the way each filament tapers and its springy resilience. A good sable brush is fatter at its centre than at its base and will sweep from this 'belly' towards an exceptionally fine point. Sable holds large amounts of wash, but can deliver it with precision. In use it follows the gestures of the hand most sympathetically and responds to variations in pressure by spreading and re-forming.

Sable hair is reddish brown or yellowish brown in colour. It is hard wearing and, looked after well, sable brushes will last for many years, though they do become worn and lose their points after a while. Even then, they will still be good brushes. Top-quality sable is known as Kolinsky sable; such brushes are likely to be expensive, especially in large sizes, but most painters will only require this quality for small to medium-sized brushes. Brushes that use lower grades of red or brown sable can cost less than half as much as Kolinsky hair and will still be very desirable brushes to have.

You can tell the quality of a sable watercolour brush by the way it 'bellies' and points when wet. If you want really cost-effective performance, sable-synthetic mixtures are the answer. The better ones are almost as good as mid-ranking sables and are appreciably less expensive. Sable undoubtedly makes the best watercolour brushes.

Squirrel

Squirrel hair is much softer than sable and does not have such a springy touch, but it does have a superb wash-carrying capacity and can form a long, fine point. This permits colour to flow easily, without having to reload the brush very often, or, alternatively, allows for an intentionally sloppy approach where colour is flooded onto the painting in lavish quantities. The fact that it does not snap back perfectly into shape can be an advantage when seeking rough, dragged, random effects from a splayed and distorted brush head. Dipping it in water afterwards will restore its original shape.

It is also possible to work very finely with squirrel hair brushes. The smaller sizes can have needle-sharp points, longer and finer than equivalent brushes in sable. It is all a matter of how they are handled. Ideally, the stroke must always pull the point behind it to prevent the movement of the hand causing it to distort so that the perfection of the point is then lost. You can also run colour from the tip of squirrel brush by holding it near upright, with the point just grazing the surface being painted on, then there is insufficient contact to make the brush head lose its shape and the point will follow the action of the hand much more responsively.

After sable, squirrel hair makes the most useful watercolour brushes. There are two types in current use: Kazan squirrel is, I believe, the same as the Siberian squirrel mentioned in 19th-century catalogues. It is a sleek-looking black to dark brown

hair type, very soft to the touch and of a good length. This type of squirrel is used to make the best brushes which can be moderately expensive, though not as costly as sable. The other sort is Canadian squirrel, a mottled brown and yellow hair, not as long as the Kazan, but inexpensive and usually able to point reasonably well.

Ox

Ox hair comes from a cow's ear. It can be dark or light brown and is sometimes mixed with other types of hair. It is supple and springy and holds wash well, but it will not point, so it is usually used for flat, square-ended brushes. These were originally made as sign writers' lettering brushes and are called one strokes – some are made in sable hair, but the ox hair versions are arguably better for watercolour and they are certainly much cheaper.

Pony

This is a coarse, dark brown hair, superficially like Kazan squirrel hair to look at. However, it is very unresponsive in use and does not point well at all. It is mainly found in cheap brushes – which are of no use to the serious watercolourist – and in large wash brushes, which can at least carry a fair amount of liquid. Even their performance is not very good though. Pony hair mixed with other hair types may work better.

Camel

The only thing that is certain about camel hair is that it does not come from camels. Nowadays it appears to be a trade term applied indiscriminately to less useful qualities of natural hair and perhaps also to blends of different hair types. However, references to camel hair in the 18th and 19th centuries imply that it was then of reasonable quality. A type of squirrel hair is used in Indian brushes so perhaps the term once referred to soft-haired watercolour brushes imported from the east.

Synthetic

Synthetic hair, unlike natural hair, is cheap, readily available and there is no moral question about the use of animals – though of course there are others about the effects of industry.

Today's synthetic hair brushes successfully imitate some of the important characteristics of the natural hair types: they carry quite reasonable quantities of wash, point well enough when new

and are resilient and fairly responsive in use. They are nowhere near as good or as useful as sable or squirrel brushes, but they offer the amateur and beginner the opportunity to use affordable, adequately sized brushes. The extra-large sizes are potentially interesting to all watercolourists because there are almost no equivalents in present-day natural hair brush ranges. However, their value should not be overstated, synthetic hair brushes do have a springy touch, but in practice they are rather rigid and characterless to use.

The combination of natural and synthetic hair has already been mentioned in the section on sable hair. Watercolour painters at all levels will probably find brushes of this type useful, especially in the larger sizes.

Brush shapes

The traditional watercolour brush is round in section, with a substantial body of hair in the head. It tapers to a fine point when wet. The length of the head, the length and shape of the sweep towards the tip and the exactness of the point itself may

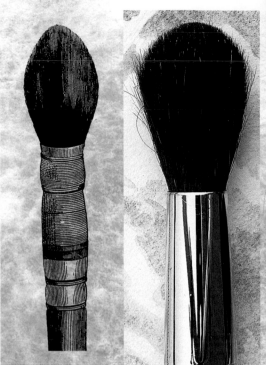

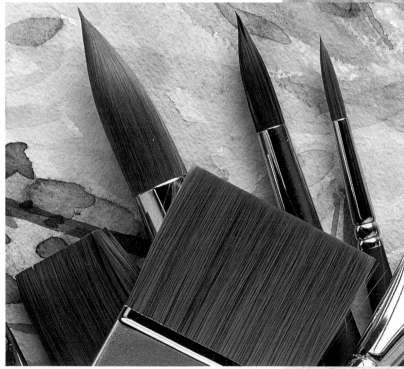

Wash brushes (above) come in various shapes, sizes and hair types. Any large brush can serve as a wash brush. The 19th-century example is wire-bound and made of Siberian hair.

Good synthetic hair brushes (left) are made by blending fibres of different thicknesses. This makes them perform more like natural hair. They are inexpensive and suit leisure painters and beginners. Most painters find the large sizes tempting and they generally work well in support of other brushes. These are from Winsor & Newton's Cotman range.

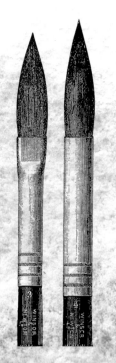

Nineteenth-century watercolour sable hair brushes with ebony handles from Winsor & Newton. The shapes shown are round (right) and flat (left). Interestingly, the flat is shown pointed.

vary according to the quality or design of the brush. As previously mentioned, a sable brush will be fattest about halfway down the exposed hair – this is the belly of the brush which acts as a reservoir for colour. Brushes of this type are simply called watercolour brushes without any further definition of their shape. They are the most useful brushes to have and with watercolour paint will enable you to do almost anything you want.

A designer's brush is similar to a watercolour brush, but it has an elongated shape, giving it a longer and finer point. A rigger is very like a designer's brush, but is perhaps a little longer still. It is used for painting long, fine lines and takes its name from its original use in marine painting – for putting on ship's rigging. Riggers are oil painters' brushes, but the name is occasionally applied to ones meant for watercolour. Lettering brushes, for example, are sometimes described this way. These are even longer, the exposed hair length being about twice that – or more – of an ordinary watercolour brush. Some lettering brushes have a flat point.

Miniature painting brushes are another variation on the traditional round watercolour brush – this

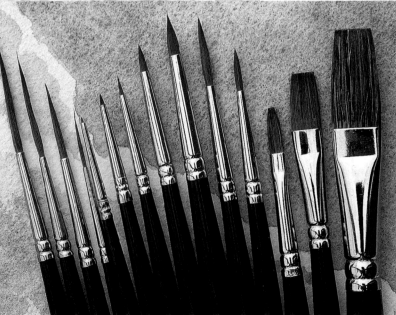

Different brush shapes may be used for watercolour. These examples, shown life size, are from left to right, two extra-long and two standard length riggers, they could also be described as lettering brushes. Next to these are five miniature painting brushes in different sizes; the two smallest ones are designed for delivering dots of wash rather than strokes. A designers' sable brush is next to an artists' watercolour brush and finally three different sizes of long one stroke brushes are shown. These are of light ox hair.

time the hair is shorter, tightening the control over the point so that tiny strokes can be made. Sometimes the smallest sizes are so short that they can only deliver a pin-point dot of colour. Retouching and spotting brushes are very similar.

Flat soft-haired brushes with chisel-edged tips and short handles are usually called one strokes. Occasionally they are just called flats. The hair length out of the ferrule may vary according to the type of hair used. Large one strokes may be used as wash brushes.

Wash brushes are large watercolour brushes intended for placing water or wash across big areas. The terms sky, or sky wash, brushes are also used. They can be round or flat, or flat with a slightly rounded end, which is called domed flat. The filbert is also flat with a rounded end, but it is well rounded, making it tongue shaped. Mops are medium to large sized, round, full-headed brushes, often bound to the handle in a traditional manner with strips of quill and wire. They make pleasantly sloppy wash brushes. A similar, but more carefully shaped and pointed brush style is made in Kazan squirrel. These are versatile watercolour brushes that I also call mops. Filbert wash brushes in squirrel hair or squirrel mixtures can be useful painting brushes too. Finally, it is appropriate to mention oriental brushes. They are not specifically linked to traditional western watercolour techniques, but Turner had some. Today, oriental brushes are widely available and you may wish to consider including them among your watercolour materials.

Brush sizes

You only need a few brushes to paint well in watercolour, but they must be the right shapes, qualities and sizes for your purpose. One or two small brushes, a middle-sized one and a large one are usually enough. Always use the best brushes that you can afford. In Part 3 the brushes used in each demonstration are specified. In many instances, most of the painting is carried out with one particular brush, frequently a fairly large one and where others are also used there are seldom more than two or three in total. The brush sizes quoted in the text are British and to avoid any misunderstandings several of the examples illustrated in this section are shown life size. Brush sizes tend to vary from manufacturer to manufacturer, as well as from country to country.

WATERCOLOUR PAPERS

Paper takes its name, in English, from papyrus, which the ancient Egyptians used, but modern papers originate from China, where paper was probably first made from waste silk in *c.* 300–200 BC. Its manufacture and use spread to the Middle East via the Turks, but paper was not introduced into Europe until the 12th century AD. It first appeared in Spain and southern Italy, and then in the course of the next 200 to 300 years paper making became established across Europe.

Paper did not immediately displace parchment, and in particular vellum, as a substance for painting on. Its success as a material owes more to its suitability for writing and printing on and to its modest cost. Papers were not made specifically for artists before the late 18th century and watercolour

Here, a sheet of Fabriano Roma – a modern hand-made paper – is held against the light to reveal the imprint of a laid mould, an identifying watermark and its deckle edges. These features are typical of early, traditional papers. The colouring in this case is intentional, but some papers had a tint due to the fermentation of the rags from which it was made.

papers, as they would now be known – they were originally called drawing papers – were not in widespread use before the 19th century. This was when the familiar surface textures and paper weights now associated with watercolour papers first appeared.

Prior to this, watercolourists used papers meant for writing, printing or wrapping. This contributed to the individuality of many early watercolourists' work, but was also a source of problems as John Varley's (1778–1842) remark demonstrates: 'With regard to the painter in watercolours, a very great proportion of his time is employed in overcoming the peculiarities and defects in paper.' Today's watercolour papers are standard products of consistent quality, but they differ from those used in the 18th and 19th centuries, so there are aspects of traditional watercolour methods that do not translate comfortably.

Hand-made paper

The essential nature of today's watercolour papers was established between the 18th and 19th centuries, particularly by the paper-making firm of James Whatman and its successors, which dominated the market in Britain and subsequently in America for over 150 years – though it was by no means the only producer of such papers.

For centuries, paper was made by hand using rags – originally linen and then cotton – as a raw material. The invention in the 17th century of the 'Hollander' beater – a machine that pulped rags – greatly assisted the process and helped to expand the industry.

To make paper, the separated fibres from the rags, suspended in water, known as stuff, are drained through a wire screen, the mould, which is manipulated by the principal papermaker – the vatman. A frame, called a deckle, that sits over the mould retains some of the stuff as it is dipped into it. Then quickly, before it drains through the wires, the vatman shakes it from front to back and from side to side. This gives the fibres a multi directional alignment and makes the sheet strong. The design of the mould, the consistency of the stuff and the depth of the deckle determine the thickness of the sheet. Some fibres get under the deckle as the paper is made, giving it ragged edges. A hand-

These modern hand-made watercolour papers by Two Rivers (below) are hard-sized wove and laid papers which are traditional in concept and offer an alternative to the machine-made mass-market product. The interesting surface textures and colourings are part of their appeal.

made sheet has four of these characteristic deckle edges, one on each side.

The newly formed sheet is then transferred onto a loosely woven woollen cloth called a felt. This is done by the coucher, who builds interleaved sheets of paper and felts into a stack known as a post – this is subsequently pressed to remove excess water. The surface texture of a watercolour paper is the imprint of the felt.

After the post has been pressed, the hand-made sheets are separated and dried slowly in a drying loft, where they are hung over cow hair ropes or laid flat on canvas sails. This carefully controlled process allows the sheets to stabilize as they lose moisture and contract. Hydrogen bonding also takes place between the cellulose fibres during this curing process and the sheet is further strengthened by it. Next comes tub sizing, in which the sheets of paper are immersed in a solution of gelatine or animal glue and are allowed to soak it up. A few sheets at a time are held apart and dunked – often this action is repeated holding the sheets at a different angle to ensure an even coverage. James Whatman developed a sizing machine that immersed a whole post of paper for about an hour. After sizing, the sheets are again dried very slowly and carefully.

A major advance in paper manufacture was the introduction of the wove mould in place of the laid one. A laid mould has the wires parallel to each other and held at intervals; it drains quickly and leaves a distinct imprint on the paper. Until the latter part of the 18th century all papers were laid. James Whatman first produced wove papers for the printer John Baskerville in around 1757. As its name suggests, a wove mould has the wires woven together. It drains more slowly and leaves a less pronounced mark, so thicker, smoother sheets can be made. Laid papers continued to dominate until at least the end of the 18th century and are a feature of many early watercolours, but the wove mould made possible the kind of watercolour papers from which those of today are descended.

Commercially, the supply of hand-made paper is no longer of major importance, though it is still produced on a small scale and should not be too difficult to obtain. However, it is extremely relevant to the subject of traditional watercolour techniques as hand-made watercolour papers were extensively used until well into the 20th century and it is only comparatively recently that they have finally given way to their machine-made equivalents.

Machine-made paper

Paper-making machines have existed since around 1800. Their speed and efficiency inevitably made them a success, but artists were slow to abandon the hand-made products, which seemed superior in many subtle ways. The use of inferior raw materials, chemical bleaches and a degenerative type of size also gave machine-made papers a bad reputation during the 19th century. John Ruskin appears to be comparing the hand-made against the machine-made product with these damning remarks: 'From all I can gather respecting the recklessness of modern paper manufacture, my belief is that though you may still handle an Albrecht Dürer engraving, 200 years old, fearlessly, not one half of that time will have passed over your modern watercolours before most of them will be reduced to near white or brown rags; and your descendants, twitching them contemptuously into fragments, between finger and thumb, will mutter against you, half in scorn and half in anger, "Those wretched 19th-century people! They kept vapouring and fuming about the world, doing what they call business and they couldn't make a sheet of paper that wasn't rotten".'

It is likely that the materials and the control of the process rather than the machinery itself resulted in this inferior product. Similar machines are used today and some excellent artists' papers are made on them. There are two types of paper-

Above are top-quality cylinder mould-made watercolour papers presented as watercolour blocks from some of today's leading manufacturers. All of these papers are 100% cotton and acid free.

Watercolour papers are made in three different surface qualities: rough, not (cold-pressed) and hot-pressed. Here are some examples offered by different manufacturers.

mould can only produce two deckle edges, but it is common practice to fold and tear as the individual sheets are separated, giving them the appearance of a hand-made sheet, with four deckle edges.

Modern machine-made papers have the advantages of being produced to exact standards and of being uniform in quality. The best makes have excellent specifications and, in a purely technical sense, are better than a comparable hand-made paper. In watercolour painting, however, choosing the right paper for a particular technique involves many considerations and is partly a subjective issue. This is why I have specified the paper used in each of the demonstrations in Part 3.

Today, there are plenty of reliable papers, but they are all different, and while in a given context one might be better than another, there is no overall best. It is important to experiment with watercolour papers, so that you can make the right choices for your own work. You also need to know something of their specifications in order to understand why one paper may be more suitable than another for your intended use. These are now briefly considered.

Raw materials

As already noted, paper was originally made from rags, which until the 19th century would have been linen and from then progressively more and more of cotton. In lower grades of paper sail cloth and old rope might have been incorporated, but all these

Some watercolour papers need to be stretched on a drawing board or over a frame before use. You should wet the paper and then secure the edges with gummed tape or starch paste. Heavy papers need not be stretched, but should be fixed at intervals along the edges with drawing pins or small pieces of tape while being painted on. Masking tape can be used to hold the edges of a dry sheet of paper, but it must be removed immediately once the painting is finished.

making machine: the Fourdrinier and the cylinder mould machine. The Fourdrinier is fast and well suited to general paper making. Some artists' papers are made on these, but watercolour papers are usually made on cylinder mould machines – which offer, in effect, a mechanized version of the traditional hand-making process.

On such machines the wire mould is cylindrical rather than flat. It rotates partly submerged in the agitated pulp and on the ascendant side, where it simulates the action of the mould being lifted from the stuff, a continual sheet of paper forms. This is carried through the rest of the machine which, in turn, squeezes it against a web of felt, dries it against heated rollers and, on the best machines, runs it through a trough of gelatine before drying it again. The process is continuous and takes only a fraction of the time of hand making. A cylinder

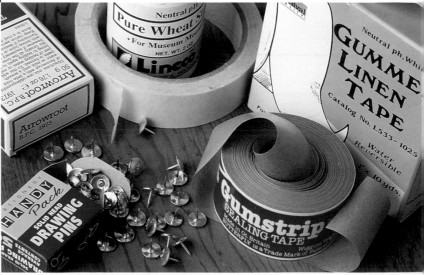

The textured surfaces offered in modern watercolour paper ranges, like this example, may have originally derived from the coarse wrapping papers – called cartridge papers – that were a frequent choice of watercolourists during the late 18th and early 19th centuries.

were sources of durable, natural fibres and the papers made from them were strong and long lasting. Wood pulp was also used as a raw material from the 19th century onwards, but this turns acidic and self destructs in a comparatively short time.

The highest quality modern watercolour papers are still made of cotton, but no longer from rags, although the term rag paper may still be used. Instead the manufacturers start with a pure raw material, virgin cotton fibres. The fibre length and the fact that it has not had previous use may, however, account for certain features of modern papers. The structure and surface quality of today's watercolour papers appears to be quite different from those of historical examples, which may have affected their technical possibilities. The purity and standardization of the modern product has led to a loss of character. Some hand-made papers still combine other traditional fibres such as flax (linen) or manila with cotton in pursuit of specific qualities.

Watercolour papers for the amateur are generally described as wood free, though they are, in fact, made from forms of wood pulp – ones that are free from harmful ingredients. The terms alpha cellulose and photographic wood pulp may be used to describe what they are made of. These are usually good, serviceable, economically priced papers. Cotton papers perform better, but are considerably more expensive. There are now a few intermediate quality watercolour papers that combine a high cotton content with other ingredients.

Weights

Watercolour papers are comparatively substantial. Their relative thicknesses and densities are expressed in terms of their weight. This is either given in pounds (lbs), which was originally a reference to the weight of a ream – 500 sheets – or as a metric measurement, where the weight of the paper is described in grams per square metre (gsm or gm^2).

Around the middle of the 19th century, the now familiar weights of 90lbs and 140lbs were categorized as 'drawing papers of extra weights and thickness'. Typical modern weights for watercolour papers are 90lbs (190gsm); 140lbs (300gsm) and 300lbs (630gsm); others such as 175lbs (370gsm) and 250–260lbs (525–545gsm) are not unusual. The heavier the paper, the better it copes with water when painted on – lightweight papers cockle badly when wet and should ideally be stretched before use. Arguably, all watercolour papers will benefit from stretching, but it is an inconvenience that many watercolourists seek to avoid. Stretching is shown as part of the *Roche Abbey* demonstration in Part 3. The heavier the paper, the more it will cost. Usually 140lbs (300gsm) is a good standard to work on. Traditional watercolour papers are likely to have been more robust for their weight than modern examples.

Surfaces

As previously mentioned, it is the pressing of the newly made paper against the felt that gives it its surface texture. A coarsely woven felt gives a rough-textured surface, while a moderately fine weave and gentle compression during manufacture gives the less emphatic texture of the not or cold-pressed surface. The smooth hot-pressed surface is achieved by compressing the not surface as a finishing process. This was originally done by placing hot copper plates between the sheets and then pressing them, but now heavy, smooth rollers are used to flatten the paper's surface as it comes off the cylinder mould machine.

The different surfaces suit different styles and subject matter. The not surface is very adaptable and is, understandably, the most popular. Note that the surfaces offered by different paper makers may have the same descriptions, but can vary considerably.

Gelatine or a good-quality hide glue – traditional sizing materials for paper – may be used to modify modern papers. A concentration of one part in 20–30 parts of water is usually sufficient. The best present-day watercolour papers are still sized with gelatine.

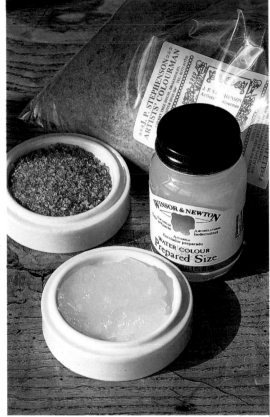

alum-rosin size proved to be very destructive and has since been abandoned, but internal sizing with more suitable materials – starch-based sizes, for example – remains a feature of modern paper making. Even most of today's hand makers use internal sizes to some extent.

One of the benefits of internal sizing is that because it spreads right through the paper, rough handling – such as repeated erasing or multiple attempts at washing back and even physical damage to the paper's surface – does not prevent it from accepting wash, ink or body colour, whereas size concentrated at the surface can be penetrated, leaving the paper vulnerable and unable to perform. Because amateurs are more likely to mishandle paper, but also no doubt because it is a cost-effective option, the lower-ranking papers tend to rely on internal sizing only. There is also at least one pure cotton watercolour paper that is just internally sized, but the more usual practice now with top-quality papers is to size them both internally and externally. This means that the paper is sized internally at the pulp stage and after making is then passed through a solution of gelatine which additionally sizes the external surfaces of the paper.

Watercolour papers with this type of dual sizing are undoubtedly the best of the modern standard products. The use of a gelatine size can be taken as an indication of quality, though the amount

Watercolour blocks (below) are convenient to use. When you have completed your painting, you remove the top sheet by sliding a knife under it.

Sizing

Modern papers differ most from each other and from those used previously because of their sizing. The tub sizing of traditional papers with animal glue or gelatine, even when indifferently done, would have produced robust surfaces, likely to respond in interesting ways when painted over with wash or when dampened. Heavily sized papers are said to be hard sized. Almost certainly many of the papers used in the past had a far harder sizing than any of the present-day examples.

In the 19th century, internal sizing using alum-rosin size was adopted commercially. An internal size is put into the pulp before the paper is made and it can therefore shorten the manufacturing process by making a separate sizing operation unnecessary. Technically, it also has the benefit of spreading the size throughout the sheet, not just concentrating it at its surface. The use of

that is applied by these modern methods and its penetration into the paper may not result in the exact equivalent of a traditionally hard-sized paper.

Again, the products of different manufacturers vary. On the whole, hard-sized papers are to be preferred for watercolour painting, but a soft sizing – where the concentration of size in the paper is low – can suit some techniques.

Archival quality

Old hand-made papers have survived well because of the simplicity of their ingredients and manufacture. Many more recent mass-produced papers have aged badly – it is now known that acid is a major enemy of paper. This is present in, for example, unrefined wood pulp, alum-rosin size and chemical bleaches, all of which have been used in paper making. Alum, which is acidic, was also commonly used to harden and fix gelatine or animal glue sizing on traditional hand-made papers, but its low concentration and isolation within the size seem to have prevented it from being destructive.

Modern artists' papers should be made acid free. This may be expressed as a pH number – pH7 is neutral and so readings from around 6.5 to 8 are classed as acid free. To protect against future contact with acid, good watercolour papers are likely to be buffered as well. This is done with

Nineteenth-century watercolour blocks such as the one below were originally known as solid sketch books.

You can paint water-colours on surfaces other than paper, for instance (below, from left to right), silk, fine linen, ivory and vellum.

calcium carbonate – chalk – which is capable of neutralizing acid. Buffering is useful because acids can migrate into papers from their surroundings and, until quite recently, unsuitable framing materials were a major source of damage.

Similar specifications are therefore required of Mount Board (Matt Board) and of the various other

materials used when framing works on paper. The terms conservation, archival and museum quality may be used to describe them. The ideal standard of framing for a watercolour is conservation framing, which uses acid-free materials exclusively, and seeks to eliminate or minimize all external influences. For aesthetic or practical reasons, you may not want full conservation framing for your work, but do always ensure that anything that is in immediate contact with your watercolour is acid free. This also applies to work kept in portfolios, which should be interleaved with sheets of acid-free tissue.

Choosing your paper

During the 19th century a range of more or less standard sizes, which may have varied slightly from paper maker to paper maker, was established for artists' drawing papers, that is to say watercolour

These hand-made book repair papers by Griffen Mill offer some traditional characteristics. The sample book (left) shows Indian papers with inclusions of tea and straw.

This is a typical sketching portfolio (c. 1886) made to carry standard sizes of paper. The japanned tin frame was used to fasten the paper down – holding it all around the edges – while it was being worked on.

1 MATERIALS

papers. They were derived from the mould sizes used when making these papers by hand. Typically, in Britain and America at least, they were as follows: Demy – 20" x 15" (51cm x 38cm); Medium – 22" x 17" (56cm x 43cm); Royal – 24" x 19" (61cm x 48cm); Super Royal – 27" x 19" (69cm x 48cm); Imperial – 30" x 21" (76cm x 53cm); Atlas – 33" x 26" (84cm x 66cm); Colombier – 34" x 23" (86cm x 58cm); Double Elephant – 40" x 26" (102cm x 66cm); Antiquarian – 52" x 31" (132cm x 79cm).

The heaviest papers tended to be made in Imperial or Double Elephant – Imperial is still the standard size for a sheet of watercolour paper, though it is now more usually 30" x 22" (76cm x 56cm) rather than 30" x 21". Sizes similar to the traditional Double Elephant, Demy and Royal are still supplied as either machine- or hand-made papers, but their use is not widespread. Since a cylinder mould machine does not make paper sheet by sheet, but in a continuous strip, and is not restricted to traditional widths, today's watercolour papers are also supplied in rolls and extra-large sheets.

Artists have always used sketch books. Present-day sizes are often based on divisions of the Imperial, Medium and Super Royal, however, the more up-to-date sizes of A5, A4, A3, A2 and A1 are gradually being introduced to artists.

Mass-market watercolour sketch books are either gummed along one edge or are spiral bound with a coil of wire, which allows the pages to be turned easily. They are immensely popular with amateurs since they are portable, but they are only good for sketching as the paper is not fully secured and is liable to cockle. Handbound sketch books of good paper are occasionally available, but you will still encounter the same problems.

Watercolour blocks – used since the first half of the 19th century – are far better than sketch books to paint on. Originally known as solid sketch books, these have all four edges gummed with just one small area unfixed. The paper is not pre-stretched, but it almost behaves as if it is, and, when painted on, should eventually dry flat. Afterwards, a knife is inserted where the edge is unfixed and the top sheet is separated, exposing a fresh surface to paint on. Watercolour blocks are usually made up from top-quality papers and may seem expensive, but they are very practical for watercolour painting, either done or begun out of doors.

Incidentally, slight distortions of watercolour papers can usually be remedied by pressing them flat under a weight over a period of time – storage in a portfolio is sometimes sufficient. This applies to papers that have been taken from blocks, sketch books or used as loose sheets. However, papers do not always behave perfectly, even when properly stretched. In extreme circumstances they can be flattened by pasting them onto a more substantial paper that has itself been stretched.

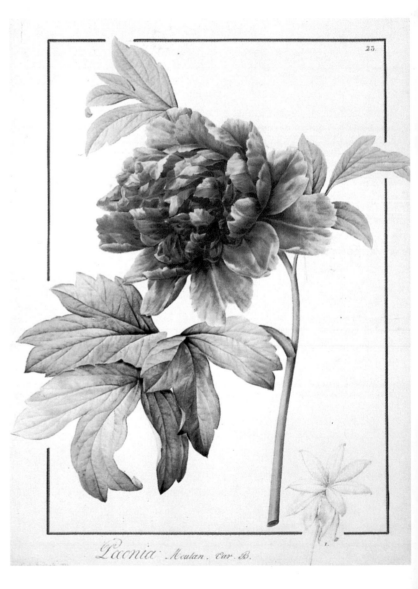

Double Peony (1812) by Pierre-Joseph Redouté. Watercolour on vellum with black chalk. One of a series of studies of rare plants collected for the Empress Josephine at La Malmaison, Paris.

ALTERNATIVE SURFACES AND SUPPORTS

The cartridge papers that were once used for watercolour painting were rough, hand-made wrapping papers – often used to make cartridges for muzzle-loading fire arms, hence their name. Modern cartridge papers are machine-made drawing papers and are nothing like the original, however, some watercolourists do like to paint on them. They are usually appreciably less substantial than watercolour papers, are unlikely to be as heavily sized and will probably have been made on a Fourdrinier machine, which may give them a less even distribution of strength. These factors have to be taken account of when using cartridge papers. They are unlikely to cope well with watercolours unless properly stretched.

Ingres paper – a fine-laid drawing paper – can be suitable for some watercolour techniques, but again it needs to be carefully prepared. Ingres paper is used for pastels and, like other pastel papers, is available in colours as well as white or off-white values – some coloured watercolour papers are also available. Coloured papers work particularly well

lightest mark and is potentially the least intrusive, but you may want the drawing to show, in which case the blacker grades are better. Avoid H grades unless you can handle them with a very light touch, as they tend to indent the paper. Grades softer than 2B give very black drawings and can smudge and be picked up by the wash. The same applies to black chalk and charcoal, but they can also work well with watercolour in appropriate circumstances.

Always try to keep erasures to a minimum, so you do not damage the paper's surface or its sizing. Use a soft, good-quality eraser and keep it clean. Vinyl erasers are probably best for removing pencil. Kneadable putty erasers should be used with chalk and charcoal.

When doing pen drawings you will achieve the best results by using a traditional dip pen to ink over a light pencil drawing. Technical drawing pens and fine-pointed fibre or plastic-tipped pens can also produce agreeable affects with watercolours.

Artists' graphite pencils, drawing chalks and charcoal by Faber Castell, Rexel Cumberland and Conté (above).

Late 19th-century pencils (below).

with gouache or when using transparent washes and body colour together.

Book repair papers, Indian papers and Japanese papers have their own unique qualities, and some of them also resemble earlier paper types. You may have to investigate the quality and work out how best to prepare such papers if they are not made specifically for painting on.

Cloth – linen, silk or cotton – prepared hide, vellum or parchment and thin sheets of ivory can all be used for watercolour painting. A substitute for ivory called ivorine is now used more often for obvious conservation reasons.

Watercolour board is watercolour paper mounted onto a sturdy card backing. This makes it able to cope with the wetness of the wash better. Similar types of board are used for professional illustration and some mount boards (Matt Boards) are suitable for painting on. Note, though, that the board, the surface paper and the mounting adhesive must all be acid free if put to this purpose.

Drawing materials

Most watercolour painting involves a drawing and that drawing can be a crucial feature of the method. Obviously, good-quality drawing materials are essential. Graphite pencils graded HB, B or 2B are suitable for preliminary drawings – HB gives the

Ink should always be fast to light and it is generally best if it is waterproof.

Painting mediums

Painting mediums – additives that modify the appearance or behaviour of watercolours – feature quite often in traditional methods, but their use has tended to be selective and for a specific purpose.

Steel drawing pens have flexible points; mapping pens have very fine points; traditional dip pens produce expressive drawings that work well with watercolour washes.

behaviour of the colour. See *The Cherry Tree* in Part 3 for a demonstration of stopping out.

Historically there has been some use of varnish on watercolour, but the merits of this are debatable. Mediums for use with acrylic paints are usually compatible with watercolours and egg yolk or beaten egg-white or other tempera emulsions may also be added.

Other materials and equipment

Watercolour offers so many possibilities that the range of relevant materials and equipment is extensive. Mixing slabs, tinting saucers and stacking 'cabinet' saucers are not as essential as they were in the days of hard watercolour cakes, but they are convenient and promote a disciplined approach. Making up sufficient quantities of wash before you start to paint is often of major importance, as is keeping all the equipment clean.

Gold has traditional associations with watercolour, where it is used either as metal leaf or as a paint. Dutch metal and bronze powders may be used as less expensive alternatives.

A selection of painting mediums for use with watercolours mostly based on gum arabic; also ox gall, masking fluid and watercolour varnish.

Gum arabic as a solution in water may be added to watercolours to increase their richness and depth – for example, to modify areas of shadow. It can act as a selective varnish when placed on top of the wash. Though if it is used too heavily, a glassy quality will result that may eventually crack and peel.

Extra gum also thickens the wash as it dries, and makes it more vulnerable to water when it is dry. This can aid scratching through or lifting off colour. You can see some of the ways in which gum can be used in *Figures in a Cornfield* in Part 3.

Gum tragacanth has similar properties to gum arabic, but may also contribute to a slight impasto effect. Starch pastes give rise to a rather different textured finish – one that shows streaky brushmarks.

Ox gall increases the wetting capacity of a wash and improves its flow. Glycerine in the painting water slows the drying rate on hot days, while alcohol increases it on cold ones. In 1802, Paul Sandby was observed 'making the tint thin with gin, sometimes adding a little gum water.'

Gelatine also has some potential as a watercolour medium. Used strongly, it can act as a 'resist' or stopping-out medium. Modern masking fluids (liquid frisket), however, are based on latex. Strictly, a resist is not a medium because it works separately from the paint, but it does alter the

Drawing boards should be flat and sturdy, but preferably not too heavy. There are different types and you should choose one that suits your individual needs – for instance, it should not stain paper that is stretched over it wet or, if you wish to use drawing pins, it must be soft enough to accept them. It can be practical to have several drawing boards so that you can work on more than one watercolour

Knives and other sharp implements (below) are needed for scraping out. Traditional china slabs and saucers (bottom) are used for preparing wash; a sponge can be used to lift off colour.

at a time and it obviously makes sense if the dimensions of a drawing board relate to a particular size of paper – it should be a little bigger all round than the paper. Studio drawing boards are items of furniture that stand on legs and can be tilted. They are arguably better than easels for working indoors.

The typical watercolour easel is a lightweight tripod that can hold a drawing board or watercolour block at an upright tilt or horizontally – they are mostly used for painting out of doors. Easels that have handles or carrying cases are useful when painting in places that can only be reached on foot.

Some other useful items are shown below – studio knives, sponges and spray diffusers, you may find all sorts of odd items that suit a purpose.

A wax candle can be used as a resist for effects like these (below). A spray diffuser (bottom) – with pastel fixatives – may be used to spray or spatter water, watercolour wash or dilute gouache.

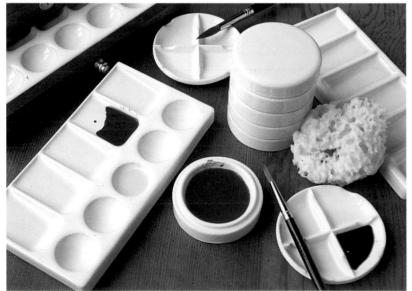

PART 2

WATERCOLOURISTS
at work

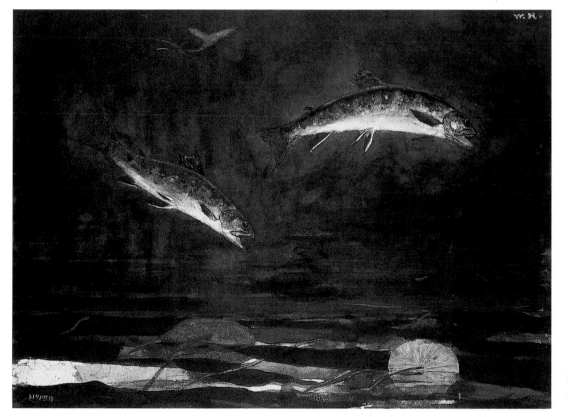

Leaping Trout *(1889)*
by Winslow Homer.
Watercolour on paper.

DURER AND THE MINIATURISTS

In western culture the use of watercolour materials can be traced to the early Christian era. They were used for illumination – the illustration of hand-copied books or the decoration of important documents. The earliest surviving examples date from the 6th century AD. Illumination continued to be widely practised throughout the Middle Ages and the Renaissance, although it declined with the introduction of printing. Today, it is a minor art form associated with calligraphy.

During the 15th and 16th centuries, artists began to use the same materials and techniques that had been used for illumination for small paintings. This marked the beginning of the watercolour tradition and although later influences were to shape the art as we now know it, there are still methods in use that originate from then.

Albrecht Dürer (1471–1528) was the most outstanding early practitioner of watercolour. His subjects included nature studies and landscapes.

He was a superb draughtsman and was accustomed to drawing with a brush – graphite pencils were not then in use – and his watercolour methods depended on this skill. Of particular interest is the fact that he often painted on paper – perhaps because he was also a printmaker – at a time when parchment and especially vellum were the established and more obvious choices.

There is an unfinished Dürer landscape in the Ashmolean Museum, Oxford, which reveals a good deal about his methods. It is on thin, creamish white paper that has a fairly smooth surface, although it retains the fine, closely spaced parallel line patterning of a laid mould – a typical paper of the period that would not have been made specifically for artistic use. It has been worked upon in three stages: there is no preliminary drawing, the painting started with a rough lay-in of thinly applied colour, put on with a medium-sized brush, probably the equivalent of a modern size 4 to 6

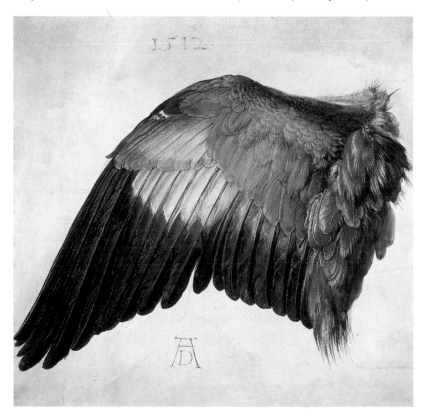

Roller's Wing *(1512)*
by Albrecht Dürer uses black ink, body colour and watercolour, all delicately applied by brush. It is painted on vellum as is a companion piece Dead Common Roller *(1512), which is also highlighted with gold. The use of these materials is derived from illumination.*

Large Piece of Turf
*(1503) is on paper and
like several of Dürer's
watercolours, it is an
isolated study with
the background left
plain. It differs from an
illuminated page because
of its subject matter
and the accuracy of its
observations of nature.*

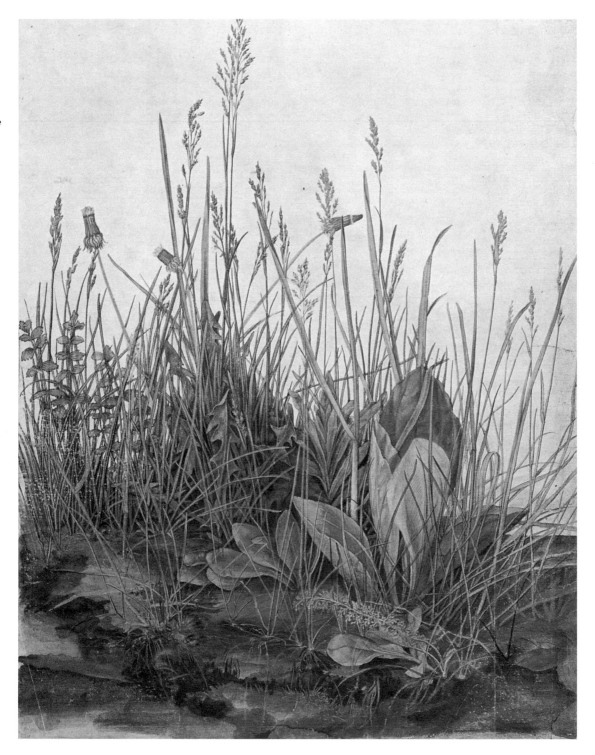

watercolour brush. The paint is not transparent. It was applied as body-colour tints, but as these are dilute and thinly applied, they are not fully opaque. The brush will have been neither dry nor fully loaded and in the lower layers it was apparently used on its side to make broad, overlapping strokes. There is also a chain-like pattern in evidence, made from dabs of the brush head.

Over this foundation is a layer made up of further applications of more solidly stated, but still quite thin, colour and some fine outlining from a small brush point. Within this layer a careful use of the brush began to express the subject so that details of the landscape could be determined. Fields, hedgerows, a ploughed area, a church, a house and the undulation of the landscape, with rounded hillocks and valleys cut by little streams, are all roughly indicated. So, having started vaguely, Dürer refined his concept with preliminary indications of detail while also taking the quality of the painted effects towards an intermediate state of completion. There is still uncertainty at this stage and fine finishing is reserved for another layer.

The final overpainting of the surface was done exclusively with a very small brush with a fine point. Firstly, tiny details were drawn in and then painted with minute linear strokes of colour.

In English miniature painting, which flourished during the 16th century amid the intrigues of Elizabeth I's court, once again the methods and materials are taken from illumination, or 'limning' as it was known – particularly the minutely worked surface with its rich decorative quality. The greatest of the Elizabethan miniaturists, Nicholas Hilliard (c. 1547–1619) explained that it was this decorativeness combined with their scale, suited only to an audience of one, that made them so desirable, intimate and exclusive.

Here is how he described limning: 'It excelleth all other painting whatsoever in sundry points, in giving the true lustre to pearl and the precious stone and worketh the metals gold or silver with themselves, which so enricheth and ennobleth the work that it seemeth to be the thing itself, even the work of God and not of man, being fittest for the decking of princes' books or to put in jewels of gold and for the imitation of the purest flowers and most beautiful creatures in the finest and purest colours which are chargeable, and is for the service of noble persons very mete in small volumes in private manner for them to have the portraits and pictures of themselves, their peers.'

English 16th-century miniatures are tiny portraits showing just the head or head and shoulders. They are mostly painted on vellum which has been pasted onto card – sometimes a symbolic playing card – and may afterwards have been burnished from the back. The first stage is as Edward Norgate (d. 1650) explained: 'to lay a ground of flesh colour, which the limners call a carnation, and is nothing but a ground whereon to work, but is to be tempered according to the complexion of the party whose picture you are to make.' This layer corresponds to Dürer's thin, broad applications of colour.

Norgate's instructions further reflect the methods used by Dürer. He recommended brushes in different sizes for the various stages of the work, saying that all should be 'of a reasonable length, full, round, and sharp, not too long, nor too slender, which are troublesome to work with.' He also advised the use of a large or mid-sized brush at the beginning, 'especially for dead colouring and laying grounds; besides they hold and keep the colour longer and work more flowing than any other.' The paint in the opening stages, he said, should be 'rather thin and waterish than too thick and clammy'. Hilliard also speaks of laying the

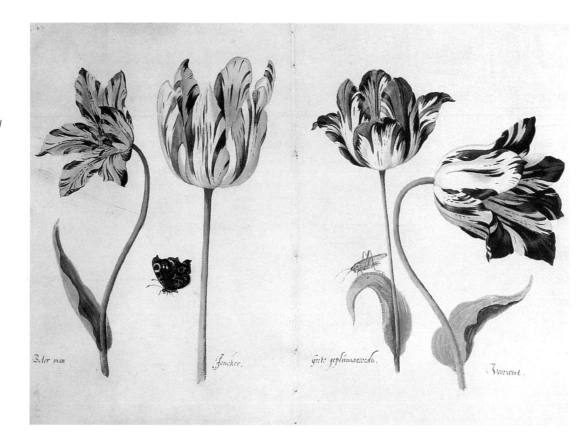

carnation in a manner that seemingly relates to Dürer's handling of his first colours, saying it 'must be laid flowing, not too full flowing neither, for cockling your card etc., but somewhat flowing, that it dry not before your pencil [brush] until you have done, lest it seem patched and rough.'

The features are then drawn lightly with a brush on top of this flat patch of flesh colour and, as Norgate says: 'what remains when your face is drawn must be afterwards taken off with a wet pencil [brush]'. The painting process is then one of gradual refinement, just as it appears to be with Dürer in which delicate shading and fine detail are added. The process works from light to dark, as the majority of watercolour methods do, so it is important not to have too strong a tint as a foundation colour. As Hilliard explained: 'limning is but a shadowing of the same colour your ground is of'. The finishing colours are often applied to miniatures in tiny dots, placed by the merest touch of the absolute tip of the brush. An account from the 1620s describes the methods used: 'All this you must work after the manner of washing or hatching, drawing your pencil [brush] along and with faint and gentle strokes, or rather washing or wiping them with pricks to prick and punch it, as some do affect.' Interestingly, this finishing technique can involve the use of transparent watercolour over body colours, subtle touches modifying underlying values.

To achieve a dense, even background colour around the head, usually done in blue, miniature painters would lay the colour once, let it dry, and then flood more of the same colour into a thin covering of clean water.

Later portrait miniatures are on ivory and use watercolour more transparently, though there are technical similarities in the handling of it. Following the trend established by Dürer, the materials and methods of the early watercolourists continued to be used for natural history illustration until the beginning of the 19th century. Echoes of this relationship remain in modern practice in this field.

Draughtsmen and drawing masters

The 18th century saw the use of transparent washes – that is watercolour as it is most generally recognized today – established as a separate art form. It is most likely that it evolved from the use of line and ink wash for preliminary studies, a practice common since the Renaissance. In the 1630s Sir Anthony Van Dyck (1599–1641) was already producing what were in essence coloured watercolours and the sketches of Rembrandt (1606–69) and Claude Lorrain (c. 1604–82) can be seen to be close to watercolour in concept.

During the same period the use of printed illustrations, especially in books on the history or the principle sights of countries or regions, grew. The engravings for these were based on monochrome paintings, that is washed-over drawings, provided by artists who painted on location. Sometimes, subdued washes of colour would be added over the top as a guide for the hand colouring of the print. To do this cheaply and effectively, it was essential that the print itself was not obscured, so transparent colours were used.

Francis Towne usually restated the initial drawing in pen and ink. In Bridge and Waterfall near Llyngwellyn *(1777) you can see this outline clearly and can easily detect the monochrome shading beneath the washes of colour.*

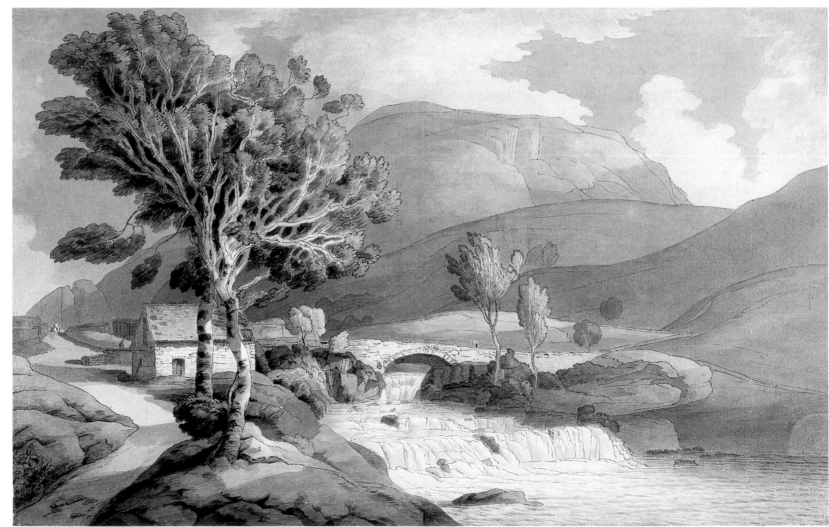

The same tints, frequently in liquid form and probably based on dyes rather than pigments, were applied to maps for which watercolour drawings may also have supplied information.

Watercolours were now used for topographical views of landscape – a literal survey of the lie of the land and its features. There was also an interest in the 'picturesque', a concept introduced by the Reverend William Gilpin between 1768 and 1792. Early watercolourists such as Francis Place (1647–1728), Alexander and John Cozens (1717–86 and 1752–97), and Francis Towne (1740–1816) were topographical draughtsmen, a term now used dismissively, but they and their watercolour paintings must be considered in context. They laboured with limited materials and many of their works have faded, but not necessarily in a uniform way, which makes it difficult to assess their original qualities. A subsequent generation, which included Turner and Girtin, was inspired by these draughtsmen's work and, in consequence, expanded the concept of watercolour and added enormously to its range of techniques.

The methods of the topographical draughtsmen clearly define and demonstrate the principles of transparent watercolour and were the basis of its teaching until well into the 19th century. In his instructions for 'Drawing and Colouring Landscapes', Edward Dayes (1763–1804) summarizes the process as follows: 'First, then, in making the outline everything that relates to the shape of the objects must be settled, as the student will have the advantage of doing it without the interference of light and shadow, or colour; and so far his attention, being less engaged, may be the more vigorously applied. Secondly, he will consider light and shadow independent of form or colour, and carry on the drawing as directed under light and shade; and thirdly, having only the colouring to regard, it is but reasonable to expect that his success will be greater than if he had to attend to all the different parts at one and the same time.'

This means you begin with a careful outline drawing that describes all the important shapes within your subject. Then you add a description of the light and shade, using transparent washes of a single colour in different tint strengths – Indian Ink, meaning Chinese Ink, was commonly employed in the late 18th century. When that stage is dry, appropriate colours are applied to each part of the painting, again using transparent washes over the top of the shading. In practice a few finishing touches are also necessary.

The drawing guides the laying on of the shadow tints and the colours, while both the drawing and the shadow tints act through the colours, giving a cumulative effect. It is a systematic and comparatively easy method to follow, since the painting can be separated into distinct stages. Working like this allows far greater subtlety than you might imagine and is full of opportunities for developing the basic skills that watercolour painting requires. This is how Dayes explains how you should make the drawing: 'Proceed to sketch lightly, with the black lead pencil ... begin to draw with a fine, but sure and firm line, the most remote distance; then come on with the nearer parts, making each stronger; and, lastly, touch in the foreground very strong; and in the darkest parts, make the pencil mark as strong as possible: this will give great spirit and boldness to the lines and will also indicate the different degrees of distance.'

Dayes' own method of shading involves two colours, Prussian Blue and Brown Indian Ink. They are used either separately or together in mixtures, which permits a wide range of tonal values that hints at colour, while also introducing cool or warm casts to the shadows. There were many variant methods. For instance, that of William Payne (c. 1760–1830) is of special interest as the colour known as Payne's Grey still features in most watercolour ranges. This account from 1831 explains how it was originally used: 'The chiaroscuro [the shading] of this style was principally wrought by use of a compound colour denominated "Payne's Grey". With this and a mixture of Indigo the sky was prepared, and the distant mountains laid in; the middle ground was effected with the grey alone; and the foreground was prepared with Lamp Black or Indian Ink. These materials working freely, and combining in a pleasing harmony of simple light and shadow, afforded a ready preparation for Mr Payne's process of colouring; – and simple enough assuredly it was.'

Payne was a popular drawing master who taught a method 'so eminently calculated for producing effect with facility, that it is peculiarly suited to the amateur who practices landscape drawing merely for amusement.' One of Payne's tricks was to drag the brush on its side, so that it missed small patches of the paper – an easy way to indicate pebbles, stones or gravel.

Watercolour painting became a popular pastime – as well as books of instruction, pictorial reference works were published full of rustic figures like these that artists could copy for use in their paintings. These books were sometimes called microcosms.

Tour d'Horloge, Rouen
*(1829) by David Cox
(below). The pencil
drawing beneath this
watercolour is really quite
fluid and free, but the
work depends on it totally.
The colours have almost
been slopped down, but
are carried beautifully by
the drawing.*

*Near Hampton-in-Arden,
Warwickshire by Cox.
A drawing for students
to copy and base
watercolour paintings
on from his treatise
of 1813.*

John Glover (1767–1849) was also a drawing master and had a few tricks of his own. He would put a graduated wash on the paper before working on it – starting at the top of the sky with plain water and then gradually introducing a warm-toned wash of a yellow or red earth that he made stronger and stronger as it approached the bottom of the paper, where the foreground of the landscape would be represented. Another trick was to dampen the paper before laying in the sky, which gave an easy soft-cloud effect, but his most notable trick was to use a multiple brush point to depict leaves or grasses. This description from 1823 implies that he joined several small brushes together: 'Who that had not seen this eminent artist at his easel could have supposed the possibility of twisting camel hair brushes together, spreading them, to the apparent destruction of their utility ... and by a rapid and seemingly adventitious scrambling over the surface of his design, prepared the light and elegant forms of the birch or willow, the graceful sweepings of the branches of trees of larger growth, and the vast masses of woods and groves sparkling in their various foliage?' The same or similar easy ways to paint are still being peddled by today's 'Drawing Masters'.

Other far more notable watercolourists have also been obliged to act as drawing masters in order to make a living – for example, John Sell Cotman (1782–1842) and David Cox (1783–1859), who also published instruction books. On the issue of drawing Cox made this valuable comment: 'He who devotes his time to the completion of a perfect outline, when he has attained this point, has more than half finished his piece.' As his own work confirms, by a 'perfect outline' Cox does not mean an example of precise technical draughtsmanship, rather he intends a complete drawing – one that

embodies the essential character of the subject and provides a structure to guide and support the washes of colour. He also gave a very clear description of the use of monochrome washes: 'It will be necessary that the pupil will be provided with good hair pencils [brushes], sepia or Indian Ink, and saucers to mix each separate shade in; also paper strained upon a proper drawing board. The outline being made very correct, the pupil will mix up three or four different shades, according to the number of distances that there may be … and carefully match them to each, commencing with the sky, and keeping the drawing board a good deal sloped, which will assist the tint to follow the pencil [brush] in the part where he is at work. He will also be particularly careful to always lay it on clear to the outline.'

In 1836, Cox discovered a rough Scottish wrapping paper on which he developed a free and spontaneous style of watercolour painting. An eyewitness recalled that: 'He worked with a large swan quill brush, and swamped his colours with

Near Bolsover by Cox (after 1836) is on Cox paper. It has been drawn with charcoal and was painted boldly using a large brush.

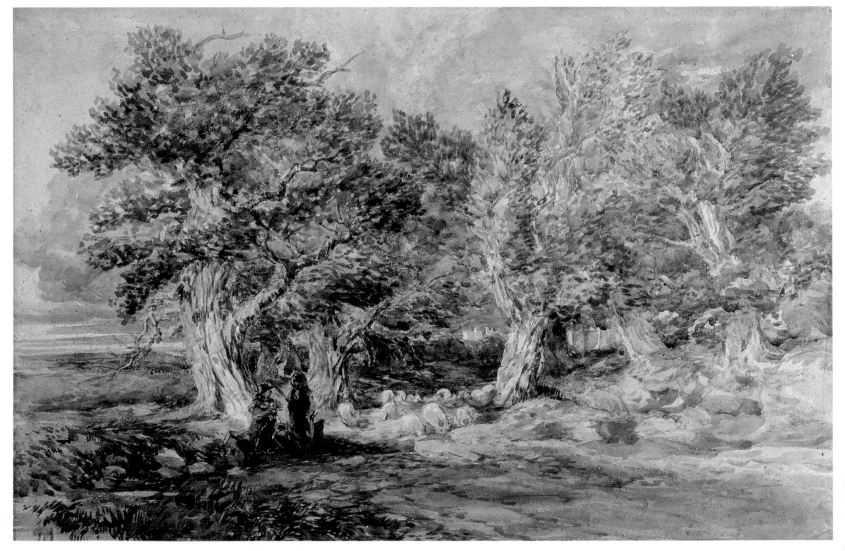

Hampton-in-Arden, Warwickshire by Cox. This was a drawing for students to copy. Cox was known for putting flights of crows into his paintings which he sometimes did to cover blemishes in the paper.

water. … His tints were very fluid, but not watery and he explained that, by working with a full brush, the colours never dried dark as they would do if the brush were half dry. I noticed that tints that looked very dark dried quite light. His system was constant repetition of touches till the effect was produced, being very careful that the preceding touches were dry. He seldom washed his tints after laying out, as he liked to see each touch defined, not softened off; he said it gave spirit and character to the sketch. "But mind", he said, "I am only showing you how I sketch. These are three sketches I have just done for you, they are not drawings".'

In a letter of 1842 Cox himself described other aspects of this unusual technique: 'Try by lamplight a subject in charcoal, and don't be afraid of the darks and work up to the subject throughout with charcoal in the darks, middle tint and half, with some very spirited touches in parts to give a marking. When you have done all this, have your colours quite soft, and colour upon the charcoal. Get all the depth of the charcoal, and be not afraid of the colour. When you look at it by daylight, and clean it with bread, you will find a number of light parts which have been left where the colour would not exactly adhere over the charcoal. For a distant mountain I have used Cobalt and Vermilion; and in the greyer part I mix a little Lake and a small quantity of Yellow Ochre with the Cobalt. In the middle distance I work each part separately; in fact something like mosaic work. The foreground the

Part of Kenilworth Castle by Cox. A study from his Treatise on Landscape Painting and Effect *from 1813.*

same, taking care to leave the reflected lights clear for a distant cool or bluish tint. I use very similar colours for the middle distance – for green, indigo, lake and gamboge, with its varieties; occasionally, for the rocks, cobalt, Vermilion, or Yellow Ochre, and sometimes Lake instead of Vermilion. In the foreground I use Indigo and Van Dyke Brown and Indigo and Brown-Pink – sometimes add Sepia to the Indigo and Brown-Pink. I use for the grey in the sky Cobalt and Vermilion; and for the more neutral grey, Cobalt and Light Red.'

TURNER AND THE GOLDEN AGE

Thomas Girtin's Morpeth Bridge *was painted in c. 1802, the year of his death. It is interesting to compare this with Towne's painting shown previously. Girtin's colours are much stronger and more natural and the play of light and shade across the whole painting is more carefully studied and expressed.*

The beginning of the 19th century was the dawn of a golden age of watercolour painting. Two young artists led the way – Thomas Girtin (1775–1802) and J. M. W. Turner (1775–1851), who had met and become friends while colouring prints for the engraver, John Raphael Smith, and copying earlier watercolours for the collector, Dr Munro. At the time, Girtin was judged the better painter, but he died young. Turner is much quoted as having said: 'If poor Tom had lived, I should have starved.'

With hindsight, it seems that Girtin's contribution has been assessed as being more focused than it

actually was, but there does seem to have been a significant turning-point in the evolution of watercolour in the paintings of his last few years – a combination of technical innovations, with a change of emphasis in the treatment of his subjects. In his mature style, Girtin painted on off-white coarse cartridge paper. He used this to add character to his colouring and very effectively left reserved spaces – it was assumed at the time that these were achieved with a 'stopping-out' medium, though they almost certainly were not – products were marketed that helped to

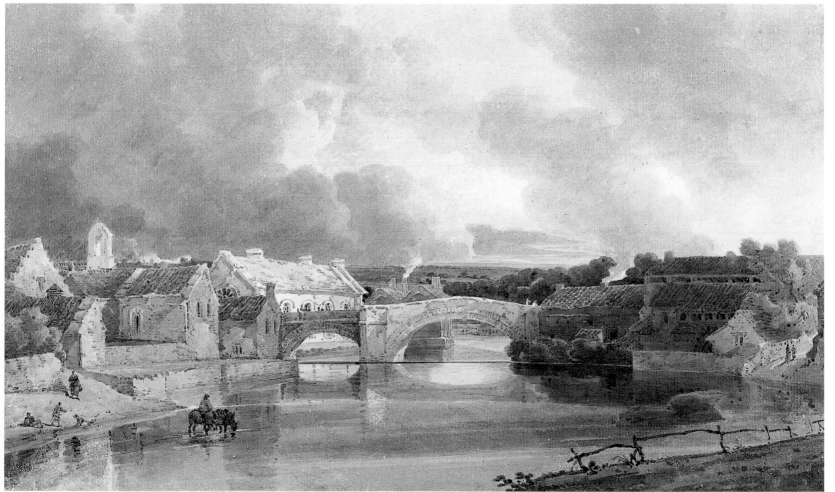

imitate the effect. He also painted some small watercolours 'on the spot' as notes in one of his sketchbooks reveal. This must have increased his awareness of the amount of colour in nature and of the transient atmospheric effects that give landscapes their mood.

As a result, he is credited with abandoning the use of monochrome washes in favour of working directly in the local colour of his subjects (a local colour is the 'natural' or normally accepted colour of a given object). In fact, it seems more likely that Girtin made a very subtle use of blue and brown shading, placed under and above his local colours so that it seemed to be part of the same activity.

In Girtin's Bamburgh Castle, Northumberland *(c. 1797–99) the 'romantic' presentation of the subject is obvious. By showing this ruin on its towering mass of rock against the sea and a threatening sky, Girtin creates a setting for the imagination to explore.*

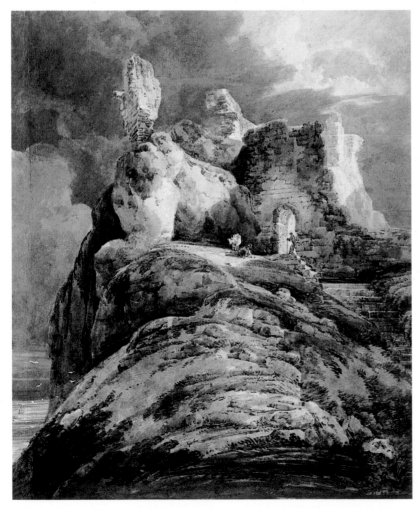

Girtin's watercolours were paintings, not tinted drawings, and his subjects were 'landscape effects' – settings seen under the influence of atmospheric conditions – and not mere records of places.

Here are some early accounts of Girtin's methods, though none were actually written during his lifetime: 'The paper which he most admired was only to be had of a stationer at Charing Cross; this was cartridge, with slight wiremarks, and folded like foolscap or post.'

'He laid on his skies first and they were always remarkably luminous. Sometimes he used warm tinted paper and left it for the light; his moonlight was brilliant, his variety of light and shade captivating.'

'For blue clear skies he used washes of Indigo and Lake, and for cloud shadows Indian Red and Indigo, with an occasional addition of Lake.'

'It was a great treat to see this artist at his studies, he was always accessible. When he had accomplished the laying in of his sky, he would proceed with great facility in the general arrangement of his tints, on the buildings, trees, water, and other objects. Every colour appeared to be placed with a most judicious perception to affecting a general union or harmony.

His light stone tints were put in with thin washes of Roman Ochre, the same mixed with light red, and certain spaces, free from the warm tints, were touched with grey, composed of Light Red and Indigo, – or brighter still with Ultramarine and Light Red. The brick buildings with Roman Ochre, Light Red and Lake and a mixture of Roman Ochre, Lake and Indigo, the Roman Ochre, Madder Brown and Indigo; also with Burnt Sienna and Roman Ochre, Madder Brown and Roman Ochre, and these colours in all their combinations. For finishing the buildings which came the nearest to the foreground, where the local colour and form were intended to be represented with particular force and effect, Van Dyke Brown and Cologne Earth were combined with these tints, which gave depth and richness of tones that raised the scale of effect without the least diminution of harmony – on the contrary, the richness of effect was increased from the glowing warmth, by neutralising the previous tones, and by throwing them into their respective distances or into proper keeping.

The trees, which he frequently introduced in his views, exhibiting all the varieties of autumnal hues, he coloured with corresponding harmony to the

scale or richness exhibited with his buildings. The greens for these operations were composed of Gamboge, Indigo, and Burnt Sienna, occasionally heightened with Yellow Lake, Brown Pink and Gamboge, these mixed too sometimes with Prussian Blue. The shadows for the trees were Indigo and Burnt Sienna, and with a most beautiful and harmonious shadow tint, composed of grey and Madder Brown; which perhaps is nearer to the general tone of the shadow of trees than any other combinations that can be formed with watercolours. Girtin made his greys sometimes with Venetian Red and Indigo. Indian Red and Indigo, and a useful and most harmonious series of warm and cool greys of Roman Ochre, Indigo, and Lake, which used judiciously, will serve to represent the basis for every species of subject and effect, as viewed in the middle grounds, under the influence of that painter's atmosphere, so prevalent in the autumnal season in our humid climate; which constantly exhibits to the picturesque eye, the charms of rich effects, in a greater variety than any country in Europe.'

Some of these colours and colour combinations are similar, so it seems unlikely that Girtin would have used them all at the same time. Ignoring the actual names, the colour selection referred to comprises yellow and red earths, browns, blues, a transparent mid-yellow and a transparent crimson or pinkish red.

Turner's early work was very like Girtin's. John Ruskin, who assessed Turner's enormous legacy of work after his death, considered that Turner had five stylistic periods. However, his watercolour techniques are more numerous than that, so the following consideration of his methods is necessarily selective. The earliest accounts of Turner's use of watercolour already indicate his preference for certain elements of technique that subsequently dominate his methods.

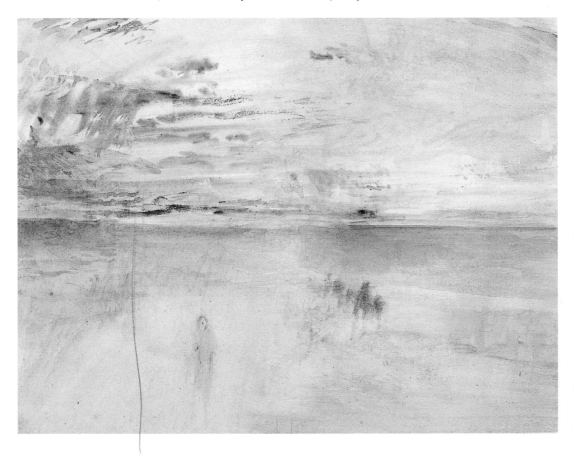

Sunset on Wet Sand (c. 1845) by J. M. W. Turner. This deceptively simple sketch records an experience rather than a place. Turner's early works were carefully drawn and more like Girtin's in their colouring. He began using rich, bright colours in his watercolour paintings early in the 19th century and by the 1840s he used them exclusively.

Turner's methods were inspired by his imagination. In Goldau with the Lake of Zug in the Distance *(1842–43) he began with a light pencil drawing done very quickly on location. He would have added the colouring afterwards and typically did not follow the pencil outline with any particular care. The resulting sketch may have its origins in observations and recollections of the scene, but it is also substantially invented. This was actually a sample study on the basis of which a larger studio version* (opposite) *was ordered, compare them with each other.*

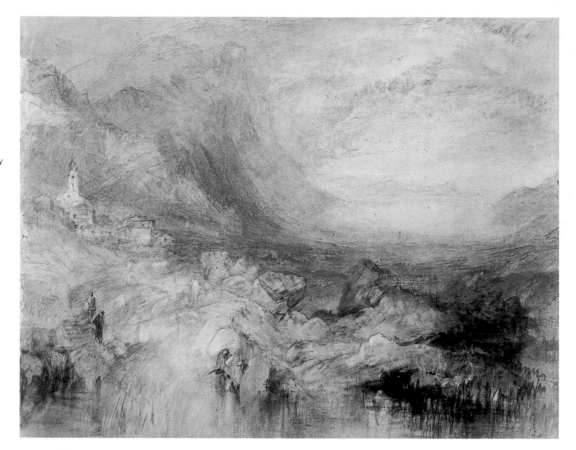

In 1799 Joseph Farington (1747–1821) noted that: 'Turner has no settled process but drives the colours about till he has expressed the idea in his mind.' This might not seem like the description of a technique, but it is what Turner often did. Rather than working in a steady progressive manner that led towards a predictable outcome, he initiated chaos by allowing his materials to respond to chance. He then reacted instinctively and attempted to recover from the random effects a satisfying image that successfully expressed the concept he had in mind, even though it might not be exactly what he had first intended. The result comes from an interaction between Turner and his materials and was unpredictable but not beyond his control – experience teaches how to provoke and direct chance effects.

In a letter of 1802, Andrew Robertson explains the method of 'Lights washed off. Turner uses it much. ... His style is to rub, sponge and wash off

lights.' A similar account is given in Farington's diary in 1804 of the techniques used by William Daniel to imitate Turner's manner: 'The lights are made out by drawing a pencil [brush] with water in it over the parts intended to be light (a general ground of dark colour having been laid where required) and raising the colour so damped by means of blotting paper; after which with crumbs of bread the parts are cleaned. Such colour as may afterwards be necessary may be passed over the different parts. A white chalk pencil (Gibraltar rock pencil) to sketch the forms that are to be light. A rich draggy appearance may be obtained by passing a camel-hair pencil nearly dry over them, which only flirts the damp on the part so touched and by blotting paper the lights are shown partially.'

These may not be exact descriptions of Turner's technique, but they do summarize his general approach – the use of 'subtractive' methods. In other words, he removed colour by various

means in order to progress his work. He was only able to remove watercolour successfully because of the types of paper that were available to him.

Turner seems to have preferred relatively thin, smooth papers – many have proved to be writing papers. Paper then was still hand made. Its main ingredient was linen and it was heavily sized with animal glue or gelatine – particularly writing paper, to help it withstand pens and take a firm line in ink. For writing on, it was also made fairly smooth. Because of the materials and process of manufacture, this type of paper had a compressed and robust surface that could easily withstand the kind of rough treatment that Turner subjected it to. The amount of size in the paper is also very important because it softens and swells in water, affecting the way the paper takes wash and making a variety of subtractive techniques much easier.

In some Turner watercolours there is a beading of the wash in opening brushstrokes that were applied onto dry paper. This is due to the initial resistance of the hard sizing. As Turner adds wash or simply wets the paper, the size absorbs water and the paper progressively responds differently to his colours. While surface wet, they float and swirl, but as this changes to a thoroughly wet condition, the colour is taken cleanly and exactly, but without a hard edge. At this stage Turner is painting on the swollen size which can be wiped away or scraped away without touching the paper. There is a brief opportunity for each technique to be used as the paper goes from dry to wet to thoroughly dampened and then gradually back to dry again and Turner took advantage of opportunities as they came.

If successful at the first attempt, Turner achieved remarkable results surprisingly quickly. He was rarely open about his methods, but he did let the

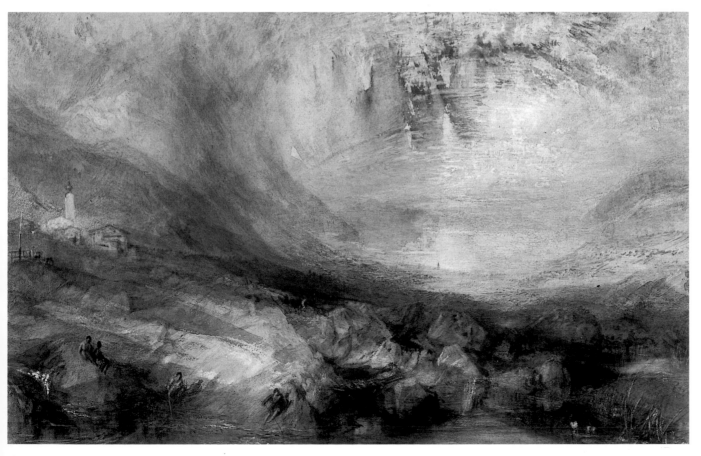

In Goldau *(1843)* Turner altered the proportions as well as the size of his original sketch, stretching out the image to fill a different space. The key elements are present – the rocks, the cluster of buildings and the valley sides, but they are not even remotely the same. He applied artistic licence liberally and in responding to his materials, let his imagination run riot. It is relevant, of course, that the subject here is not the place itself, but the symbolic connotations of the awesome and tragic rock fall that occurred there in 1806.

eldest son of his friend and patron, Walter Fawkes, of Farnley Hall watch him on one occasion. This is one account of what he saw: 'The way Turner went to work was very extra-ordinary; he began by pouring wet paint onto the paper until it was saturated, he tore, he scrubbed at it in a kind of frenzy and the whole thing was chaos – but gradually and as if by magic the lovely ship, with all its exquisite minutia, came into being and by luncheontime the drawing was taken down in triumph.'

Here is another account of the same experience: 'At Farnley is a drawing of a man-o-war, complete, elaborate, and intricate, with a fine frothy, troubled sea in the foreground. This Turner did, under Mr Fawkes' [the son's] observation, in three hours; tearing up the sea with his eagle-claw of a thumb-nail, and working like a madman; yet the detail is full and delicate, betraying no sign of hurry.'

Incredibly the painting concerned was *The First Rate Taking in Stores* (1818) shown here. Another witness on a different occasion describes a similar method saying: 'He stretched the paper on boards and, after plunging them into water, he dropped the colours onto the paper while it was wet making marblings and gradations throughout the work. His completing process was marvellously rapid, for he indicated his masses and incidents, took out half lights, scraped out highlights and dragged, hatched and stippled until the design was finished.'

Turner may not always have worked this quickly. Many of his watercolours appear to have been worked on in three separate stages, consisting of a chaotic beginning, followed by subtractions that could have been made by rewetting the paper and then a distinct process of finishing, where the surface is selectively reworked very finely with brush drawing and veil-like additions of colour applied in the manner of a miniature painter.

Turner used the brush handle, as well as his thumb nail, to scrape back through the paint and when the work was dry he sometimes scratched out highlights and fine details, most probably with a knife, going through the paper's painted surface to reveal its white interior. Sometimes Turner used colour-washed paper, which provided a unifying tone but also kept the ultimate white highlights in reserve for scraping out. Turner was no doubt preparing to sketch using this method when his bedroom at Farnley Hall was seen with 'chords spread across the room as in that of a washerwoman, and papers tinted with pink and blue and yellow hanging on

them to dry'. He also used a flecked blue or blue-grey paper which he painted on with opaque body colour.

Turner's watercolour paints were in his studio when he died and we have this description of the objects in his studio from a Mr Trimmer, the son of one of Turner's executors: 'A red Morocco pocket book, from the wear and tear it exhibited, one might have imagined to have been his companion through life. There were cakes of watercolour, fastened on a leaf, the centres of which were worn away; the commonest colours, and one being a cake of Verditer; one or two sable brushes and lead pencils, not in wood, with which he seemed to have drawn outlines in his sketchbook.'

Trimmer then continues with these interesting observations on the slight manner of the drawings typically beneath Turner's watercolour sketches: 'These consisted of a few lines which he used to say no-one could make out but himself. I have some doubts if he could have made them out himself without the assistance of other drawings; and he seems to have purchased detailed views of foreign scenery, of which there was a large assortment well thumbed; the drudgery of art, of which masterminds avail themselves.'

Turner's pocket set still exists: significantly, the watercolour cakes are glued to the leather backing, making it impossible for them to be rubbed against a china palette to make wash as was the custom. There is nowhere to mix the colours either, possibly implying that Turner lifted colour straight from the cake and put it directly onto the paper. The condition of the watercolour cakes and the heavy granular trails of unevenly dissolved colour that occur in some of his sketches would tend to confirm this.

There is also a small flat china palette shaped like an oil painter's which belonged to Turner. If this was used for watercolour, as seems likely, then the remnants of colour on it suggest that he also mixed pigment directly with gum water using a palette knife to make fresh watercolour or gouache for immediate use. Turner certainly prepared his oil colours this way and kept many of his colours as pigments. Of his blues, Trimmer says this: 'I remember, on my father's observing to Turner that nothing was to be done without Ultramarine, his saying that Cobalt was good enough for him; and Cobalt to be sure there was, but also several bottles of Ultramarine of various depths; and Smalts of various intensities,

The First Rate Taking in Stores (1818) was apparently painted by Turner in a single morning. The atmospheric sky, choppy sea and most distant ship were probably pulled from a loose wet beginning by wiping, scraping and selectively lifting the colour. A web of detail over this foundation would have given the image its coherence. Turner's paper would have helped him to do this.

of which I think he made great use. There was also some Verditer. [Presumably Trimmer means Blue Verditer here, but it can be either blue or green.] Subsequently I was told by his housekeeper that Ultramarine was employed by him very sparingly, and that Smalts and Cobalt were his usual blues.'

Finally, Turner had once shown Trimmer's father 'some Chinese brushes he was in the habit of using.' The remark does not specify watercolour, but oriental brushes would probably have suited the way he apparently handles the medium in many of his sketches.

Some of Turner's younger contemporaries must be briefly mentioned as they also contributed to this golden age of watercolour painting. Peter de Wint (1784–1849) developed a relaxed, fluid and

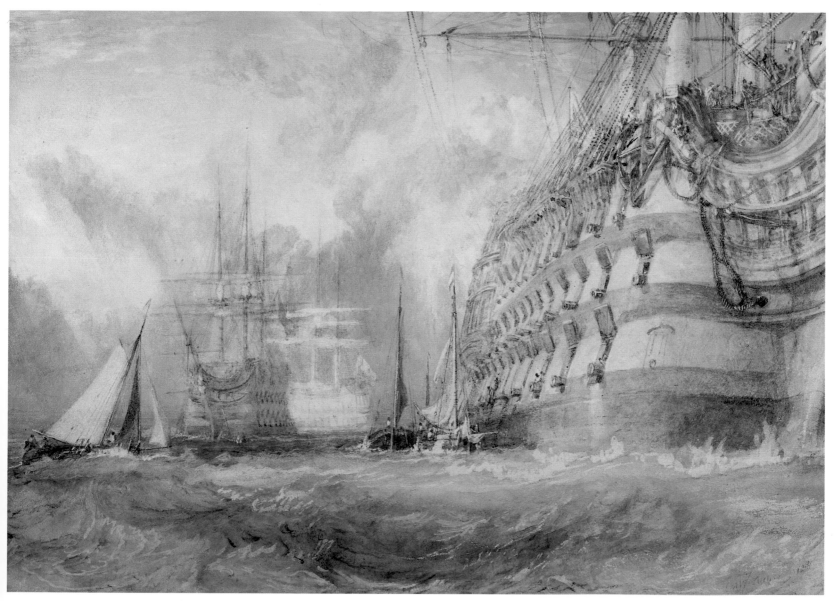

charmingly sloppy use of richly transparent washes on textured 'Creswick' paper. John Sell Cotman also exploited the surface texture of his paper, allowing it to introduce irregularity into his otherwise evenly applied and exactly placed washes. These are of strong local colour and are laid, wash over wash, wet over dry, in such a way as to incorporate all the drawing and modelling of form into his use of colour. He excels also at achieving muted harmonies of colour, but in this respect he was out of step with the tastes of his time and despairingly wrote after having seen some of John Frederick Lewis' (1805–76) work: 'My poor Reds, Blues and Yellows for which I have in Norwich been so much abused and broken hearted about are "faded fades" to what I saw there. Yes, Aye, *faded fades* and trash, nonsense and stuff.'

Cotman's technique depends on a carefully composed outline drawing which analyses the subject in terms of its physical masses and areas of colour. In 1818, some of his drawings were made with the aid of a camera lucida – an optical device that projects its image onto paper and can then be traced round. It can, however, be supposed from this account that this was not his usual method.

'Elizabeth Dawson Turner, who has such excellent sight and can use the camera lucida with so much ease, has been of the greatest service to Mr Cotman. His sight is by no means equal to hers, and she has a rapidity which is fully his equal so that, on the whole, she is better qualified in the use of this instrument than he. There were no less than five large drawings completed by this means yesterday between him and her. I do not mean finished drawings, but with all the lines in the right places and memoranda on the margins, all needful to be known towards making finished drawings.'

In A Ploughed Field *(c. 1808) John Sell Cotman has used the texture of his paper to achieve the ragged edges of the wash areas and the gaps in their colouring that help to express the rugged character of this land-scape beneath its bleak sky. The powerful, almost abstract design of this timeless scene accounts for its impact – it comes from the basic drawing, but in the painting none of the drawing remains. The wash edges and the gaps between them provide all the definition. Cotman leads the eye from the crow in the foreground to the farmer and into the background. Amid the sombre colour, he gives the farmer a bright red neckerchief to focus our attention. His use of blocks of wash gives this image a very solid and structural feel.*

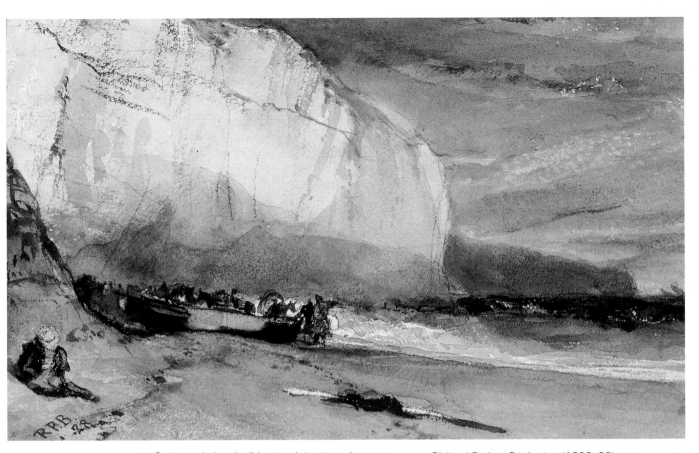

The Underacliff (1828) may have been Richard Parkes Bonington's last watercolour. His mother's inscription on the back tells us that it was painted over two days in August. He died on 23 September. It is tempting to think it was begun on site – it has the immediacy of a sketch from nature – but it is not surprising that it took two days to paint as it is technically quite complex. Bonington has used the palm of his hand to achieve the soft atmospheric quality that you see here. He has scraped through wet wash at the top of the cliff and has scratched out highlights on the sea. There is some dry brush drawing and suggestions of glazed-over white, but mostly this watercolour is composed of wash put skilfully over wash.

Cotman obviously did not paint watercolours on location, even though he had claimed that works such as *Greta Bridge* (1810) were 'coloured from nature and close copies of that fickle dame'. The more usual practice was to make drawings and take notes on sketching expeditions. Watercolour paintings based on them would be done in the studio, perhaps during the winter and maybe even a year or two later. This separation from the subject matter and reliance on the drawing actually makes it easier to achieve the kind of simplification that is so characteristic of Cotman's work. He makes the most mundane subjects appear monumental – an effect sometimes amplified by the fact that they fill the page and are seen from close to. This might relate to the use of a camera lucida or to the quality of his eyesight – both are referred to in the above account. In his late work, Cotman added starch to his paint. Samuel Palmer (1805–81) and William Blake (1757–1827) are also noted for their unusual uses of watercolour.

Richard Parkes Bonington (1802–28) was English by birth but trained and painted in France. Like Girtin, he died young, but by the end of his short career he had started to combine a subtle appreciation of nature's effects with a firmness of colour and a touch of technical wizardry which is often concealed by the apparent simplicity of his paintings. He was a friend of the painter Eugène Delacroix (1798–1863) who said this of him: 'As a youth he developed an astonishing skill in the use of watercolours, which were then in 1817 an English novelty. Other artists were perhaps more powerful and more accurate than Bonington, but no one in the modern school, perhaps no earlier artist, possessed the lightness of execution which makes his works, in a certain sense, diamonds, by which the eye is enticed and charmed independently of the subject or of imitative appeal.'

Some of Bonington's paintings are, indeed, like diamonds or at least like jewels, since they are

A passion for detail

Watercolourists – in order to compete with oil painting – looked for stronger and stronger effects as the 19th century progressed. Also, in response to public taste and perhaps because of the influence of photography, there was a growing passion for detail. Some painters therefore turned to methods that were really reinventions or adaptations of the earlier watercolour techniques.

There had been some interest in gouache during the 18th century, but by now the purists' view of watercolour – that it should depend entirely on transparent washes – was well entrenched and its use attracted criticism. A compromise that preserved and, in fact, enhanced the luminosity of watercolours was discovered by William Henry Hunt (1790–1864). His technique involved using opaque white body colour, which was placed beneath the wash tints and not allowed to mix with them. This description of Hunt's methods derives from James Orrock, who is likely to have seen him painting: 'In early life, Hunt painted without the use of any body-colour and it was not until the middle period that he used it. It is quite certain, however, that as no luminous sky can be produced with body-colour, so no still life of the highest excellence can be produced without it. Hunt found this out, and left off an excessive use of transparent colour when he painted his wondrous still life pictures. He never, however, at any time used body-colour in his figure painting. Body-color painting in the ordinary sense means mixing pigment with body colour. Hunt never did this; he painted on body-colour which was laid on the objects thick, and then left to dry to hardness. He would, for instance, roughly pencil out a group of flowers or grapes, and thickly coat each one with Chinese white, which he would leave to harden. On this brilliant china-like ground he would put his colours, not in washes, but solid and sure, so as not to disturb the ground which he had prepared. By this process the utmost value for obtaining strength and brilliancy was secured, for the colours were made to "bear out" and almost rival Nature herself.'

Hunt does seem to have used his watercolours at wash strength, but he did not apply them as even washes. Instead, they were set down in small flickering touches and he arrived at a fine finish by minute stippling. This is very similar to the technique of the earlier miniature painters, but Hunt's method allows continual amendment. This

often small and yet contain marvellously rich and varied effects. The most distinguishing features of his technique are that he dragged the brush on a fairly smooth paper and finished with fine line drawing from a brush point, but he also scratched out, touched in in gouache, underpainted with white, added gum to his colour and scraped into wet paint. In addition, Bonington used his hands as Turner did, but perhaps more so.

Bonington's The Castelbarco Tomb, Verona (1827) was guided by a light pencil drawing done with the aid of a ruler – traces of it are visible beneath the columns and on the right. The painting itself reveals the techniques that Bonington used – the sky wash has been dragged on the left and where it meets the clouds; the clouds' shadows are also dragged on. Bonington's finger or thumb prints can be made out on the right and on the bottom left he has scored the brush handle through the shadow tone. The figures in the centre are touched over with body colour, while the one deeper in shadow is cleverly constructed from a gap in the wash. Bonington's crisp brush drawing provides most of the detail.

Rowney and the firm offered a watercolour box called 'W. Hunt's Arrangement (Fruit, Flower and Etc)'. It must be assumed that he selected the colours and that they are similar to those that he used. Oddly, Chinese White was not included, but at that time it was also sold in bottles which would have suited his methods better. This watercolour painters' box contained: 'Whole pans: Gamboge, Lemon Yellow, Indian Yellow, Raw Sienna, Venetian Red, Scarlet Vermilion, Rose Madder, Cerulean Blue, Cobalt, French Ultramarine, Madder Brown, Sepia, Brown Pink, Veronese Green. Half pans: Cadmium Yellow, Deep Cadmium, Chinese Orange, Carmine, Burnt Carmine, Deep Rose, Extract of Madder Carmine, Purple Madder, Purple Lake, Violet Carmine, Indian Red, Indigo, Lamp Black, Ultramarine Ash.'

Myles Birket Foster (1825–99) used an alternative version of this technique. His paintings began like ordinary watercolours – with transparent washes laid over a pencil drawing. He would then add corrections, highlights and deliberate underpainting in white and, when this was dry, fresh transparent colour would be placed on top. A selective repetition of this process soon produces a powerful effect.

John Frederick Lewis combined watercolour and body colours in a different way. He painted his mid-tones and shadows with transparent wash, but his lighter mid-tones and highlights were placed in opaque gouache tints. Lewis' paper often has a pale tint which provides a central mid-tone to work against. His precise finishing detail seems to be in watercolour. Judging by his sketches, Lewis began with a careful pencil drawing that may have been highlighted with white before any colour was added. Unlike Hunt's and Foster's, his technique was painstakingly slow. He commented in a letter that he had spent seven months, or longer, on two large drawings, still unfinished. An example of his work, *Life in the Hareem, Cairo* (1858), is shown in Part 1.

William Henry Hunt's Plums (c. 1845) is a fine example of his still-life painting. Hunt had deformed legs and may have concentrated on such subject matter as he got older simply because it was more practical. His working method can be much faster than you might think – his output of paintings like this was prolific. He earned the nickname 'Birds' nest Hunt' since nests feature in many of his paintings. He may have used a camera lucida (one was found in his studio) to help him with his drawings.

conceals his creative process, which may have been far less sure and organized than the immaculate end results suggest. Asked to explain an aspect of his colouring, Hunt replied: 'I don't know; I am just aiming at it.' Commenting on the work of another painter, he also said: 'Well, he has fudged it out. We must all fudge it out. There is no other way than fudging it out.'

Hunt's sudden adoption of this method part way through his career is presumably linked to the introduction of Chinese White by Winsor & Newton. In his old age he endorsed the watercolours of

SARGENT AND THE IMPRESSIONIST LEGACY

The professional status of watercolour was firmly established in the 19th century, but there was – as there still is now – a contradictory association between using the medium and leisure activity. Interestingly, two 19th-century painters who extended the methods and concepts of watercolour, Paul Cézanne (1839–1906) and John Singer Sargent (1856–1925), originally adopted the medium as a recreational diversion from oil painting.

In 1866, Cézanne wrote: 'I must buy a box of watercolours so that I can paint when I am not working on my picture.' He used them to make studies and to paint the same subjects that he did in oils, but his watercolours are more relaxed and spontaneous than his oil paintings. Perhaps because he was painting for pleasure they are more intimate and evocative too, but this is also because the nature of the medium has intervened.

Cézanne said: 'The method of working arises from a contact with nature; it is developed according to circumstance. It entails seeking an expression of what one feels, then of organizing the feeling according to a personal aesthetic. I try to develop logically what we see and feel by studying nature, and I do not worry about the methods until later, because they are, for us, merely the means of making the public aware of what we feel, and getting them to accept it.'

In his later watercolours the faltering, ambiguous drawing, the uncertain dabs of wash and the untouched patches of paper are a physical record of his stumbling process of expression. He did, in fact, follow a basic technique out of habit, but did not think about his methods and did not consciously try to control the watercolour. The luminous colouring and simple sloppy charm of the resulting paintings are just the natural consequences of his use of the medium.

Cézanne and Sargent were both associated with the Impressionists and were influenced by them. Working directly from nature and painting as an immediate response to it, the use of fragmented brushwork and bright colours and a general disregard for the evenness and quality of finish, so long as a desired sensation or effect was conveyed, are characteristics of what became known as Impressionism. The translation of these aspects of method from oil painting to watercolours shaped the development of watercolour in the late 19th and early 20th centuries.

Unlike Cézanne, Sargent was concerned with technique, at least as a means to an end. He probably chose the subject and a place to paint it from in advance and would arrive well equipped for painting watercolours out of doors. Photographs show him seated at a sketching easel, almost certainly made of tubular metal, on which the work was mounted – in one case at a slight tilt and in another at a steep incline. In one photograph he has a small folding table or stool and two large umbrellas to shade him and his work area, or to provide protection against the elements.

Sargent used watercolour in tubes – two photographs show him holding a folding metal palette for watercolours and fifteen tubes of moist watercolour were found in his studio after his death. They contained Alizarin Carmine, Brown Pink, Burnt Sienna, Cadmium Yellow Pale, Cadmium Yellow (No. 2 shade), Chrome Yellow, Cobalt Blue, Gamboge, Lamp Black, Rose Madder, Ultramarine, Van Dyke Brown, Scarlet Vermilion, Deep Vermilion and Viridian. There were also ten brushes and a sharp stylus, presumably used for scraping.

Sargent had a broad flat brush, apparently of badger hair. Such brushes were used by decorators and oil painters for softening effects but it is unclear how they would have been used with watercolour – perhaps it was for wetting out the whole sheet with clean water. It is thought that Sir William Russell Flint (1880–1969), also a watercolourist, actually used a badger hair shaving brush to paint with. Sargent had a large quill and wire-bound mop – not of the type that shapes well when wet, so this too would have been of most use for wetting out, although perhaps on a smaller scale or selectively. Neither of these brushes are worn, which probably confirms that this is what they were used for. The remainder show every sign of rough and vigorous handling. They range from a flat skywash brush to a group of surprisingly small round watercolour brushes, with a large watercolour brush and a filbert and smaller brush with long hair, which may be a rigger for long, thin strokes.

Adrian Stokes (1902–72), the watercolourist, described Sargent at work as follows: 'Fine and correct drawing was the foundation on which all his work was built: while natural taste, combined with

long practice in composition, seemed to make it easy for him to place his subjects on paper in a telling way. ... The rapidity and directness with which he worked was amazing. ... His hand seemed to move with the same agility as when playing the keys of a piano. That is a minor matter; what was really marvellous was the lightness of every touch. ... All was rendered or suggested with the utmost fidelity. On a few occasions when I saw him begin a drawing, he simply opened a block and began to paint straight away.'

Evan Charteris, a friend of Sargent, gives a slightly different account: 'His general habit was to make the lightest indications in pencil to fit the relative position of objects and then, after wetting the paper, to paint with great rapidity.' Neither description excludes the other, but I think that Stokes' reference to drawing should be interpreted as a general comment on Sargent's draughtsmanship and not on the actual quality of the pencil drawing that he began with.

Sargent's use of a robust, rough-surfaced watercolour paper seems fairly consistent. Other aspects of his methods vary – he used whatever techniques he needed to attain his goal. At the heart of a Sargent watercolour there is a dashing and spontaneous performance, but his use of stopping-out media, possible use of paint additives, and the existence of some preliminary drawings and sketches show that his actions were sometimes premeditated or practised, while his use of gouache, white body colour and scraping out show the need to correct afterwards.

The apparent certainty of Sargent's every stroke may be misleading. He eliminated his mistakes as he painted and he may not always have worked in a single session on location. It is also possible that he edited his work, allowing only his best watercolours to be seen. Even so, Sargent must be admired for his superb skill and versatility.

In *Derelicts* (1917) Sargent used watercolours over a slight pencil sketch. The sketch only records

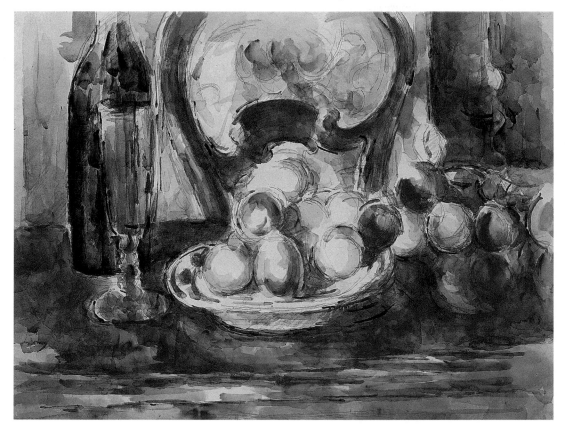

In Still Life with Apples, Bottle and Chairback (c. *1902–06). Paul Cézanne shows his fascination with the structure of objects and their spatial relationships. He rejected conventional ways of illustrating a still life and aimed for a more fundamental truth. During the period when he painted this watercolour, he said: 'I try to render perspective solely by means by colour.' He also told Emile Bernard: 'Nature for us is more depth than surface, hence the need to bring into our light vibrations, represented by reds and yellows, a sufficient amount of bluishness to make the air felt.' Here touches of blue hover around the red and yellow apples, implying surrounding space.*

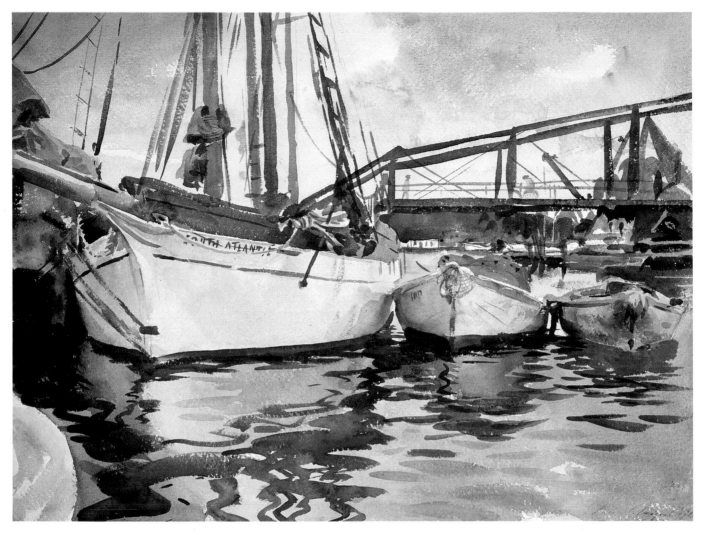

John Singer Sargent's
Boats at Anchor *(1917).*
Watercolour on rough-
textured paper. The
low viewpoint of
this brilliantly and
economically handled
painting suggests that
it was done from a
small boat.

the basic shapes and positions as a guide for the brush – traces of it can be seen around the stern of each craft. Sargent has used some kind of 'resist' technique at the centre of the painting on the trees, where a stopping-out medium or wax has repelled the opening washes and left gaps. He must have then scraped this area to reveal more white paper, and then tinted it with further washes. The combined effect suggests a tree projecting into strong sunlight.

In some of the shadow areas he has apparently added a medium, causing the dark washes to lie like glazes and helping them to retain patchy brushmarks. He may have wiped some of this

back and scraped through in places before it dried. Elsewhere, blue-purple shadows are set against the paper to suggest warm, strong sunlight. Notice how cleverly Sargent has painted the water surface and the reflections in it by using sideways strokes from the tip of a brush.

Sargent's *Miss Eliza Wedgwood and Miss Sargent Sketching* (*c.* 1908) is painted on rough-textured, grey-white paper with a pronounced diagonal grain – you can see this in the top right corner, where colour has been dragged over it. He started with a loose and simple pencil drawing, which indicated the main shapes and their positions. Traces of it are visible at the bottom edge of the umbrella and

in the skirt of the white dress on the right where the paper is barely covered.

The paper may have been dampened to begin with as softened brushmarks and fused colouring appear in many places. The umbrella has certainly been worked wet-into-wet, with a grey-blue wash having displaced a sloppy, ochreish one to achieve the effects of dappled shadow. The dark costume and shawl were probably started by running a blue into a brown. At the foot of the figure on the left an excess of water has reduced the edge of the dress to a blur, which serves to unite the figures and the foreground, whether intentional or not.

A second layer was placed soon afterwards, while some underlying areas remained moist but not wet – for example, the dashed and dragged shadows on the dark parts of the costumes. Crisp wash edges show wet over dry working, so the right-hand figure's

shawl must have been painted or restated onto dry paper. It is possible that Sargent had selectively wet the paper or had simply worked wet-into-wet into base washes put onto dry paper. The paper was certainly dry where the green background wash was brought over it to define the white dress on the right-hand side.

Some of Sargent's paint here is heavily applied watercolour, denser than a transparent wash, but not as solid or opaque as gouache. There is also some use of sloppy body colour. The cuffs and intricate bodice of the figure on the right certainly involve tints that are made with white. The faces too are reworked and refined with opaque tints on top of watercolour. In the background the gouache-like greens probably contain a little white, but Sargent's choice of yellows could also be responsible – Cadmium and Chrome Yellow are both opaque.

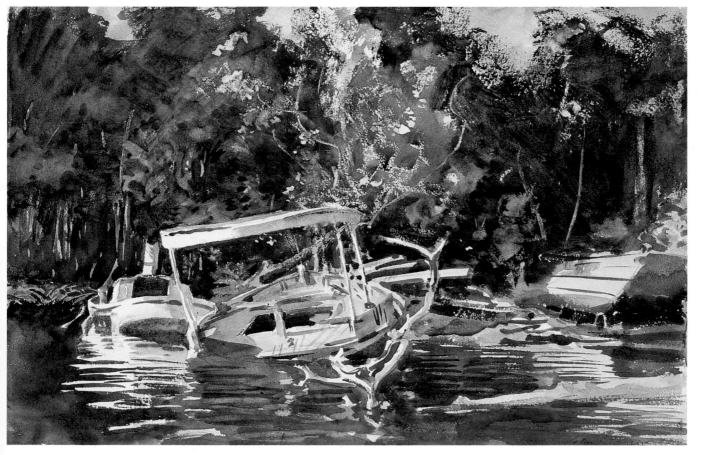

In Derelicts *(1917) Sargent used watercolours over a slight pencil sketch, which only records the basic shapes and positions as a guide for the brush. Traces of it can be seen around the stern of each craft. This apparently spontaneous painting in fact uses a complex combination of techniques.*

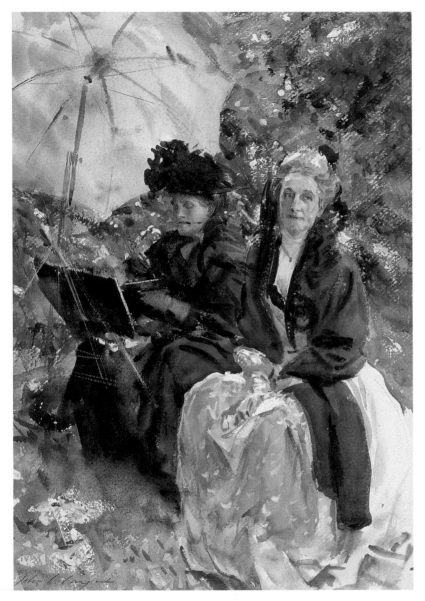

Sargent's ability to suggest is excellent. These rough marks could be taken as wild flowers or patches of light falling through foliage – they have no precise meaning, but their presence is not questioned. Notice how brilliantly he has implied the sketching easel, watercolour block, paint box and brushes. On the right-hand figure's knee, Sargent has placed a pure white highlight – it is so heavy that it cracked badly on drying.

Sargent's fellow American Winslow Homer (1836–1910) stands apart from European tradition. His connection to the Impressionists is more obscure than that of Sargent. In 1867 a work of his represented American art at the Paris Exposition Universelle and he made his only known visit to Paris and, indeed, to France. Impressionism, as we think of it, had not then begun, but Gustave Courbet (1819–77) and Edouard Manet (1832–83) had special pavilions at the Paris Exposition Universelle and Homer would have been exposed to the same formative influences. Realism, light, colour and painting directly from nature are very much part of Homer's art, but it is as if he developed these ideas independently. His painting is specifically American and, while it strangely parallels European trends, it is at the same time original and different.

In an interview, in 1880, Homer expressed this view which places him alongside the French Realists and Impressionists in spirit: 'I prefer every time a picture composed and painted out doors. The thing is done without your knowing it. Very much of the work now done in studios should be done in the open air. This making studies and then taking them home to use them is only half right. You get the composition, but you lose freshness, you miss the subtle and, to the artist, the finer characteristics of the scene itself. I tell you it is impossible to paint an out-door figure in a studio light with any degree of certainty. Out doors you have the sky overhead giving one light; then the reflected light from whatever reflects; then the direct light of the sun: so that, in the blending and suffusing of these several luminations, there is no such thing as a line to be seen anywhere. I can tell in a second if an outdoor picture with figures has been painted in a studio. When there is any sunlight in it, the shadows are too positive. Yet you see these faults constantly in pictures in the exhibitions and you know that they are bad. Nor can they be avoided when such work is done indoors. By the nature of the case the light in a studio must be emphasized at some point or

Typically Sargent's Miss Eliza Wedgwood and Miss Sargent Sketching *(c. 1908) is painted on rough-textured paper with a pronounced diagonal grain – you can see this in the top right corner.*

Sargent's colour becomes drier and heavier in the final stages. As this painting neared completion, he scattered highlights across it using thick, tube-consistency white – dabbed, dragged and scuffed into place. When this had dried hard, he glazed it with wash. The broadest of these touches are easily seen in the bottom left corner, where they disguise and detract from the smudged edge of the dress.

part of the figure; the very fact that there are walls around the painter which shut out the sky show this.'

Homer began as an illustrator and gradually established himself as a painter. His early watercolours – often of children in a landscape or coastal setting – are well observed and are, at times, quite charming pieces, but the connection with illustration is obvious and his watercolour methods are relatively crude. In 1881, he visited Britain and stayed for about 20 months. Nobody knows why or why he went to live and paint at Cullercoats, a small fishing village near Newcastle-upon-Tyne on the north-eastern coast, but it is agreed that the experience was a turning-point in his career as a watercolourist.

Homer's watercolour *Houses of Parliament* is dated 1881, so he must have visited London and it is very likely that he saw works by Turner and other British watercolour masters. He had been an illustrator, a wood engraver and might well have visited Newcastle because the great wood engraver, Thomas Bewick (1753–1828), had come from there. There is even a possible connection through James Abbott McNeill Whistler (1834–1903), an American by birth, to Joseph Crawhall (1861–1913), from Newcastle, who had family associations with the Bewicks.

The North Sea fishing villages of this time were isolated communities, each with their own dialect and local style of dress. The lifestyle was hard, but to the outside observer it could be seen as

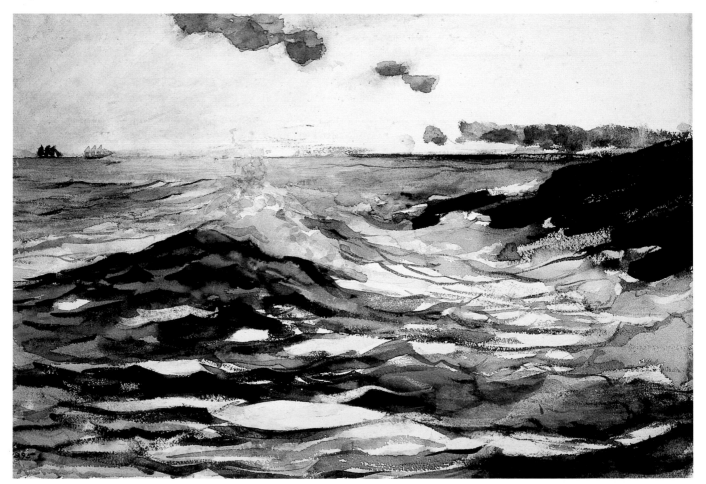

Winslow Homer's Sunset, Prout's Neck *(1895) was probably influenced by Japanese art. The famous print* Mount Fuji across the Water *by Katsushika Hokusai has many similarities.*

romantic or heroic and because of this, their remote locations and coastal light these villages already attracted attention from artists. In the mid-1870s in Cullercoats there had been a famous incident when, during a fierce storm, the women of the village had harnessed themselves to the lifeboat and dragged it along the beach to effect a rescue. This, at least, explains Homer's fascination with the fisherwomen of Cullercoats and the neighbouring village of Tynemouth in his watercolours of 1881 to 1883.

Homer obviously witnessed the brutality of the North Sea during this time, which will have made a lasting impression on him. It must be equally certain that he had contact with British watercolourists – either directly or indirectly – and was able to learn from them a much wider range of techniques. The Cullercoats paintings were highly praised on his return to America and his reputation as a watercolourist was secured. By this time he had a full understanding of traditional watercolour methods and was able to apply them to uniquely American subject matter.

Scenes of hunting and fishing in wilderness settings are familiar Homer subjects that are particularly felt to express the American spirit. *Leaping Trout* (1889) (*see* p. 45) is an unusual variation of the fishing theme and an unusual painting. The influence of Japanese art is beyond question, but Homer does not seem to have received this via the Impressionists in Europe, so it must have been a response to America's own trade with Japan.

Two sets of watercolour paints that belonged to Homer survive. They are typical black japanned boxes, each capable of holding 20 whole pans of moist watercolour. One was wrapped in a soft carrying pouch and combined brush case and was accompanied by a tube of Chinese White and a burnishing tool. There are also two quill-mounted watercolour brushes that belonged to him. They seem to be a small and a large swan's quill – both quite big brushes – and their handles have probably been used for scratching off paint. The burnisher would be for smoothing the paper after scratching or scraping out. Homer's colours were as follows: Antwerp Blue, Aureolin, Burnt Sienna, Burnt Umber, Cadmium Yellow, Chinese White, Chrome Orange, Crimson Lake, Green Earth (Terre Vert), Hooker's Green Shades 1 and 2, Indian Purple, Indian Red, Indian Yellow, Ivory Black, Payne's Grey, Prussian Green, Scarlet Lake, Sepia, Van Dyke Brown, Vermilion, Scarlet Vermilion and Warm Sepia.

After his visit to Britain, Homer began using good-quality, purpose-made watercolour papers. He preferred a medium weight, not (cold-pressed) surfaced paper, but he was not entirely consistent in his choice. There is some evidence that he used watercolour blocks and that he 'cropped' work after completion – trimming the edges to improve the image.

There is one other important point that unites these late 19th-century painters – they all appear to paint or start painting their watercolours on an easel. This is convenient when sketching out of doors and was therefore a feature of Realist and Impressionist painting in oil. Earlier watercolourists worked more in the studio and laid their paintings flat or had the drawing board at only a very slight tilt. Painting on an upright easel with the work sloped produces a very different result – the washes run downwards and collect at the bottom of the wetted area and brushstrokes become more dashing and casual because there is nothing to rest on as they are made. Since the type of image that emerges is affected by this it must therefore be seen as part of the method.

PART 3
DEMONSTRATIONS

DEMONSTRATIONS

The breakfast table using the methods of Paul Cézanne

MATERIALS

Paper
300lbs (638gsm) Saunders Waterford not (cold-pressed) surfaced watercolour paper. Size 22" x 15" (56cm x 38cm) – a half Imperial sheet.

Paint
Half-pan watercolours

Ash Blue
Cadmium Light Red
Cadmium Orange
Chrome Green Light
Lemon Yellow
Naples Yellow
Quinacridone Magenta
Quinacridone Rose
Raw Sienna
Ultramarine Light

Several of these colours were chosen for their semi-transparent or opaque character.

Brushes
Chiefly a ½" (13mm) wide long one stroke in ox hair with support from a ³⁄₁₆" (5mm) one stroke also in ox hair and a small, pointed squirrel hair mop-style watercolour brush.

Other items
A graphite pencil, a drawing board and an easel.

Paul Cézanne's (1839–1906) paintings are an expression of his relationship with his subject – he saw them as studies of fundamental truth, of the essence of nature, of something beyond the immediate and obvious. He explained it as follows: 'All that we see dissipates, moves on. Nature is always the same, but nothing of her remains, nothing of what appears before us. Our art must provide some fleeting sense of her permanence, with the essence, the appearance of her changeability. It must give us an awareness of her eternal qualities. What lies below her? Nothing, perhaps. Perhaps everything. Everything, do you see?'

For Cézanne the actual method was irrelevant – it was just a consequence of the way he worked. By setting up similar circumstances you can re-create it. In this case, the first step was to select and arrange the subject. Cézanne was fascinated by the structure of objects and tended to represent them in terms of their underlying geometry. He made this much-quoted remark in a letter: 'May I repeat what I told you here: treat nature by the cylinder, the sphere, the cone, everything in proper perspective so that each side of an object or a plane is directed towards a central point.' In his still lifes Cézanne usually focuses on the issue of roundness – the sphere, the circle and the ellipse. Apples, oranges, plates, dishes, jugs, mugs, cups, saucers, jars, vases, glasses and baskets provide these shapes and are the typical ingredients of his arrangements.

The viewpoint from which the subject is painted is also important as it can emphasize the basic geometry of the ensemble. Cézanne often appears to have adopted a position close to his subject, looking down on it. Circular forms seen at an angle are perceived as ellipses, but such a position makes them broad and well rounded – an effect that Cézanne is said to have exaggerated still more by propping items up with small piles of coins which gave them an extra tilt towards him.

Another consequence of standing close to the subject is that small changes of position introduce much greater changes to the angle of view than they would from further away. As a result, Cézanne constructs his final image quite literally from different aspects of his subject.

For this demonstration, I laid out some objects on a table as if it was set for an informal breakfast. There was nothing special about any of the items used, except that they provided the right kind of shapes: the fruits, spheres; the fruit basket, an oval; the dishes, shallow, wide circular forms; the mugs, cylinders and the jug, a section from a gently tapering cone.

The painting was done on an easel which was placed right against the table, as close as it would go, so that I was looking down on the table top.

I specifically chose the viewpoint that is shown here because it eliminated the floor, making the table top and the cupboards behind it appear to join. Spatial ambiguity is a recurrent theme in Cézanne's work.

1 My paper was fixed to a drawing board which I put on the easel. As it was heavy-weight paper it did not need to be stretched, but was just held at the corners and at intervals along each side with small pieces of masking tape, though on a softer drawing board I might have used drawing pins. The easel was adjusted to hold the paper at an angle of about 45° from the vertical axis – a fairly steep slope.

In Cézanne's own watercolours the pencil drawing tends to be loosely constructed out of fragments of outline completed to varying degrees. Most of the lines are curved and all are done freehand. Some of them suggest long sweeping strokes; others are shorter and imply less confident gestures. Working at an easel encourages the use of the whole arm to direct the pencil or brush. This leads to generous movements, and relaxes the degree of control, so the marks made tend to be broad in character, but inexact in detail. Combined with slight shifts in viewpoint as the drawing proceeds and a concentration on shape, this results in a hesitant and uncertain drawing.

My opening sketch was arrived at like this: I started by looking at isolated elements of each shape – the general roundness of an apple, the ellipse at the top of a mug and on larger objects, such as the dish, the curve of a specific part of its rim. These were drawn with generous strokes, often in a single gesture, as a kind of physical response to the shape. The sequence that I followed was like this: I looked for shapes – and recognized them – and then repeated that shape with my hand, while holding the pencil, as if I was physically moving round it. As the process is repeated across different parts of the subject, a disjointed image of the composition builds from these separately observed aspects of shape.

After this, a second study of the subject allowed me to look at each object in more detail and concentrate on the surface planes that reveal themselves around the outline. This time the pencil is aimed as if it were meant to glance off the identified plane. The result is a shorter mark, which may either reinforce or contradict the first loose drawing.

Again, because the drawing is done on an easel, the marks can land imprecisely and you can try again until eventually several marks combine to isolate the space that is occupied by the object. The goal is not a precise drawing of the contours, as that would merely represent a two-dimensional view of the subject – its silhouette – but rather the idea is to represent the subject in terms of its volume, its physical presence.

You should be able to appreciate that some of the shapes are, in a sense, felt rather than seen. The pencil marks are merely a record of what I imagined it would be like to touch the objects.

1

2 I chose my colours and the paint range from which several of them came very carefully. To begin with, if you look at the subject again, you will realize that exaggerating the colouring produces a simple arrangement of yellow and blue, balanced by white and supported by red, orange and green. These were the colours that I felt Cézanne would have chosen. 'Complementary' relationships cause them to stand out against one another and Cézanne tried to use this to express depth.

In Cézanne's use of watercolour there seems to be a partial tendency towards translucent effects. In other words some of his colours are almost opaque, though they are not really solid enough to be called gouache. Historically it has been the

1 (detail)

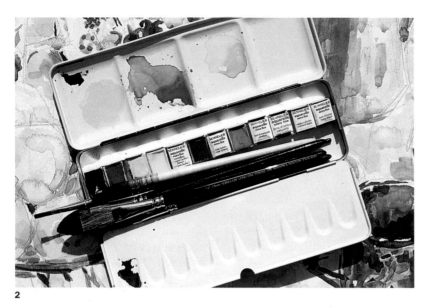

2

3

English rather than the French who have been obsessed by transparent effects, and of course Cézanne was a Frenchman painting in France, but it may also, for associated reasons, have had something to with the type of watercolours he used. Consequently, I included colours such as Naples Yellow and Chrome Green Light that were frequently used in Cézanne's time and I took them from a traditional French watercolour range.

3–4 I then mixed up some washes and started to paint. As you can see, I began by using Ash Blue – a colour rather like Cerulean – Ultramarine Light and Naples Yellow. Each colour was applied separately. Cézanne seems to have placed his colours stroke by stroke, just as he would have done with oil paint. Since a watercolour wash is more fluid and a watercolour brush can hold plenty of it, some of his strokes are longer than they would have been in oil and some merge together in a way that they would not have done in oil.

The ideas behind the drawing continue into the painting, with the strokes of wash placed to represent planes. They are added little by little in the same hesitant fashion and the image gradually builds up.

Some of the strokes in Cézanne's watercolours definitely appear to be made with a straight-edged brush, but as his movements are random and rounded – without the formal pattern of strokes

4

so often seen in his oils – and as the wash itself contributes to the final shape of each mark, it is impossible to be absolutely sure. I tried out several brushes, all capable of delivering the sloppy dabs of wash required, but felt most comfortable with an extra-long ox hair one stroke and put most of the colour on with it.

5 As you can see, I carried on adding colour, stroke next to stroke, referring always to the subject to see which colour to use and where to place it. Uncertainty is part of the process. Place a stroke, think about it, see what it does in relation to the rest of the painting, wonder where to put the next one, think about that, cautiously place another stroke and again consider it in relation to the whole. It should be a slow, contemplative progression and you must not rush to cover up the paper as the gaps in between can be as important as the touches of colour.

You may not feel your way through this sort of painting as intensely as Cézanne did – I am sure that I did not in this example. However, some of the visual charm that results comes from an almost incidental aspect of the method which is very easy to reproduce. It originates from what I will call a 'drop stroke' and from the fact that the painting is done on an easel – this is why the brush is so important. You need one with an excellent wash-carrying capacity and you must always work with the brush fully loaded. It must be dipped back in the wash and recharged between almost every stroke.

The brush, when it touches the paper, should flood wash onto its surface, delivering two or three times as much as is really needed to make the mark. Surface tension – the force that makes water form into drops – prevents it from spreading too far from the stroke, but because the work is tilted on an upright easel, this excess of wash collects at the bottom of it. If it is too upright, a drop will form and run down the paper. At about 45°, the wash does not run, although the bottom edge of the stroke, where the wash collects, often creeps forward under its own weight. Sometimes, wet adjacent strokes will touch, either because this is what you intend or accidentally, and then some of the wash may run from stroke to stroke to find the lowest level. This will mean that the relative colour loading of the strokes will change and the shape and intensity of the brushmark may alter at random. In addition, because the wash collects at the lowest point of the drop stroke, the wash higher up the stroke dries sooner since there is less of it. If the quantity of wash and other conditions are just right, the result will be a brushstroke that dries with a graduating intensity of colour towards the bottom, where a hard edge caused by the last concentrated bit of wash will outline the base of the stroke.

Of course, varying intensities of mark can also depend on differences in the loading of the brush and whether or not it has recently been rubbed on some watercolour paint. There is also one more effect – similar to that described above – that is a tell-tale sign of upright working. If the amount of wash that collects is almost enough to cause a run, then it is likely to take a long time to dry and the part of the stroke that is higher up the painting will dry sooner. As this happens, and the dry area approaches the droplet of wash, it climbs back up and leaves a hard edge in a kind of cauliflower shape. Some of these effects can be seen already. They are also shown in the enlarged details of the finished painting.

By this stage I had already started to add detail in a rather sloppy way. The patterns on the crockery and flowers, for example, are indicated in a simple fashion with smaller touches of wash, again using drop strokes, but this time from a smaller one stroke brush. I also began to introduce some other colours. Raw Sienna was dabbed onto the background in a few places, in particular on the chairback to separate it from its surroundings. Red and mixed purples were also introduced and I started to place Cadmium Orange on the fruit and for the shadows.

6 As the painting neared completion, I added more touches of Raw Sienna wash over the first ones to strengthen the effect and a few watery lines of it to define the table and the edge of the board on the left. More touches of orange were put on as well, mostly at the top where they suggest the panelling on the cupboards behind the chair. Their meaning is uncertain to someone who has not seen the subject, but they serve a design function by contributing a vertical pattern and add greatly to the definition of space. Extra strokes of Ash Blue were added to the jug in the finishing stages and more Ultramarine Light was put onto the mug in the foreground.

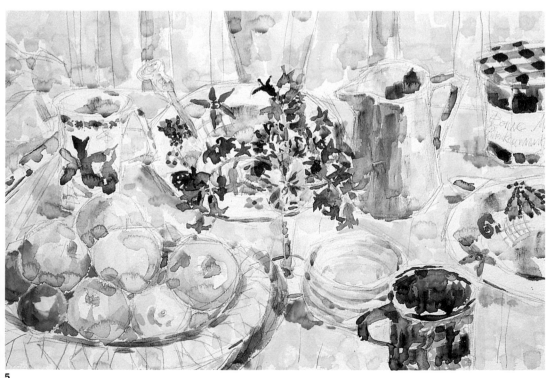

5

Finally a strong wash of Ultramarine was used to place defining shadows on the jug. Touches of the same wash confirmed the contours of the main objects with incomplete and interrupted strokes placed on the shadow side of some outlines. Scrawls of this same blue from the point of a small squirrel mop put the finishing touches to the knife and spoon handles and added the lettering to the label on the jam pot. A partial restatement of the original pencil drawing, sometimes in blue and sometimes in black, occurs in much the same manner in Cézanne's own watercolours and, like the pencil work, it tends to be uncertain and repeated.

The fragmented pencil drawing is part of the painting, but I erased a little of it from the flowers where it seemed to be interfering with the colouring and dulling the effect. It has been said that watercolours by Cézanne would have been complete at any stage and part of his skill was knowing when to stop. It is certainly true that overworking such

6 (detail)

6 (detail)

pieces spoils them, so you must constantly assess whether you have done enough and as soon as you begin to feel that you have, stop.

The enlarged details are shown much nearer to life size than the full view of the finished painting so that you can identify the methods and the effects that I have been describing. The jug, for example, is painted as a collection of surface planes, each represented by a sloppy stroke of pale blue wash placed vertically from a straight-edged brush. The defining stroke of dark blue at the top is obviously a single curved touch that started on the right. An even darker drip of wash has collected at its lowest point, as has one on the dark blue by the spout, where two brushmarks have run together.

The contributions made by the drawing and the areas of untouched paper are easily seen on the apples. It is also quite easy to follow the different touches of wash, some of which have been placed as curved strokes, as if they were being wrapped around the surfaces being described. You can also see how hard edges have formed on some of these strokes and the 'cauliflower effect' of collected wash crawling upwards as it dries.

6 (detail)

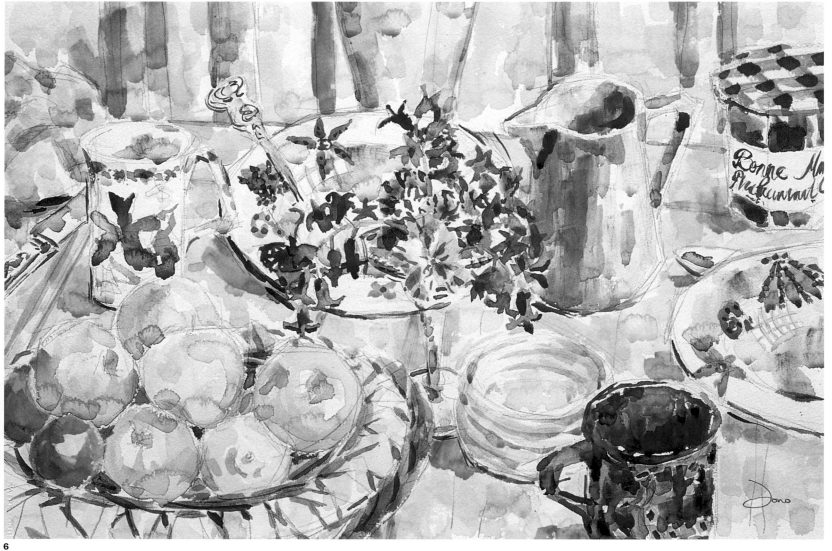

6

DEMONSTRATIONS

Rainbow over Drakeholes

using the methods of J. M. W. Turner

MATERIALS

Paper
140lbs (300gsm) hot-pressed Arches
Aquarelle watercolour paper in the form
of a watercolour block. Size approximately
10" x 7" (26cm x 18cm).

Paint
Half-pan watercolours

Burnt Sienna
Cobalt Blue
Permanent Magenta (Quinacridone)
Raw Sienna
Yellow Ochre

Brushes
Most of this painting was done with a small
Kazan squirrel mop. This was particularly
suited to the method, but any reasonably large
watercolour brush, a size 8, 10 or 12, for
example, ought to give acceptable results.
A size 4 sable-synthetic hair brush was
employed for the rainbow and a good-quality
size 1 sable watercolour brush was used for
a few finishing details.

Other items
An HB graphite pencil, a pair of compasses
and some paper tissue.

In 1803, Joseph Farington (1747–1821) recorded in his diary a remark made by the painter, James Northcote (1746–1831): 'Turner has a great deal of painter's feeling, but his work's too much made up from pictures, not enough of original observation of nature.' It does seem unlikely that he painted directly from nature, but, in practice, the atmospheric effects that so often feature in J. M. W. Turner's (1775–1851) watercolours, and especially in his sketches, do not last long enough to allow them to be painted, or they represent conditions under which it would be virtually impossible to paint. So it is reasonable to assume that his representations of them are distilled from his recollections. This does not mean that they are not based on observations of nature, only that they are not necessarily an exact record of them.

My painting is as much an invention as I expect many of Turner's were. It is composed of elements of truth and relies substantially on the retained memory of an actual experience. This rainbow occurred in the evening and was impressive for two reasons. Firstly, the complete arc was visible and secondly, the surrounding sky was deeply coloured.

Rainbows do not last long, so I spent what time there was looking at it very carefully and immediately afterwards made some rapid notes. This fixed the essential image in my memory.

I began this watercolour painting the following day and by then I had decided to paint the rainbow as if I had seen it from a different position, so that the place from which I had actually observed it was included in the painting. I thought this would make a more interesting composition. Although the actual image was imagined, it drew on real observations and experiences and was built around an on-the-spot sketch of a genuine place, which made it plausible and seemingly real. Separated by time from the immediacy of the original event, you can focus on its essential nature. Then, in the absence of any contradictory observations of fact, as they are no longer there to be seen, the imagination can rebuild the image as an expression of the experience.

As Turner's watercolour methods were driven by instinct and provoked the intervention of chance, it also follows that the finished piece must in part depend upon the process of painting it. You may find it interesting to compare what happens in this

1

case and in *Sunset over Barrow Hills* with the reconstruction of Cotman's technique in *An Old Bridge at Clayworth* or Girtin's in *Roche Abbey*, where the methods are more controlled and the results more predictable.

1 My choice of paper was determined by Turner's apparent preference for smooth and heavily sized papers. Made of pure cotton and sized with gelatine, it is a top-quality modern paper capable of the essential feature of this demonstration – the creation of the rainbow – but it is far from being the same as the papers that Turner used.

As you can see, I started with a very simple pencil sketch – using an HB pencil – chiefly devoted to the outlines of the main aspects of the subject. I kept my touch light so as not to make too emphatic a drawing. The position of the rainbow was lightly indicated at this stage with the pencil and a pair of compasses. I chose a watercolour block because they are convenient for sketching. Turner used sketchbooks rather than watercolour blocks, though they did become available during his lifetime.

As a point of interest, you may realize as you follow this step-by-step example that the drawing was made from almost the same viewpoint as in *Figures in a Cornfield*, which demonstrates some of Bonington's methods. This shows how a different technique and focus of interest can produce a completely different type of painting.

2–7 To paint the sky, I took Cobalt Blue straight from a watercolour half pan, and lifted it directly with a thoroughly wet brush, not taking it from a mixing well of wash. The colour was slopped directly onto the paper, using a curved, diagonal stroke made by sweeping the hand backwards and forwards from the wrist. These strokes result naturally from working quickly and broadly, but Turner also used stroke patterns to keep the eye within the composition, frequently hinting at a round or oval shape within the pictorial boundary.

As you can see, the brush was well loaded with colour at all times. I regularly dipped it in water and recharged it straight from the watercolour pan. Because it is applied in this way, there are areas of uneven strength and, in some places, there is a textural quality to the wash caused by an intense lifting of colour, which has only partially broken down in the wetness both of the brush and on the paper's

2

3

surface. These characteristic effects are often found in Turner's watercolours and the method also fits with his frequent use of pure, unmixed colour. His surviving pocket set seems to confirm that he worked in this way without preparing washes at an intermediate stage.

Typically, Turner used his opening wash over a large area of the painting. Here, I brought the Cobalt Blue down to the most prominent part of the skyline, took it over the more distant part of the landscape on the left and obliterated the more distant landscape from the centre out towards the right. Turner often ignores part of his original drawing in order to simplify and strengthen the image. I had to recharge the brush with more colour several times and deliberately made some heavy strokes in Cobalt

4

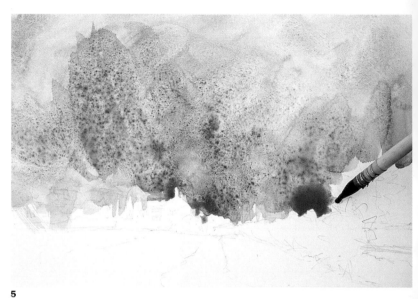

5

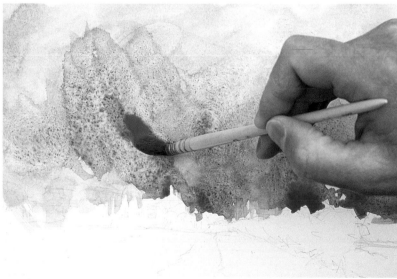

6

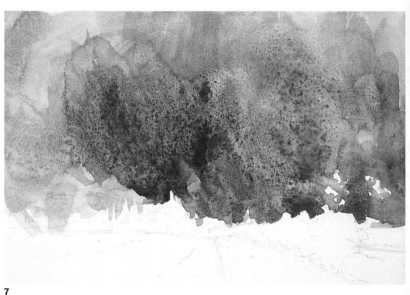

7

Blue into the wet wash at the centre using an inward curving stroke that features in Turner's work. This is made by pulling the hand back in line with the elbow.

You do not have much thinking time when working like this and must paint instinctively, picking up more colour or more water with the brush as needed and directing the strokes however you think fit. Note how the brush is being pulled in different directions at various times and how it is used from its point to edge around the skyline, but on its side for the broader strokes. The curve of the brush head in each illustration tails away from the direction in which the brush is being pulled.

It took no more than a few minutes to complete this stage of the painting, but before it was finished some areas had already begun to dry, hence the lightening in colour that you may notice across the top of the painting. As this seemed too pale I took the brush back across it before it was finally lifted from the paper. Illustration 7 shows the sky when it had dried. You can see how some vertical strokes have been taken back over the previous ones to strengthen the colour.

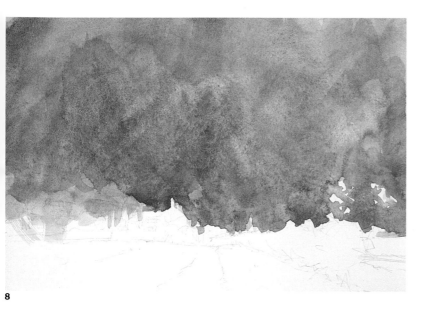

8

9 Rather than painting the rainbow in, I took it out by washing back using a brush taped to a pair of compasses. This delivered clean water to the recently dried surface, softening and disturbing some of the colour, so that it could be lifted off with a clean tissue. Modern papers are not as good at this as those of Turner's time, though some are better than others. The full range of Turner's 'subtractive' techniques cannot be matched easily today.

Turner lifted colour out by various means – a brush, his fingertip, a crumpled handkerchief or a handkerchief wound around his finger. I have no reason to suppose that Turner used compasses, but the rainbows in his paintings are usually well shaped, which suggests some method of control, especially since incorrect wiping back would ruin the painting. Pivoting the arm from the elbow or using a piece of string attached to a pin in the drawing board are other means of shaping an arc.

8 As the sky had dried unevenly, I re-wet it with the same brush dipped in clean water soon after it was complete. This took away some of the hard edges, but was done swiftly so as not to disturb the bulk of the colour. At the same time, I added some curved, diagonal strokes of Permanent Magenta (Quinacridone) on the left into the surface wetness. The brush was dragged swiftly over the pan to pick up only a trace of colour. See how these curved strokes engage the eye and help to generate a swirling motion within the colouring.

The original sky that had inspired this painting did not, of course, look exactly like this. The painting is simply a satisfying expression of the impression that the sky had made. The choice of colours and the use of the brush would in Turner's paintings, as in this one of mine, have been largely a matter of instinct, habit and whim. Indeed the same could be said of the subject in Turner's case. As John Ruskin (1819–1900) observed: 'A rainbow is another of his most frequently permitted indulgences.'

9

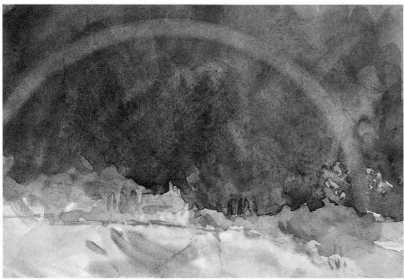

10

10 The landscape was completed with Raw Sienna and Yellow Ochre, laid first as a thin broad wash and then retouched while still wet; and then again, when almost dry, with heavier colour. Note how the eye is drawn into the centre of the painting by the diagonal strokes to the left of centre, which pick up on the curve suggested by the strokes in the sky, and by the rainbow's curve, the vaguely suggested tracks across the field and the sloppy, darker strokes on the right that suggest a hedge. Turner's paintings often contain quite simple directional indicators for the eye.

11–12 The electricity poles were added last with Burnt Sienna from a small, fine-pointed sable using quick confident strokes. The same brush was then deliberately spoilt by pushing it head on into the half pan of Burnt Sienna, causing it to spike. It was used with a light touch to make the vague indications of the trees. You can see this in the enlarged detail. Look also at the swift, heavy stroke of yellow-brown wash to the left of the brush. This disguises the tiny hole made by the point of the compasses, which can be seen at its centre. You may notice that the positioning has been chosen quite deliberately so that the chimney of the house points directly at the centre of the rainbow's arc. The finished painting is shown life size.

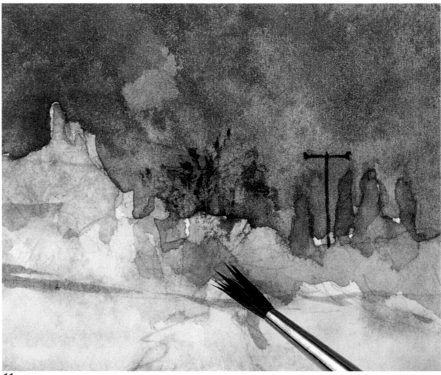

11

12

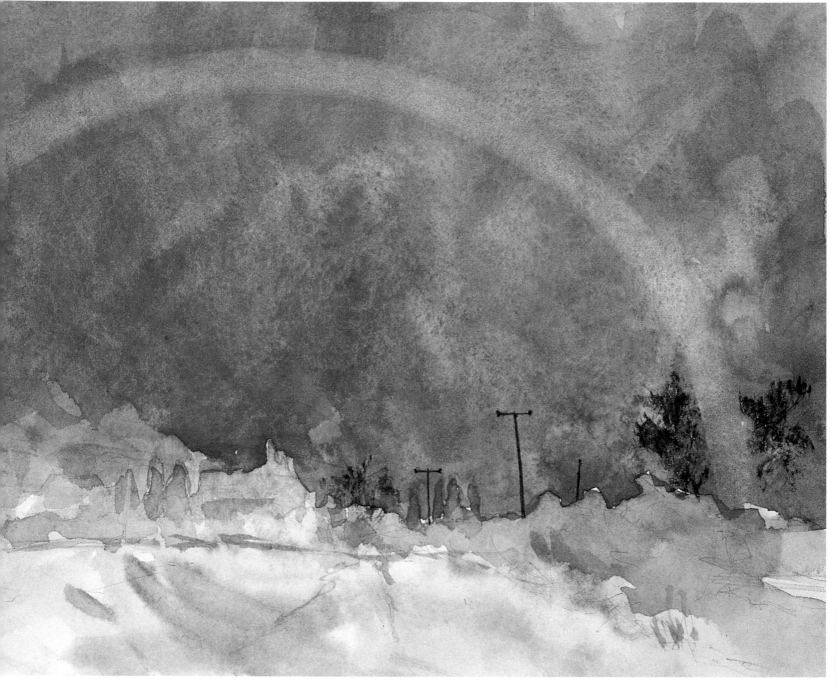

DEMONSTRATIONS

The clock tower, Benningbrough Hall using the methods of David Cox

MATERIALS

Paper
Grey Bockingford Tinted watercolour paper.
Size 11" x 15" (28cm x 38cm).

Paint
Half-pan watercolours

Cadmium Orange
French Ultramarine
Olive Green
Phthalocyanine Green
Red Ochre
Sepia
Terre Vert
Ultramarine Light
Yellow Ochre

Zinc White gouache from a tube

Brushes
A size 10 or 12 watercolour brush with very limited use of a much smaller size 1.

Other items
Charcoal, charcoal pencil or black chalk for the drawing, a putty eraser, a drawing board and a mixing palette for good quantities of wash.

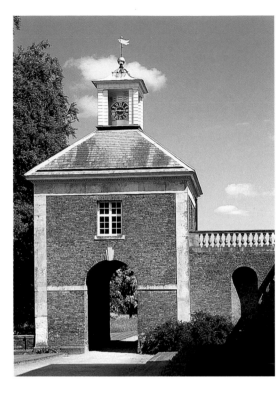

1

In this painting I have applied the technique that David Cox (1783–1859) described in a letter to his son. His account of this technique and other insights into Cox's methods are given in Part 2. It involves the simple and bold use of watercolour over a rough charcoal drawing – a method that Cox practised on a coarse Scottish wrapping paper.

There is no modern equivalent of Cox paper, as it became known, but there are some current papers that share enough of its essential characteristics to give attractive results when using Cox's methods. The original Cox paper was a roughly textured wove with a small coarse grain on its surface. It was grey-white flecked with irregular inclusions of poorly pulped matter and black specks – the latter was possibly tar from the old ropes and sail cloth from which it was made. Where these fell across the sky, Cox was obliged to make them into birds. For its time, it was a heavy-weight paper and, either because of its raw materials or its sizing, or perhaps a combination of both, it seems to have taken colour in a particularly pleasing way. A later imitation of Cox paper was made in different colours. Light and dark versions of it were still being offered in 1961.

1 I chose grey Bockingford watercolour paper because of its colour, substance and texture – it offered a very approximate version of the desired characteristics. The response of its internal sizing also seemed appropriate for this method.

The work began with a quick, bold sketch in charcoal – I, in fact, used a charcoal pencil for accuracy and convenience. Black chalk can also be employed for this method. You should keep your drawing as simple and as clean as possible. I did mine in front of the subject and it only took a few minutes. As you can see, it contains some alterations. It is important to be bold and confident, even if this results in minor errors. A timid and insubstantial drawing would not have the necessary impact.

I decided not to do the colouring on site and did the painting the following day while the image was still fresh in my memory. Cox often worked at night which means that he must have added colour without direct and immediate reference to the subject. This method may succeed when working from photographs, but this is a habit that I would not normally encourage.

2 **3**

2–4 I used one large brush for most of the colouring. Cox used a large swan's quill, roughly the equivalent of a modern size 10 to 12 watercolour brush. With the exception of the clock face, this entire painting was done with a size 10 sable. It is important to have the brush fully loaded with strong wash, just as you see it here. The wash should be very fluid, but also very rich in colour and you must have plenty of it. Cox prepared his washes in saucers; I used studio china.

On grey paper it is necessary to colour boldly over a charcoal drawing and you must work with a spontaneous and certain touch. On drying, the washes will take on a much lighter and brighter appearance if they are strong enough. Weak washes that would give a delicate effect on white paper simply look dull and unconvincing on grey.

Wherever the drawing is gone over, the charcoal will mix into the washes and produce a darker tone. This enhances shadow effects, but spoils highlights.

Swift and short brushstrokes that avoid repetitious touching of the wet surface are the answer. This prevents too much disturbance and spreading of the charcoal. You can see how I have applied the first wash of Yellow Ochre in a sequence of sloppy touches – the unevenness of effect is intentional. After the Ochre had dried Terre Vert was used for the roof slates and hedge and Terre Vert mixed with blue was used to represent the lead covering of the small roof over the clock.

4

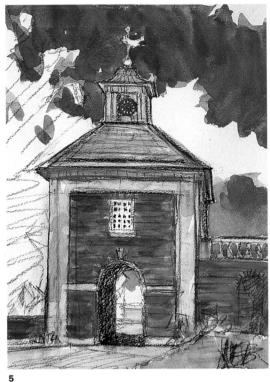

5

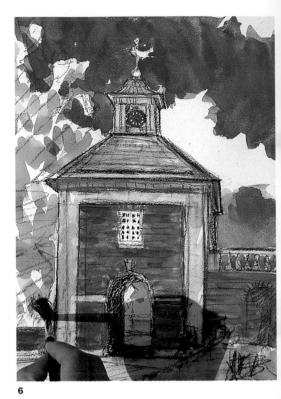

6

5–6 Flickering brushwork is a recurrent feature of Cox's own watercolours. His effects are frequently built up from overlaid hatchings of colour, each touch placed on top of previous touches that are already dry. That is essentially how I worked here when putting the orange red brick colouring over the Yellow Ochre. The brushstrokes are horizontal and their colour and wash strength varies to suggest the coursing and patina of the brickwork.

You can still see the downward curve of the strokes in the sky, even though they have been allowed to run into each other while wet. You may realize that the clouds are untouched areas of grey paper that, when surrounded by strong colour, appear to be almost white. The initial separation of the brushstrokes can be seen in the development of the trees. Note how they have been placed as dabs about the same size as the brush head.

7–8 I added shadows in Sepia and a few broad touches of detail to take this painting as far as I felt it could go using heavy but transparent washes. However, as you might expect from such a simple

and direct method, the end result was flawed, so I then made some minor corrections and improvements in body colour, principally to the stonework using a tint of Yellow Ochre and Zinc White. Cox did the same in paintings of his that I have examined, indicating that such retouching is often necessary with this technique. Here, my aim was to keep the opaque touches as fresh and as brief as the rest of the painting and, while they contribute a great deal to it, they are not extensive additions.

The final step was to take a putty eraser over the whole surface – Cox would have used bread. The eraser removes any charcoal that has not been covered by wash. Where it has been painted over, the drawing is fixed and it contributes a rough, dark tonal element to the painting. Where it has been missed by the wash, it lifts away to give scintillating and often unexpected highlights. The transformation that this brings about can be quite miraculous but it is, of course, entirely a matter of chance. Compare this with the erasure of the drawing in *An Old Bridge at Clayworth*.

6 (detail)

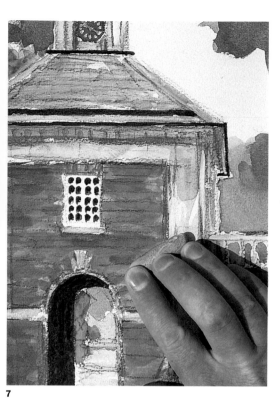

7

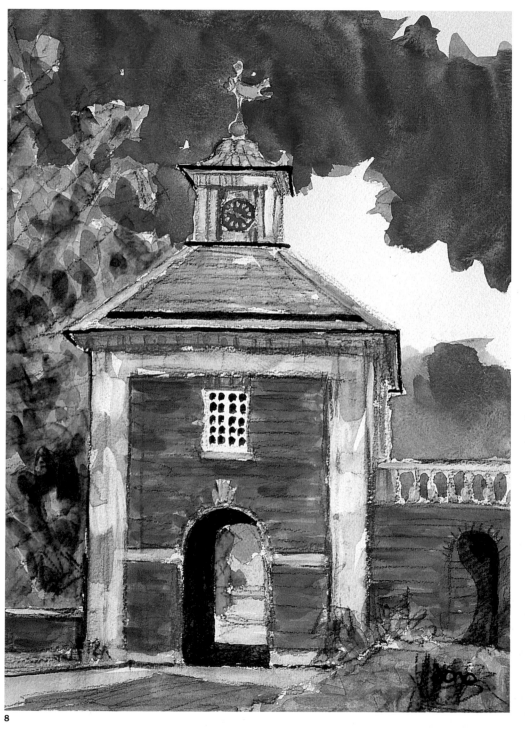

8

DEMONSTRATIONS

The cherry tree using the methods of John Singer Sargent

MATERIALS

Paper
300lbs (638gsm) Saunders Waterford 100% long cotton fibre, acid-free, internally and externally sized watercolour paper. Size 22" x 15" (56cm x 38cm) – a half Imperial sheet.

Paint
Tube watercolours

Burnt Sienna
Cadmium Lemon
Cadmium Red Light
Cadmium Yellow Deep
Chinese White
Cobalt Blue
French Ultramarine
Lamp Black
Phthalocyanine Green
Quinacridone Rose

Brushes
Watercolour brushes in sizes 10, 4 and 0. A wider selection, including some wash brushes, was available for use if needed.

Other items
A graphite pencil, masking fluid (liquid frisket) and an old brush to apply it, a folding watercolour palette, an easel and a scalpel or small craft knife.

John Singer Sargent's (1856–1925) watercolour paintings show the influence of Impressionism in their lively colouring, dashing brushwork, on-the-spot methods and choice of a sometimes quite ordinary subject. I chose to paint this cherry tree as Sargent occasionally took wayside features as his subjects. He probably planned his paintings before he started working on them. There is an interesting combination in Sargent's methods of forward planning – through preparation and practice – and almost reckless spontaneity as the paint is applied: he does not paint a picture, he gives a performance of the art of painting.

You can read about Sargent's watercolour methods in Part 2 and will see that I applied aspects of his technique here that seemed appropriate to my subject. You must remember that directly and spontaneously painted watercolours do not follow an exact path. In my experience their outcome may also depend on some circumstantial factors and so I was careful to re-create working conditions similar to Sargent's. I therefore did my painting out of doors, immediately in front of the subject, with the paper held at an upright tilt on an easel. I even assembled a selection of brushes very similar to Sargent's, although I did not find a use for more than three of them on this occasion. I chose colours that were equivalent to the ones he would have used and, like Sargent, I used tube watercolours and a folding palette. Unfortunately,

1

I overlooked the fact that he preferred rough paper and used a not (cold-pressed) surface instead.

By setting up in this way I was making it easier to imitate Sargent's techniques. For example, his vigorous brushstrokes can be seen as a consequence both of his having to work quickly because he was out of doors and his use of an easel.

1 Sargent's brilliantly handled watercolours often appear to have been dashed off in an instant, but, although he worked spontaneously, he devoted much time to preparation and practise. In at least

2

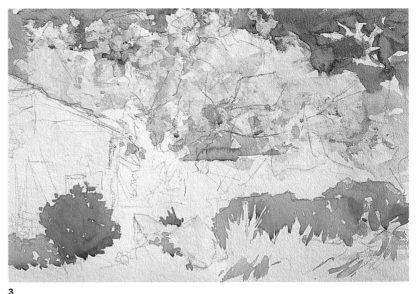

3

one instance he did a number of preliminary drawings and watercolour sketches before beginning the watercolour proper. He did not use these as models for the eventual work, but as a means of familiarizing himself with the subject and of devising the best ways of painting it.

It is difficult to say how often Sargent may have adopted this approach, but clearly a painting is much more likely to be successful if you are aware of what might or might not happen as you work – particularly if the subject is complex or unusual. I was unsure of how to go about this painting so I tried it out first in sketch form on a smaller piece of paper. I used watercolour pencils for my study because they are fast and direct.

My watercolour of the cherry tree was then painted directly from its subject, as I will now describe, but this was easier than it might have been because of the knowledge I had already gained.

2 Sargent preferred to work on watercolour blocks, but in large sizes they are expensive and not widely available, so I used a half Imperial sheet, fully secured at its edges to a drawing board with masking tape. This is equivalent to using a block and my choice of heavy-weight paper also meant it would be able to withstand rough handling.

Sargent's preliminary pencil drawings are slight and casually done. As you can see, my opening

sketch consisted of just a few scrawling lines, spread quite carelessly across the paper in a series of sweeping gestures. Drawing at an easel encourages this as there is nowhere to rest your arm.

As soon as my sketch was in place, I worked over it with masking fluid (liquid frisket), placing rough patches of it wherever I wanted to preserve the paper. Sargent certainly used resist techniques, which again shows that he pre-planned even when using an apparently spontaneous method. The beauty of masking fluid is that it lets you paint as vigorously as you like while still reserving parts of the paper for later use. I scuffed and dashed some fluid where I definitely wanted to keep white paper, but mostly put it where the cherry blossom would eventually go. I let this dry thoroughly before starting to paint with coloured wash.

Always use an old or inexpensive brush to put on masking fluid. If you dip it in water first and then squeeze it out before putting it into the fluid it is more likely to rinse clean afterwards. Wash the brush immediately after use. You can also put masking fluid on with a palette knife. It has to be taken off within a day or two of being put on and in hot weather it may be advisable to let the painting cool before trying to remove the masks.

3–6 I coloured this painting directly from nature in two separate sessions. On each occasion I took up

the same position in front of the cherry tree and painted what I saw – or rather a simplified impression of it – as quickly as I could. Sargent, with his amazing dexterity and well-practised manner, probably worked faster than I did, but even so it is difficult to conceive of a painting of this size and complexity being completed in one session.

I did not intend to work this way, but it is a natural consequence of painting out of doors. After a while the light or the weather conditions change or you begin to get tired. At that point you have to stop and the only way of maintaining the freshness of the painting – and continuing to depict nature in its true form – is to carry on working on it in exactly the same way under the same conditions at another time. This is a basic method of Impressionist painting that Sargent would have been aware of. You should, however, always aim to achieve as much as you can at the first attempt and with an easy subject you may be able to finish your painting in one go.

The illustrations show the progress of this painting during the first two to three hours. I did not spend all of this time applying paint. I studied my subject and decided what to do next. Sometimes you will also have to let washes dry before you can proceed, which was the case here. With another subject I might have begun on wet paper, which would have dictated a different pace of working.

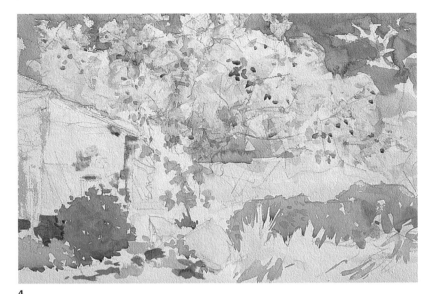

4

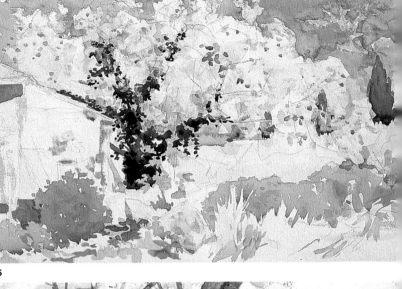

5

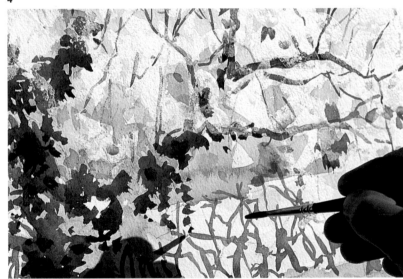

6

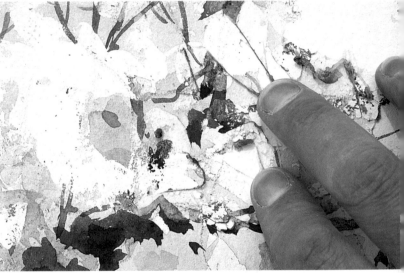

7 (detail)

I started with the sky because it occupied the top of the painting and on an easel watercolour washes can run. Sargent often allowed one wash to fuse into another in the opening stages of his paintings, but I did not want that to happen here beyond a limited extent, so my first masses of colour were separated by white paper and as I placed these washes I 'cut out' shapes with them. The outline of the foreground grasses, for example, is made with the green wash of the nettle patch behind them.

Observe also how the colour collects because of the tilt of the easel.

I continued to mix and place colours by referring to my subject. At first I worked broadly, using the size 10 brush, but towards the end of the session I began to use the size 4 for smaller and narrower strokes. In illustration 6 you can see that I have used this brush to add the branches of the tree and the bare hedge. Because the work is on an easel I made the brushstrokes with a

jabbing motion which gives rise to flowing and flamboyant marks.

7 The second session of painting also lasted two to three hours. I began by removing the masking fluid – rubbing with your fingers is usually sufficient, but you may miss small traces. This is likely to occur where the masking fluid has been scuffed over the paper. You can remove any that remains with a clean eraser.

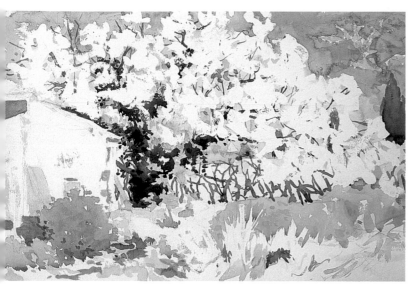

7

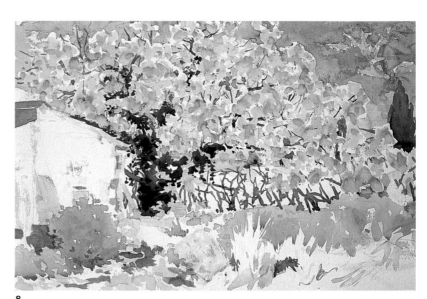

8

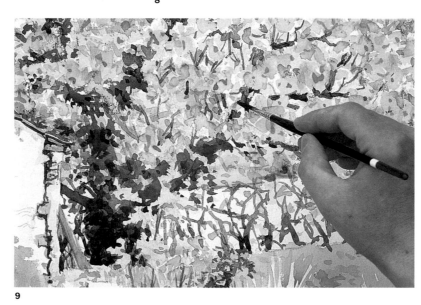

9

In the previous session I painted over the masked areas in total disregard of their presence. This included putting in some of the tree's branches with easy continual strokes. When I removed the masks it took some of the earlier painting with it – in the branches it left just those sections that would be visible between the blossoms. What goes and what stays as the masks are removed is unpredictable because of the loose instinctive handling of the masking fluid and the washes, but this is entirely in keeping with the spirit of this method.

8 I started to concentrate on working into the gaps that were now exposed. The cherry tree blossom was created in three stages of colouring. I applied them one after the other in a more or less continuous process.

Firstly, I dabbed a rose pink wash into the gaps reserved for the blossom. These blobs of wash were scattered across the painting in two or three passes, so that adjacent or overlapping touches were not necessarily placed at the same time. The effects varied because sometimes the touches were dry, partially dry or wet when the next stroke was made; the same place was sometimes touched more than once; some brushstrokes ran together while others did not and in some places they overlapped. Gradually the subtle variety of intensities and the delicate wash edges created by this process

began to suggest clusters of blossom. Patches of white paper were left exposed as well, which added to the effect by suggesting sparkling highlights – as if strong light was shining through the flimsy petals. The lack of exactness that results adds to the vitality of the image.

9 The second phase of painting the blossom involved switching to a smaller brush and preparing

a stronger wash. I then scattered sloppy touches of a more intense pink over the first colouring, breaking it up still further and providing accents of rich shadow. Finally, I added the leaves, branches and twigs around and in among the blossoms, reshaping the spaces left by the masking fluid and, by doing so, advancing the definition of the image and contributing to the element of drawing within the paint layers.

3 DEMONSTRATIONS

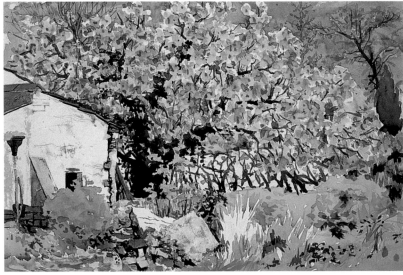

10

11 (detail)

10 I also used stronger washes of colour in shaped patches, dabs and flicks to suggest form by adding darker tones across the rest of the painting. At the same time I worked a few dots and scribbles of bright hues into the foreground colours to imply wild flowers. Intense shadow, freely drawn with the brush, sharply defined the outbuilding and the pile of rubble and bricks in the foreground, even though their details were not fully described.

I was tempted to regard my painting as finished, but Sargent probably reconsidered and retouched his watercolours away from the scene. The following day I spent another two to three hours – this time in studio conditions – contemplating my painting and making minor corrections to it.

11 If a watercolour has worked well enough and you cannot see any obvious way of improving it, leave it alone. Very often though, especially with paintings done out of doors, there will be some aspects that have been misjudged at the time of painting and correcting or modifying these will make a difference. The process of identifying what is wrong and deciding what to do about it must not be rushed.

In this case a few forceful touches of French Ultramarine were added to restate parts of the hedge and a clump of ivy in the foreground. I highlighted the edges of the tiles on the outbuilding by scraping through to the white paper with a scalpel

11 (detail)

11 (detail)

and I made a few very minor corrections with body colour. Lastly, I repainted the conifer on the far right of this painting exactly as I had painted it at first, but using stronger washes. This deepened the tone and made it contrast more with the adjacent cherry tree. I used French Ultramarine with Burnt Sienna run into it while it was wet – the running of a warm brown and a strong blue into each other is a mannerism that is found in Sargent's watercolours.

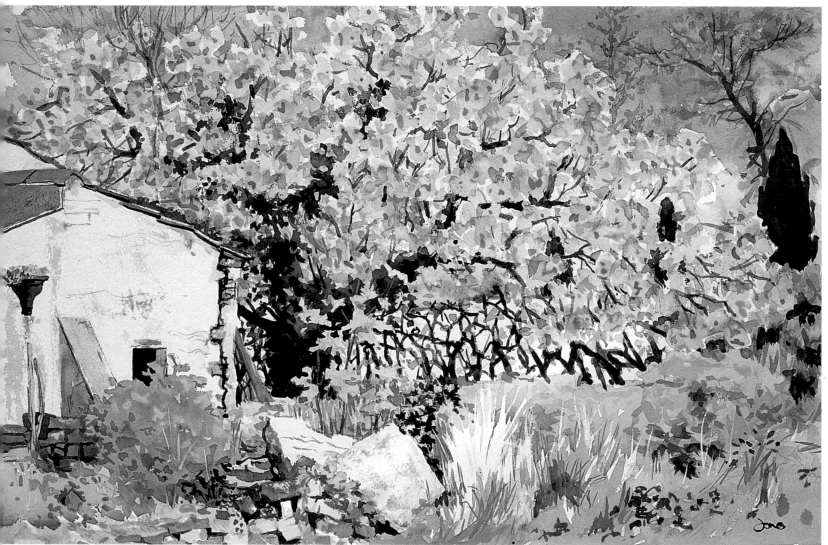

11

DEMONSTRATIONS

Cliffs near Branscombe using the methods of Richard Parkes Bonington

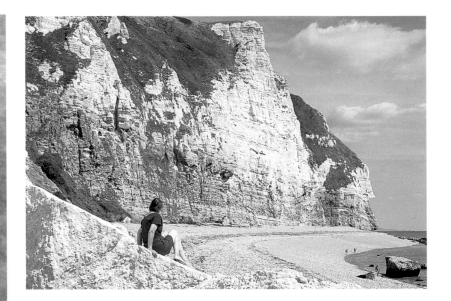

MATERIALS

Paper
140lbs (300gsm) hot-pressed Arches Aquarelle watercolour paper (100% cotton, gelatine sized) used as a watercolour block. Size of work approximately 10¼" x 7" (26cm x 18cm).

Paint
Half-pan watercolours

Burnt Umber
Cadmium Red
French Ultramarine
Red Ochre
Venetian Red
Yellow Ochre

Chinese White from a tube

Brushes
Sable watercolour brushes in sizes 7 and 4 – the size 4 was a Kolinsky sable and had a fine point – and a French size 8 (roughly equivalent to an English size 4) in squirrel hair. It had a sharp elongated point that easily delivered a fine linear stroke.

Other items
A graphite pencil, a small blunt knife and a scalpel.

The techniques I used in this watercolour painting are closely modelled on those that I found in two impressive works by Richard Parkes Bonington (1802–28), *The Undercliff* (1828) and *The Castelbarco Tomb, Verona* (1827). I chose my subject carefully in order to show the range and variety of Bonington's methods and how they are typically combined within a simple framework.

This painting involves a relatively simple overall method – the placing of uncomplicated washes onto a light pencil drawing, with a little graphic detail added over the top using a fine brush point. However, this straightforward process is embellished with frequent minor diversions into other watercolour techniques. Several times, for example, I manipulated a wash just after it had been put down and before it became too dry – a device frequently employed by Bonington. Such actions will enhance details and enrich the total effect, but they are not essential to the basic painting process.

1 Bonington would have worked up many of his watercolours from drawings, but it is likely that he painted at least some of them on site. I began my painting in front of the subject but finished it away from the scene. It started with a brief outline drawing in pencil which included all the essential details – this type of watercolour painting needs to be governed by a drawing, even though the completeness and quality of it may vary from piece to piece. In this case, I was fairly careful and tried to record information about my subject by using the character of the line. This made it easier to complete the work off site.

This is a fairly small painting, but by Bonington's standards it is quite large. For convenience I used a watercolour block and worked on hot-pressed paper. Bonington's papers were between a modern hot-pressed and not (cold-pressed).

2–3 All of the initial painting was done with a wash of French Ultramarine. To depict the sky a size 7 brush, moderately filled with colour, was worked against the contour of the cliff. Spaces were left for the clouds. Then, before the wash began to sink into the paper, I pulled it to the right across the sky, with the brush head held flat against the paper's surface.

Dragging the brush on its side is a characteristic technique of Bonington's. It produces irregular wash patterns as the brush misses the paper or begins to run dry. The result will depend on the size of the brush, the loading of the colour and the presence of any slight texture on the paper's surface. Here, the paper was exceptionally smooth and perhaps the brush was a little large for the purpose, but a reasonable effect was still achieved. I improved upon this by almost immediately repeating a similar sequence of painting over the top of the first

1

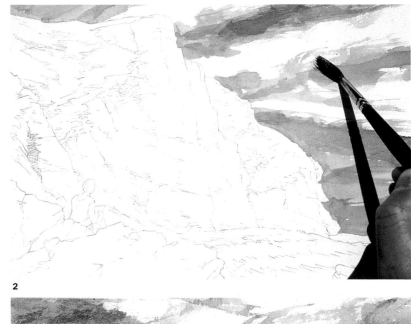

2

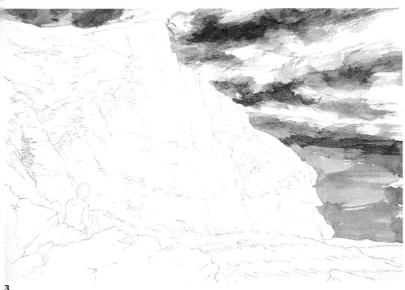

3

3 (detail)

applications. You can see the combined effect clearly in the detail. Dragging the brush creates random and ragged patterns of wash so in some places there is one layer of colour, in others two, and here and there possibly three – the white spaces representing clouds have also been broken down by this process.

The sky, as you see it here, was arrived at very quickly. However, the first wash layer had begun

to sink into the paper and was nearly dry by the time the second layer of wash was added. There was no attempt to repeat or rework the marks that chance provided, other than by making a further mark across them – this means that the colour remains clear and the wash edges stay sharp. Fussy handling is more likely to spoil than to enhance the quality so you must always proceed confidently.

4–5 I placed the shadowy stain across the base of the cliff using the same Ultramarine wash. This was put on with the brush, but then, while it was still wet, I stamped it with the palm of my hand, partially displacing, partially lifting and partially repositioning it. The result was totally random and unpredictable, but you can see the subtlety of the effects achieved in the detail and in the full view how this has already begun to establish the form of the cliff.

4

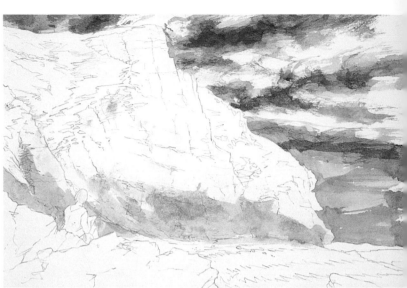

5

5 (detail)

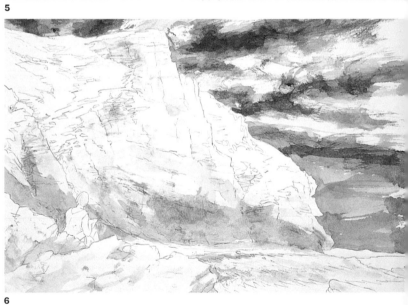

6

I could have used a similar approach to soften the sky if it had remained wet long enough. Working a wash with the hand or fingers in this manner varies its thickness and therefore its intensity of colour. You can also print back onto the painting with the colour that you have picked up. A fingerprint, for example, can provide a very delicate touch. I used this method later on to make small-scale suggestions of texture and tone.

6 I now used Yellow Ochre, again as a pure colour wash. It was pulled over the paper with the brush flat, as before, but I also used the brush point in a few places to channel the wash deliberately. As you can see, I worked away from the contours provided by the drawing, just as I did when I placed the sky. The resulting shaped patches of Ochre wash, together with the surrounding white paper, gave form to the upper part of the cliff. Where the

Ochre lies across the Ultramarine a delicate grey-green has been created.

I then made a much richer wash of Yellow Ochre by scrubbing a size 4 brush against the watercolour pan. This action tends to splay the hairs and misshape the brush head and with it like this, half dry, but carrying concentrated wash, I dragged on some scratchy brush marks, loosely guided by the initial drawing, to show areas of

6 (detail)

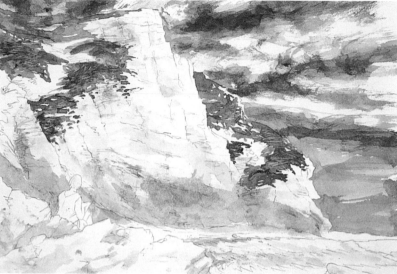

7

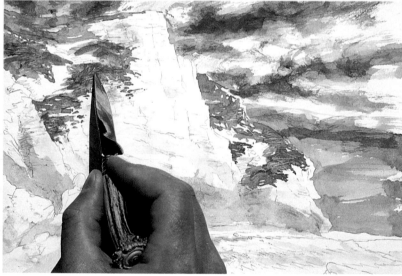

7 (detail)

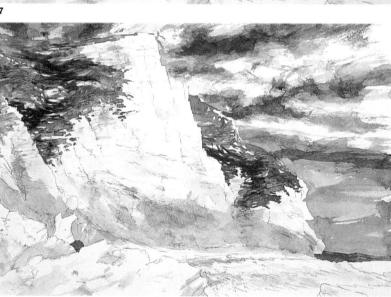

8

flaking and fissuring along horizontal seams across the rock face.

7 A dull green was mixed and laid over areas of the cliff top. Then, quickly, before it had dried, I scraped the point of a small knife through it with a zigzag and sideways motion which pushed some of the wash away and gave it a textured appearance. Bonington would have used the end of a quill stick – his brush handle – for this, but a modern brush handle tends not to have such a sharp point, hence my use of a knife. It was, in fact, a rather blunt fruit knife. To achieve the desired effect you must push the wash away, without scoring the paper, just at the right moment before it dries. The success of this method also depends on the paper itself. Those of Bonington's time were probably better suited to it than most modern papers.

8 To complete the colouring of the cliff top I added some Red Ochre using sideways strokes flicked from the tip of the size 4 brush. Where this lies over white, its own warm colour is revealed and where it lies over green, a dark brownish green appears. Notice how small, angular gaps of white have been deliberately left among the green and Red Ochre washes to suggest outcrops of rock among the rough vegetation of the cliff-top slopes.

9

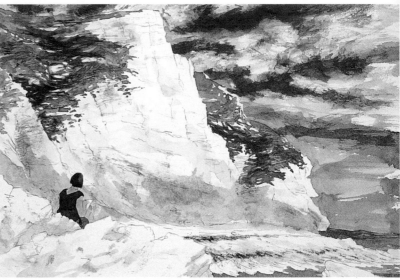

10

At this point I decided to start painting the figure in the bottom left-hand corner. A wash of Yellow and Red Ochre provided the basic colouring of the flesh and I applied a dull purple composed of Ultramarine broken with Red Ochre for the shorts. I used the same dark wash for the distant headland on the right. These colours had to dry before the rest of the figure could be painted in.

9–10 For the top part of the figure's clothing I again used French Ultramarine pure, but before applying it I reworked the sky a little. I used the size 4 brush, lightly loaded with Ultramarine wash – in fact semi-dry – and once again made use of a flat dragging action of the brush. By strengthening the colour of the open sky in specific places, the cliff was made to stand out more. This particularly shows where white rock adjoins the sky. I also slightly modified some of the cloud shadows which improved their appearance. I then placed the same Ultramarine wash over the sea and added a stronger version to the figure.

I added the figure's hair with a warm wash of Red Ochre from which a soft highlight was lifted by touching it while it was still wet with a wrung-out brush. This sucks up some of the wash, leaving an uneven covering. I then dragged the same Red Ochre wash on a half-dry brush over the beach in a series of scuffed-down brushstrokes to show the tide mark left by the waves. To soften the effect

11

12 (detail)

I stamped and smudged this colour with my fingertips immediately before it dried and printed off the lifted colour to give delicate nuances of shadow elsewhere. I had done the same while using the Ultramarine, so there are also some partial fingerprints in blue which contribute subtle touches to the shading.

11–12 Finishing mainly meant drawing over detail in a dark brown shadow tone. For this I chose a small

squirrel hair watercolour brush with a needle-sharp elongated point. The nature of the brush, together with the wash-carrying capacity of the hair type, gave me a particularly fluid and responsive line with which I loosely followed the initial drawing.

The same colour was applied broadly to represent the deep rock crevice on the far left. Before the wash dried I scraped a zigzag through it, using a knife as before. This revealed some of the lower pale blue wash which, in combination with the marks

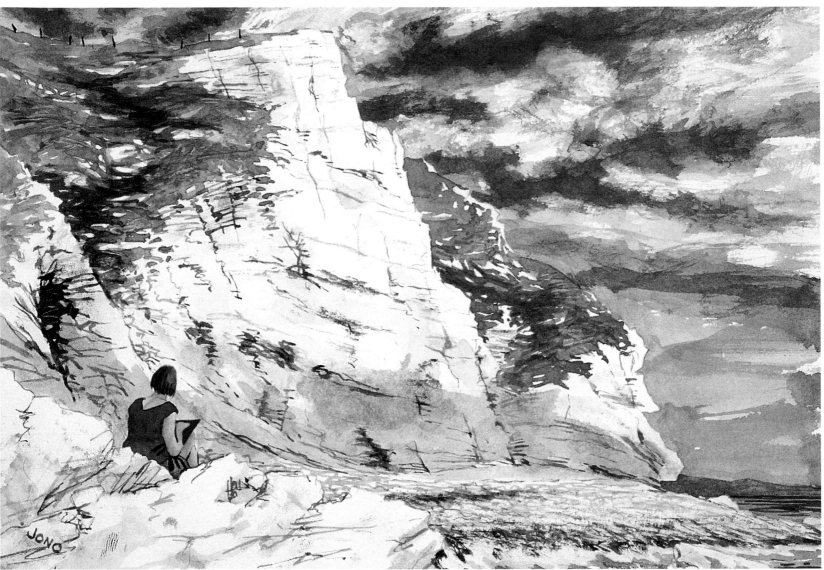

12

made, hints at the structure of the rock surface within this area of shadow. The overall effect is aided by the trace of a fingerprint in Red Ochre immediately to the right. Partial fingerprints in French Ultramarine and Yellow Ochre are also visible close to the signature.

Some brush-point drawing was added in blue and the drawing board on the figure's lap was painted with Cadmium Red. The use of a small touch of bright red to focus the viewer's attention is a traditional device that Bonington and many other painters have used.

Finally, I made a few corrections and adjustments. I scraped over the shore line with a sharp scalpel blade. This broke up the colouring by peppering it with small scratched-out highlights and subdued the unwanted sharpness in that part of the image. This scraping also helped to imply the foam at the sea's edge which was further emphasized by a few small touches of Chinese White. I also used Chinese White to place a few soft highlights on the figure. These were painted in white and then touched over with wash to give a colour effect that is still transparent. The same technique is used more prominently in *Figures in a Cornfield*, which is also based on Bonington's methods.

DEMONSTRATIONS

Poppies inspired by the work of Piet Mondrian

MATERIALS

Paper
300lbs (639gsm) not surfaced (cold-pressed) Saunders Waterford watercolour paper. Size 15" x 11" (38cm x 28cm).

Paint
Half-pan watercolours

Cadmium Lemon
Cadmium Orange
Cadmium Red
Cadmium Yellow
Cerulean Blue
Cobalt Blue
Ultramarine
Viridian

Brushes
Sizes 10 and 4 sable-synthetic mix watercolour brushes and a ⅜" (1cm) ox hair one stroke brush.

Other items
HB and B drawing pencils and a drawing board.

1

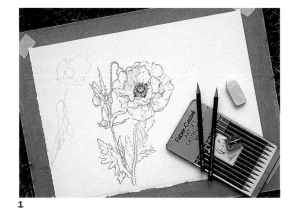

2

Piet Mondrian (1872–1944) is best known as an abstract painter, but his early works represent real objects. I was inspired by his watercolour *Amaryllis* (*c.* 1910) which shows a bright red flowerhead set against a blue background – these poppies seen against the bluish grey chippings of a car park reminded me of it.

The method I adopted may not be exactly the one that Mondrian used, but I feel sure that it has many similarities. The primary concerns here are colour and shape, but the foundation of the technique is good drawing. Mondrian – even in his later abstract works – always used a firm line to describe the shapes occupied by colours. My painting depends on the quality of the initial drawing – the colours are simply applied over it up to and within its boundaries.

1–2 The opening drawing was not elaborate, but it was careful. I took enough time to study the poppies in detail as I drew them and, having placed the first at the centre of the page, I carefully considered the position of the other two. Individually, each poppy is a close study of nature, but the composition of the three together is an arrangement.

As you can see, the drawing is essentially linear but it is not simply an outline. I took note of folds in the petals and applied some light shading. An HB pencil was used to indicate the drawing lightly, but once I was certain of its positioning I used a softer B pencil, which gives a blacker and more distinct line, to confirm it. I did this because I wanted the drawing to show through the superimposed colour, some of which would be semi-opaque.

The green used for the poppy stems contained Cadmium Yellow and Cadmium Lemon mixed with Viridian. The variation across the stems and the buds is due to different amounts of the same wash being present; the action and loading of the brush either drawing out the colour thinly or forming it into pools. Cadmium pigments are all fairly opaque, so the firm black drawing is subdued and subtly shows through these washes.

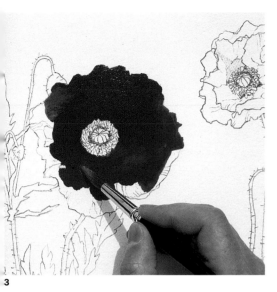

3

3–6 With the paper flat, I generously applied a rich wash of Cadmium Red to the poppy heads, starting with the large one in the centre. To enliven the colour, I picked up Cadmium Orange on the brush as well and ran it into the red. Only the petals, the parts that should be red, were coloured red. As these opening washes dried, I decided the colour was not intense enough, so I repeated the process applying a second heavy wash of Cadmium Red and Cadmium Orange over the first washes.

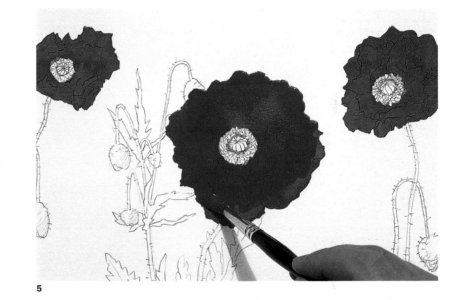

5

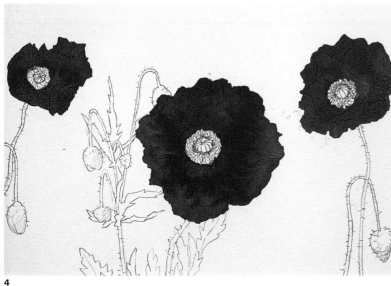

4

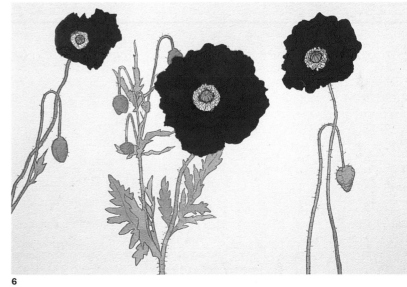

6

7–8 The poppy centres were completed with simple applications of wash. There is still no reinforcement of the pencil drawing in paint, but you may note that where the wash edges touch, the definition naturally sharpens.

Next, I added the background. Mondrian overcame the potential problems of laying such a large area of a single colour by using variable tones and touches which gave an intense and lively, yet harmonious, sense of blue, without attempting an even covering of it. It is reasonable to suppose that my method was similar to his.

I began by mixing up a large quantity of wash based on Ultramarine, but it also contained some Cobalt Blue and Cerulean Blue. Then, starting at the top left because I am right handed (working in a direction that prevented me reaching over what I had just done), I swept the wash across the paper with a very full brush.

I used the size 10 for mass coverage and the size 4 to take the colour around the delicate contours of the stems. Then, before the colouring left behind had dried, a flat ox hair brush was used to dab in oblong strokes of each of the three blues I was using. Since the surface was still damp these fused into it pleasantly.

The trick, when attempting a large covering of wash, is to keep the leading edge of it wet all the time. I interrupted the process briefly to photograph it and so lost the momentum, resulting in the swirls of colour running through the right side of the background. This could easily have happened anyway and you should expect this sort of effect where areas of wash at different stages of wetness join. It will almost certainly occur if you have to mix more wash hurriedly in order to complete an area. Since it adds to the randomness of the colouring, it may sometimes be an effect that you will wish to encourage.

Mondrian possibly applied the whole of his background wash with a flat brush, but that would not have been practical here. In my painting the blue background could be interpreted as an out of focus view of the car park surface, but the real importance of it is that it surrounds the red and so intensifies its appearance. The green also interacts with the blue and the red in an interesting way.

The final point to note is that because I used a heavy-weight paper I made no attempt to stretch it or to secure its edges completely. It was just held at the corners and at the centre of each side.

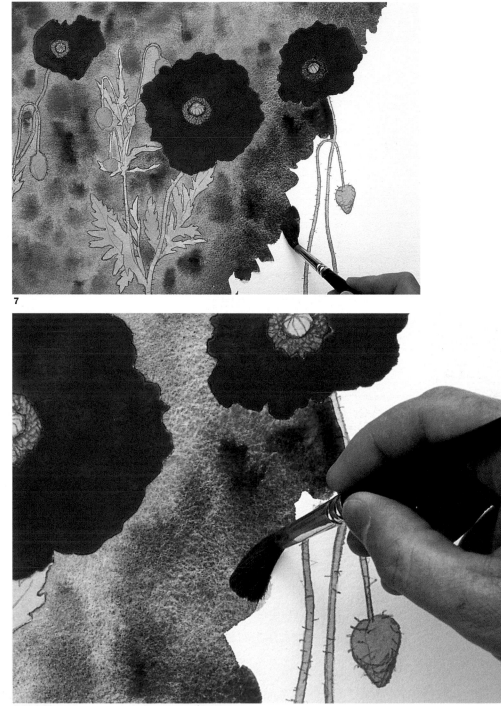

7

7 (detail)

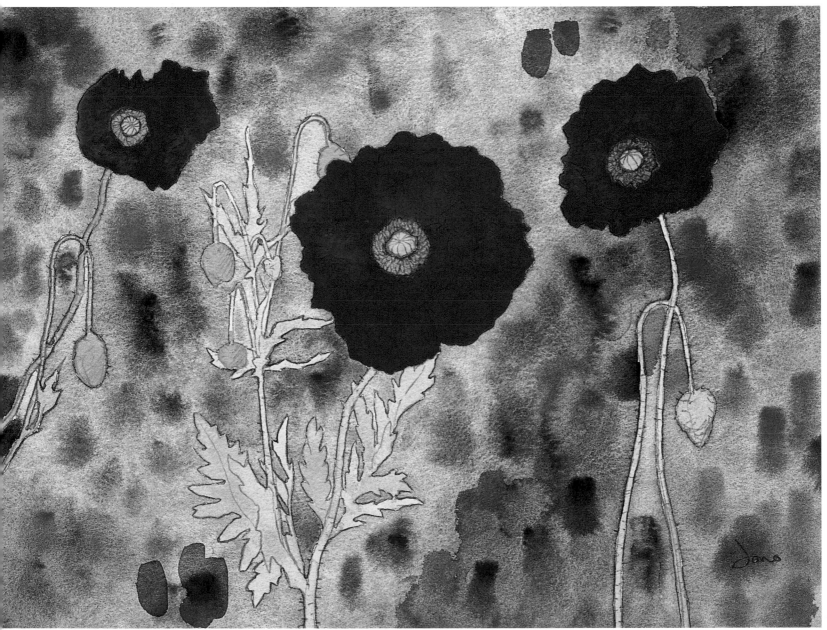

DEMONSTRATIONS

An old bridge at Clayworth
using the methods of John Sell Cotman

MATERIALS

Paper
Cream Two Rivers hand-made 175lbs (375gsm) watercolour paper. Size of work 16" x 11" (40.6cm x 28cm).

Paint
Half-pan watercolours

Burnt Sienna
Burnt Umber
Indian Red
Ivory Black
Olive Green
Phthalocyanine Blue
Phthalocyanine Green
Raw Sienna
Sepia
Venetian Red
Yellow Ochre

Brushes
Sizes 12, 7 and 2 sable watercolour brushes. These relate to the size of the painting. A sable-synthetic mix could have been used in place of pure sable. Only the size 2 was of the highest quality.

Other items
B, 2B and 4B graphite pencils, a sketch book, an eraser, paper tissues, blotting paper, a drawing board and a china mixing palette with deep wells for the prepared washes.

1

1 John Sell Cotman (1782–1842) and his early 19th-century contemporaries worked from drawings done on sketching trips and did not as a general rule paint watercolours on the spot. When applying Cotman's methods in your own work, it is important to re-create a distance from your subject as it will make the simplification of both the design and the colouring, which are at the heart of this method, much easier. You could, if you wanted, use reference photographs, but the beauty of a drawing is that it is already a simplification.

I had taken as my subject an old bridge that crosses the Chesterfield Canal. It probably dates from the 18th century when the canal was built and now has a weathered and aged appearance. As you can see, I drew the bridge in my sketchbook to begin with. This was done on site and I deliberately chose a low, close viewpoint that fills the pictorial space with the bridge and invests it with a certain monumental grandeur. Similar, carefully chosen viewpoints are a feature of Cotman's watercolours.

2 The painting was not begun until some time after the sketch was made. My first step was to transfer the drawing onto the watercolour paper that I was going to paint on. I did this freehand, enlarging it at the same time and deliberately emphasizing the distortions of perspective that my original viewing position had created. You could, of course, transfer by tracing or squaring up.

When using Cotman's methods, the character of your drawing is crucial – it establishes the design of the finished watercolour and, to a substantial extent, governs the way that it is coloured in. Apart from the slight exaggeration of the bridge's shape already mentioned, I remained in most respects faithful to my original drawing. However, you may notice that I have not used any shading in the preliminary drawing for the painting – instead,

2

Dragging the wash with the side of the brush head flat against the paper covers large areas quickly. It also encourages occasional 'misses' that are very characteristic of Cotman – this is where the wash fails to fill tiny parts of the paper's surface. It happens most easily on rough-textured paper, where air pockets can form in the grain. You can see a sprinkling of small missed areas on my painting above the arch and under it on the right.

The size 12 watercolour brush was used to lay this colour. It was also taken along the pathways in front of the bridge and over the stone and brickwork edging of the canal bank. All of this must be done with the work laid flat, fixed on a drawing board. It may help to change your own position or the board's from time to time so that you are comfortable, but the painting should remain flat at all times.

7–8 Cotman's technique amounts to building the image out of blocks of wash, at first side by side and then wash upon wash – allowing the previous ones to dry before you lay the next. Here, the shadow under the bridge and the shadow on the left-hand side of the brickwork were added after the base colour had dried. I used the same wash mixture of Raw Sienna and Venetian Red, adding a little Ivory Black. You must always make up plenty of wash for this technique and in this instance I had enough left over to make the new tone. Traditional slant-well tiles and china tinting saucers are ideal for wash preparation with this method.

As you will recall, all the important blocks of wash were contemplated at the drawing stage, including the contours of the area now shaded. The hard-edged line that tends to form around flatly applied areas of wash such as these when they dry is often quite useful, so it was not removed in this case. It can provide a subtle element of drawing within the painting's surface.

9 It sometimes helps to get all the basic colouring in place so that the image begins to make sense. Before going any further, I covered the areas of grass and foliage along the canal banks with a wash of a dull, muted green. This was mixed from Yellow Ochre and Phthalocyanine Blue. Cotman's colouring was always restrained, so I was deliberately aiming for a dull green – though the greens in his paintings may also be faded.

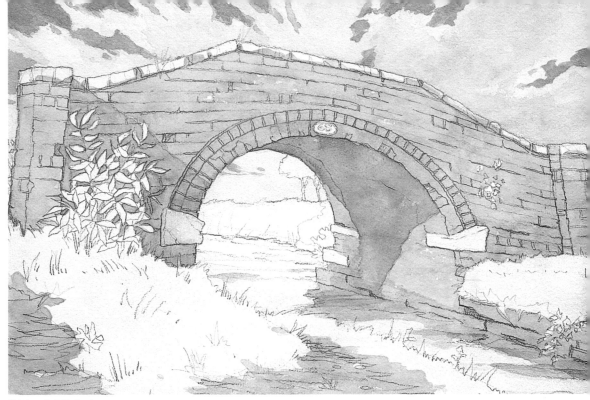

8 (above), 9 (below)

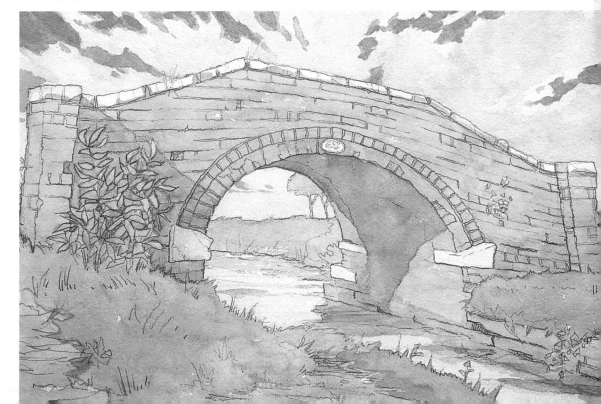

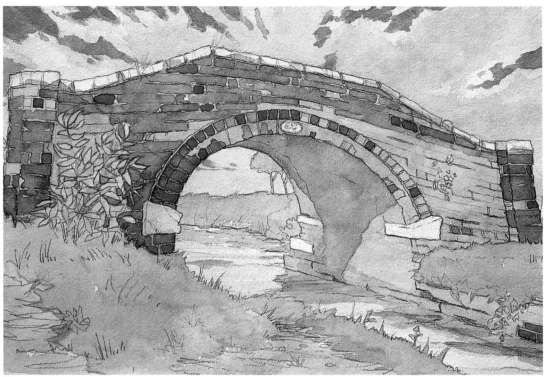

10

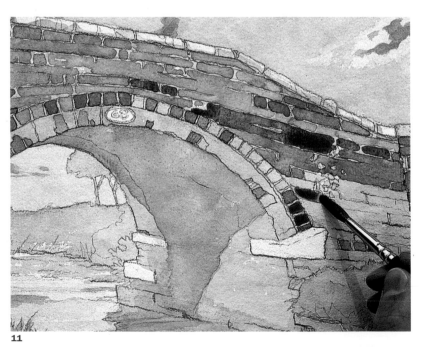

11

10–11 When this was dry, I proceeded to develop the bridge. Throughout this technique you must always allow colours to dry before continuing. You may notice that the first colouring is always done with a light wash, giving scope for further washes in richer colours and darker tones. Now, I worked over the bridge with washes of Venetian Red – a brick colour – placing it into the spaces already determined by the drawing as areas of brick. As these blocks of wash are laid on top of the lower yellow-brown wash, the colour and tonal values achieved are a combination of both. More importantly, in the spaces between these areas of superimposed wash, the lower colour shows through, as intended from the outset, and represents the courses of mortar between the bricks. The laying of one colour over another in accordance with a predetermined plan in order to create such effects is very definitely a feature of Cotman's approach to painting.

You can, however, use your intuition as effects are created. I did not want the bricks to be too evenly coloured, so I introduced variations by using different wash strengths of Venetian Red, mixtures of Venetian Red and Burnt Sienna and by covering the same areas of wash again after the first application had dried, though none of this deviated from the areas determined by the drawing. The size 7 brush was used at this stage, since it was appropriate to the scale of the work.

12 You will find that as parts of your watercolour are progressively worked from light towards dark in this way, other areas will need to be adjusted or progressed further in order to maintain unity. When the brickwork of the bridge was complete, I decided that the shadow beneath it was no longer dark enough, so I repeated it with a stronger and darker wash. This was also taken over the pathways to give them some shape and was used for the shadow's reflection in the water beneath the bridge.

As you can see, the shadow on the left-hand side of the bridge was also restated with a deep wash of Venetian Red and Burnt Sienna – still following the line of the original drawing. A thin warm brown wash was then dragged over the wedge-shaped stones on either side of the arched opening and patchily across the capping stones. After this had dried, the process was repeated.

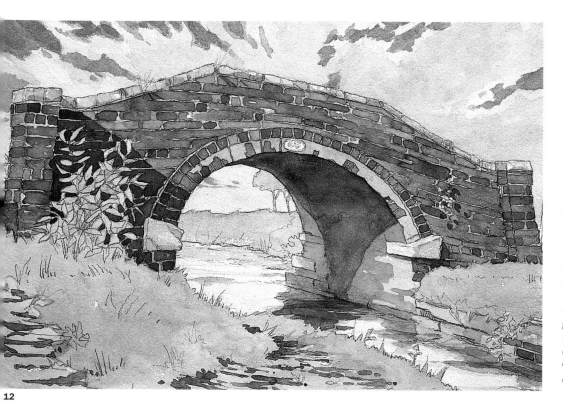

13 There was some indication in the pencil drawing of the shapes within the areas of grass and foliage, but I had not planned the masses of light and shade here very carefully. Consequently, I was obliged to develop these as I painted. Cotman's technique involves the suggestion of detail, rather than its meticulous painting and while I have used some individual strokes in painting the grass, it is mostly the shapes of the areas of tone – their outline edges – that express what is being represented. Some of this has been done by 'subtractive painting', that is to say by using water and blotting paper to remove superimposed dark colour, which creates a shape from the lighter underlying value.

The darkest tones are based on Olive Green, a manufactured watercolour generally made from a version of Yellow Ochre with Phthalocyanine Green or with black. It has the advantage of being gum rich which means it lifts off easily. Manufactured Sap Greens tend to be similar, but may not be permanent. I also made my own mixed greens from Phthalocyanine Blue, Yellow Ochre, Raw Sienna and black, intermixed with each other or with the Olive Green. The different tones of green were also used to make the bushy sapling in front of the bridge appear more real.

Coarse, weathered stone was suggested by small scintillating highlights of missed paper and the rough edges of the resulting two tones of wash.

To complete this stage of the painting, I took a strong wash of Yellow Ochre and Raw Sienna mixed together and applied it to the underside of the bridge, missing some areas of the lower wash close to the bridge opening. The shapes left suggest blocks of stone or bricks beneath rendering. This was only a minor deviation from the pencil guidelines but, as you can see, it does follow the spirit of the drawing in its use of clearly defined shape. You may also notice that there are a few missed areas of paper still showing through the paler tone. It was partly to preserve these that I shaped the darker overlay of wash as I did, since they, together with the different tones of wash, help to suggest a reflection of light from the water's surface, just where you would expect it to be found in nature. The sky is now beginning to make more sense in relation to the rest of the painting.

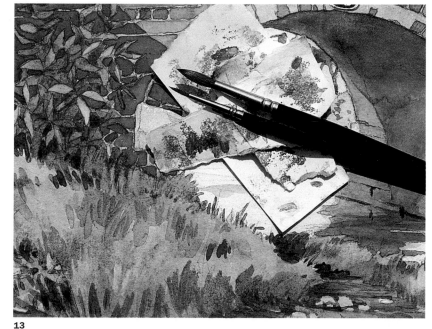

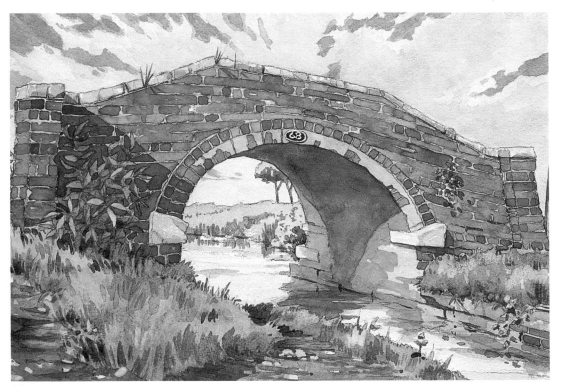

14

The accents of dark shadow close to the water beneath the bridge and immediately in front of it were now completed with the same dark brown wash and other little details like the grasses growing from the stonework along the top of the bridge were put in with green. The bridge number plate, which if you look back at the previous illustrations was already indicated in pencil, was now completed by using Ivory Black to reserve the number and the plate's border from the cream paper.

You might reasonably assume that the painting was now finished. In a sense it was, but the pencil drawing still remained very visible and in one or two places – along the top of the bridge, adjacent to the sky, for example, it seemed intrusive.

15–16 I think it is very likely that Cotman completed his paintings by abrading the entire surface with an eraser. Where a heavy wash lies over the pencil drawing, it will remain in place, but it will be removed from everywhere else. This takes away any harshness derived from the original drawing and introduces lots of tiny highlights between the areas of wash where the separating pencil line has not been covered.

14 (detail)

14 The small, dark bush that can be seen through the tunnel is more typical of Cotman's style – often flatter and more pattern-like than the sapling. See how the profile is made up of shapes like stubby fingers and how the three-dimensional nature of the bush is suggested by the use of separate tones. The basic shape is painted flatly in a mid-toned broken green. A darker tone is then placed on top in an irregular shape that implies areas of shadow within the foliage. You can see a similar use of tone upon tone – the partial covering of one wash with a darker one – on the distant trees.

Stones have also been reversed out from the path by placing wash upon wash around reserved spaces of lower colours. Some broad shadow has been added with a dark brown wash. This was another minor invention, not accounted for in the drawing, but one that made sense given the position of the other principal shadows and it helped to confirm the shape of the foreground. However successfully you have anticipated the way that a painting like this develops, there will inevitably be a few loose ends at the finishing stage where you have to rely on your own judgment.

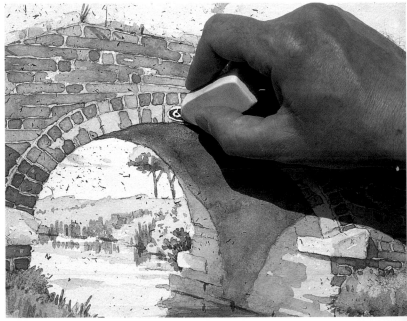

15

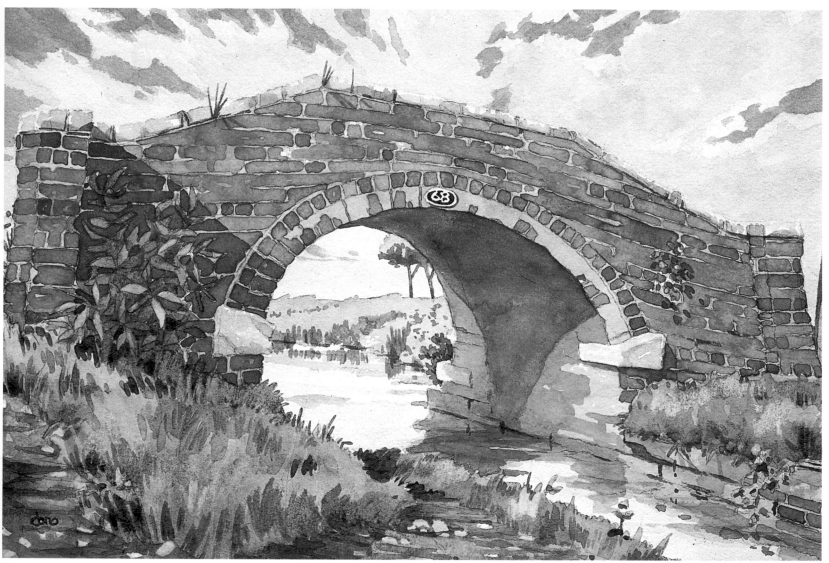

16

This adds a vital spark to the finished painting, which now depends substantially on the rough shapes of the wash edges for its definition.

The difference is most clearly seen by comparing the water's surface and the top contour of the bridge in the completed painting with the same areas at the previous stage. The removal of the pencil lines – at least those that can be removed – creates a stronger sense of light and makes the image seem more real. This finishing process may sometimes remove a little of the colour from the raised portions of the paper's texture too, but this can also contribute to the rugged and lively character of the colouring.

Now that very little of the cream paper remained exposed and the greying effect of the pencil drawing had been removed from it, it seemed brighter and whiter than ever. Look, for example, at the bridge's number plate and at the missed areas of wash in the courses of mortar above it and to the left.

16 (detail)

Elwyn Road Gardens based on the methods of Helen Allingham

MATERIALS

Paper

90lbs (190gsm) Saunders Waterford Series not surfaced (cold-pressed) artists' quality watercolour paper. Size of work 5¾" x 7½" (14.7cm x 19.1cm), but a larger sheet was used to allow for margins around the painted area.

Paint

Tube watercolours

Burnt Umber
Cadmium Red
Cadmium Yellow
Cobalt Blue
Lemon Yellow
Permanent Rose (Quinacridone)
Raw Sienna
Venetian Red
Yellow Ochre

Brushes

A size 7 and a size 4 Kolinsky sable, which was well shaped with a good point. The choice of brushes relates to the size of work.

Other items

A slant-well china slab for mixing washes, a bottle of gum arabic solution, a small drawing board and a portable easel.

Helen Allingham (1848–1926) painted picturesque country scenes, but this painting was inspired by some of her small studies of flowers and fungi. These fresh vignettes – straight from nature – were presumably gathered as studio references. The date and location is often written on them and the parts of the plant being sketched are sometimes identified. These studies would have been used to help add detail to the flower borders and the scenery in her larger and more finished paintings.

For this piece of work I have modified the idea – my subject is a simple view of a flower border, but I have decided to make a painting that is larger and more complex than Allingham's sketches. It is still quite small, though, as you can see from the finished piece, which is shown near to life size. The method used is, as far as I can determine, very close to Allingham's, but my handling in this instance is crisper and less sketch-like than hers.

When I started I had a list of colours that Allingham supposedly used: Cobalt Blue, Rose Madder, Aureolin, Yellow Ochre, Raw Sienna, Sepia, Permanent Yellow, Light Red and Cadmium Orange.

Five of these colours could be classed as yellows, there is no green and just one blue, so all of Allingham's greens, which tend to be bluish grey and ochreish greens, must be composed essentially of combinations of these yellows and the blue.

My palette for this painting was very similar in terms of the colour values used and included four yellows and Cobalt Blue. I have classed Yellow Ochre and Raw Sienna as imperfect yellows, as that is how they behave in mixtures. In an attempt to follow

Allingham's example, I have composed my greens from Cobalt Blue and the different yellows with red or brown earth colours added for darker or more broken values. Many painters do not care for brilliant greens, so some of you may like this method of colouring.

This painting was done from a sitting position with the drawing board almost level on an easel. A small table would have been equally suitable. The low viewpoint across the flower border condenses the image into a pattern-like design.

1 The studies by Allingham that I examined were on a fine-textured, almost smooth paper. I could not find a modern paper that corresponded exactly, so I chose a light-weight not (cold-pressed) paper as the surface texture of the thinner qualities is often more delicate. It is advisable to stretch such papers properly, but in this case I fixed the sheet to the drawing board with masking tape all around its edge – a reasonably effective short cut, equivalent to having the paper mounted on a watercolour block. I saw no evidence of a preliminary drawing

2

3

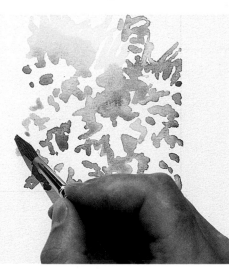

in Allingham's pieces so I didn't do one either and felt that this would ensure some sort of spontaneity. There is no reason why you should not begin such a piece with a light pencil sketch if you are more comfortable working this way.

The opening stage of the painting involved working with washes of broken greens, applying them according to their value as areas of shadow or variable colouring; and cutting out 'reserved' spaces of white paper for flowers and other distinct shapes. The idea was to keep the colour wet and to keep changing the colour on the brush, so that they would mingle with each other as the brush moved on. This would give a variety of tones and colourings as a foundation for the foliage. There is no particular plan or method here, you just have to start somewhere and keep going until the background colouring is complete. As you can see, I started in the bottom right.

2 Unless you are extremely quick, the chances are that some areas of wash will have begun to dry before they are joined to adjacent colours. In some places you may want this to happen as it then allows a shape to be cut from the dried colour by the wet one. I did this just off-centre to give some rough definition to a clump of spiky leaves.

3 I kept painting in the same way until the space was filled. The reserved areas were based on flowers that I could actually see, though obviously I simplified what was in front of me. You must learn to recognize outline shapes and to describe them by using the brush to paint only what is around them, not what is inside them. Do this quickly, otherwise the wet-into-wet fluidity of the surrounding colours will be lost.

So far, I had worked continuously, now I stopped for a few minutes and allowed the painting to dry.

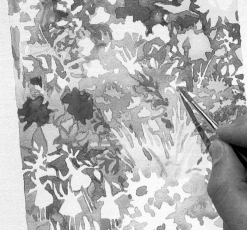

4

4–5 The next stage of the painting was straightforward enough – the reserved spaces were filled in using colours appropriate to the flowers. In one or two places I also added different shades of green for areas of foliage that had been reserved during the first stage. Cadmium Yellow was used pure for some of the flower heads, including the sunflower in the top right. It was also mixed with Cadmium Red to get an orange. Pure Cobalt Blue was used for the hydrangea heads in the background and a thin wash of Permanent Rose was applied to get the delicate pink of the rose and rosebuds on the right. The red roses on the left were an unusual colour, which I attempted to match by mixing Permanent Rose and Cadmium Red. The fuchsias were coloured in with a stronger wash of Permanent Rose. In some places I went over the fuchsias

when dry with a further wash composed of Permanent Rose and a little Cobalt Blue.

As you can see, most of this colouring was done flatly into the spaces reserved. The white roses, the centre of the sunflower and the white gladioli were still left open at this point.

6–7 Next, I added some stronger patches of coloured wash to the flower heads to give them – within their colouring – a sense of light and shade and therefore a three-dimensional quality. Denser washes of the original colouring were used on the pink and red roses. For the white flower heads delicate touches of purple, blue and brown acted, in effect, as colour-tinted greys.

All the remaining definition was done with one colour. Allingham would presumably have used Sepia. I used Burnt Umber, but both are rich, dark

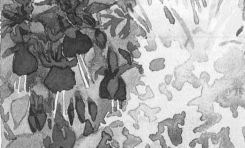

5

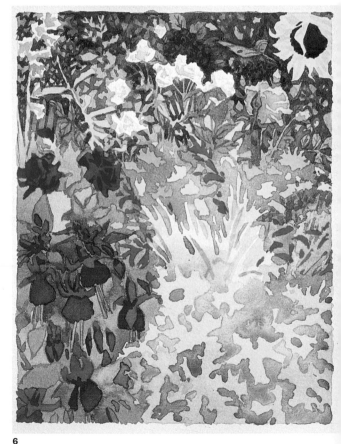

6

browns, so the effect is the same. You should not use it as plain wash, but as a tinted 'glaze'. The colour is added to a mixture of gum arabic and water, which gives a thickened medium that holds the brown pigment above the colour that it is laid on, so it is seen as if through a veil of shadow. The gum arabic also deepens the shadow effect by altering the way that light passes through the colour. You must be careful about the amount of gum arabic you use as it will crack and splinter if applied too heavily. The correct strength will produce a slight, barely noticeable gloss only. This gum-rich shadow tone also manipulates in a different way to an ordinary wash and may easily be placed with precision.

The difference that the layer of shadow makes when it is seen only half applied is obvious. You should begin at the top and work downwards. This avoids the risk of smudging through reaching over areas that are still wet and allows you to see the effect achieved so far, so that each new area of shadow can be related to it in quality. During the process I have added a lot of detail that was either only hinted at in the initial process of colouring or was completely absent from it. Note, for example, the sharpened definition of the stems beneath the white roses and the creation of hydrangea leaves and a cascade of ivy at the top of the piece. This has been done by using the shadow tone to 'cut out' shapes from the underlying colours in much the same way as the areas for the flowers were reserved from the white paper at the beginning.

When the whole of the painting had been shaped in the same way, the work was complete. Here, I have progressed cautiously and ended up with a finely worked image. The defining shadow could, alternatively, be applied in a sketch-like manner, in which case a more relaxed image would be achieved.

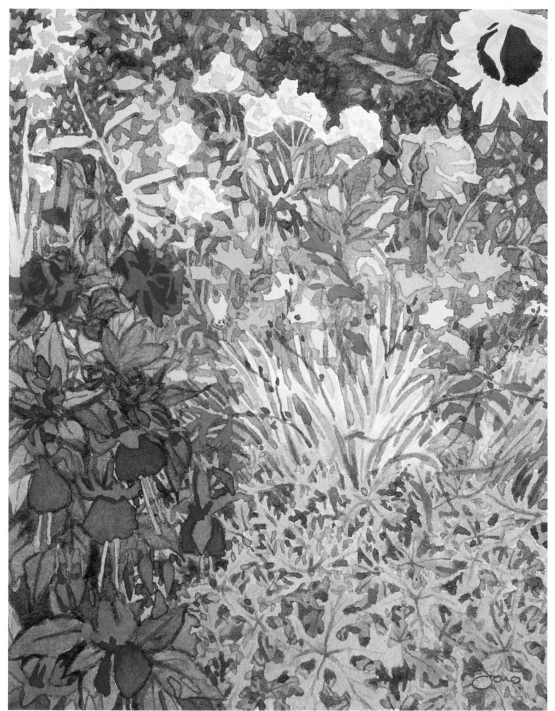

7

DEMONSTRATIONS

Cock pheasant
using the methods
of Joseph Crawhall

MATERIALS

Support
Raw, unprimed, fine artists' linen. Approximate size 23½" x 16" (59.5cm x 40.5cm).

Paint
Tube watercolours

Burnt Sienna
Cadmium Red
Cadmium Yellow
Cobalt Blue
Dioxazine Violet
Ivory Black
Lemon Yellow
Phthalocyanine Green
Raw Sienna
Venetian Red
Yellow Ochre

Zinc White gouache

Brushes
Large and small Kazan squirrel watercolour brushes (mop style) and a size 1 Kolinsky sable for painting, plus an ordinary decorator's brush for sizing the cloth.

Other items
Glue-size solution, a drawing board, drawing pins, a B pencil and studio china for mixing washes.

Joseph Crawhall (1861–1913) mostly painted birds and animals – not as natural history subjects, but as features of country life and sporting activities. His work is not widely known because his output was modest and many of his paintings went straight into the hands of private collectors.

Many of Crawhall's watercolour methods were adventurous and inventive. Here I have used his most distinctive technique – working with watercolours and body colours on raw linen cloth. A similar method was used in the Middle Ages and is also a feature of oriental art. According to his family he first worked in this way when he ran out of paper and borrowed some of the Holland linen that his sister used for sewing. However, two of his paintings in this manner appear to be on a linen-faced sketch-book cover so perhaps this is how he discovered this method of painting.

The cloth must have been coated with some sort of size otherwise it could not have been painted on so successfully, but there is no evidence to show whether or not Crawhall did this himself. One source claimed it was a cloth 'finally dressed in manufacture with the thinnest film of wheaten paste'. In Crawhall's time, stiffened fabrics for use in tailoring and dressmaking would have been widely available and perhaps he simply used anything suitable. The linens that his paintings are on are of different weights and qualities of weave which may confirm this.

Before starting this painting, I conducted some preliminary experiments and decided that hide glue and gelatine were far more effective than wheat starch or other starches as preparations for the cloth. To strain it I pinned it flat to a drawing board, fixing it at regular intervals, and placed strips of card at the edges to lift it clear of the board's surface. You must be careful not to stretch the cloth too tightly as after painting it is cut loose.

The illustration shows the cloth immediately after sizing. As you can see, when wet, linen appears much darker than when dry. This makes painting on it with watercolours inherently difficult. Glue size made up at rather less than the usual strength for sizing canvas seems to produce the desired characteristics. A concentration of one part hide glue or gelatine in 20 parts of water is probably going to be suitable in most instances, but this may depend on the actual cloth. You should let the size dry before beginning to work on your painting.

1 I decided to paint a cock pheasant that, for a time, adopted a part of my garden as its territory. I was able to observe it on several occasions, but I could not make a careful drawing of it because it never came close enough and did not stand still. Instinctively, I just tried to familiarize myself with it by looking. I then made a brief sketch of the pheasant in one of its most characteristic poses, which I roughly coloured with watercolours and surrounded with written notes. By chance I made the sketch on the back of an envelope and subsequently came across this account of Crawhall at work: 'I hardly ever saw him draw direct from nature. When he had to paint a horse, a dog, a goat, or any other animal, a branch in which he excelled all painters of his time ... he would go and look at them for a full hour, with a look so intense it seemed to burn a hole into their skin. Then perhaps but rarely, he would take a pencil or a piece of coloured chalk out of his pocket and, on the back of an old envelope, set down cabbalistic signs or dabs of colour. ... Next day, he might, or he might not, return and gaze another hour, and when one thought he had forgotten all about the animal, produce a painting so lifelike ... that it forced one to regard the animal that he limned [painted] just as he must have seen it forever afterwards.'

From previous experiments I had realized that the opening brush drawing that often seems to feature in Crawhall's work had to be done confidently and

1

2

3

without error. The only sensible option seemed to be to draw first in pencil so that the apparently spontaneous brush drawing was guided into place. I therefore began this painting with a linear pencil drawing based on my sketch and recollections of the bird – I used a B grade graphite pencil directly on the linen. Subsequently, I was not at all surprised to find what appeared to be similar indications in pencil among the paintwork of some of Crawhall's own pieces. You may wish to use photographic references to aid the drawing of a subject like this but avoid becoming obsessed with detail – this method lends itself to capturing the essence and character of the subject through subtle suggestion rather than exact and meticulous imitation.

2 I did the brush drawing with an Ivory Black wash, prepared at a moderate strength so it dried a dark grey rather than an intense black. I used a small squirrel hair brush for this, which had a long fine point. It was held almost vertically to run the wash from its tip much as an oriental calligraphy brush is used, and I aimed for long, confident strokes – this was made easier by the pencil guide. By slightly varying the brush's contact with the surface as the strokes are made you can get a flowing transition from thick to thin. I deliberately exploited this characteristic in an attempt to make the brush drawing expressive. At this stage it is just a simple outline, but it already suggests the physical presence of the cock pheasant quite effectively. You must begin this technique with a brush drawing that works well otherwise the rest of the painting will not fall into place.

3 A professor, who claimed to have corresponded with Crawhall, remarked: 'Matters were further complicated by the tendency of washes to mingle unpleasantly, and by the fact, more apparent in pure watercolour, that when applied they appeared much deeper in tone than when mixed, and when dry, were infinitely lighter than either.'

This is what you see here. My first use of colour involved thin washes of Ivory Black, Raw Sienna and Yellow Ochre used separately and painted over areas of the background to give a preliminary indication of the surroundings. The linen is wet from the watercolour washes and so appears dark.

4

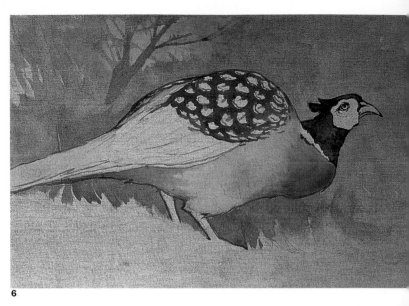

6

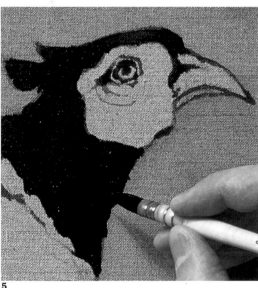

5

iridescent plumage. The colours were placed separately on to different parts of the head and were allowed to mingle at the edges. You may just be able to distinguish between them here, where they are shown wet and again you will see how the darkening of the cloth makes it difficult to anticipate the effect being achieved.

6 I added more colour progressively using strong washes of watercolour and dilute tints of body colour – made by adding Zinc White gouache to watercolour washes. The colours on the breast and underside of the bird were run into each other and in places more colour was flooded onto the wet surface after its initial painting. This produced gradations of colour and tone.

The patterned plumage on the bird's back was indicated with a brown wash. I had to wait until the previous adjacent colours were dry and then thinly applied tints containing white to the pheasant's back and tail. Areas of blue sky were added at the top left using a mixture of Cobalt Blue and Zinc White. These cut shapes from the background tone that suggest a hedge.

7 I painted the pheasant's cheek patch with Cadmium Red and began to add to the colouring with carefully considered additions of body colour. The proportion of white mixed into these tints was greater than before, making them sufficiently

7 (detail)

opaque to obscure the cloth or underlying colours. Some paint was added to the back and tail but mostly I worked on the head. In the enlarged detail, you can see how I used a pale blue and pale green to heighten the dark green and purple washes already in place. Pure white was used for the neck ring and the highlight in the eye. I then restated some of the brush drawing on top of itself in a strong wash of Ivory Black to strengthen the image.

4 This is exactly the same stage of the painting once it has completely dried, which takes an hour or more – this is not a painting technique that can be rushed. See how much lighter it now looks.

5 Once the background washes were dry, I began to add colour to the pheasant. I started on the head using strong washes of Phthalocyanine Green and Dioxazine Violet as a basic representation of the

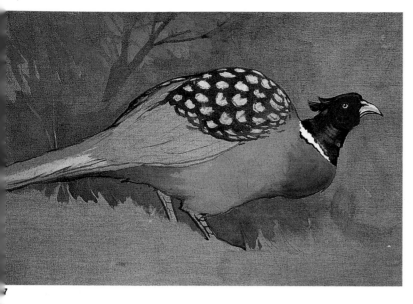

7

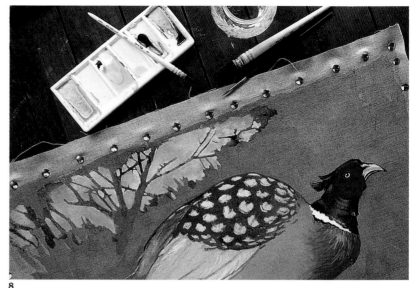

8

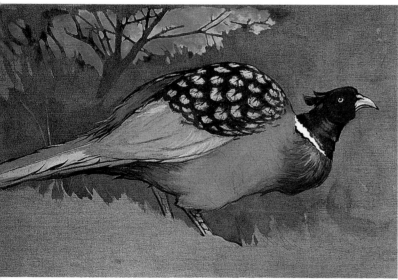

9

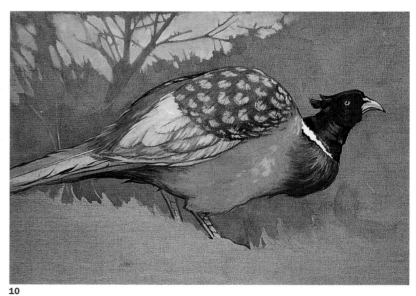

10

8–10 At this point I set out to improve on the effects I had achieved so far and soon discovered that this can be difficult. I began by modifying the sky. I dampened the area being repainted with clean water and then floated fresh tints, similar to the original colouring, over the previous painting. You need to do this delicately in order to limit the disturbance of the existing colour and to add to it selectively. It is even more difficult than before

to predict how this will turn out, since while wet any new colour lying over the cloth appears unnaturally dark, and repainted areas of body colour appear unnaturally light. In fact, I reworked the sky several times with clean water and tints of blue at different strengths.

A pleasantly sloppy unevenness – a fluid patchwork of similar tones – shows in areas of some of Crawhall's paintings. To me this implies

some reworking, most likely a strengthening of the original effect and it suggested the method I have just described.

This painting became increasingly difficult now because the effects I sought were elusive. If body colour sits too heavily on the linen's surface, or if the detail added is too fine and fussy, it simply does not look right, but alterations are not easy. Wiping back with a clean tissue or rag after wetting out with

11

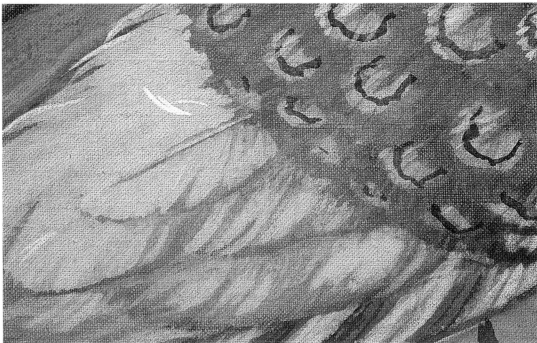

clean water thins the image and allows reworking, but the size layer gets damaged and any new colour is then more difficult to work. This is exactly in accordance with the professor's account mentioned earlier: 'So long as this film remained intact', he said, meaning the size layer, 'the linen presented a slightly absorbent surface very pleasant to paint on, but once this was disturbed it would continue to absorb colour almost indefinitely.'

You can see from looking at illustrations 8 and 9 that at first I added sharp detail to the upper wing, but this was not satisfactory and I eventually wiped it off. I used the residual stain of this painting in the canvas weave as the basis of a more subtle expression of this part of the bird's feathering. I am fairly sure that Crawhall must also have used wiping back to achieve some of the effects seen in his paintings. It is a valuable technique, but you only really have one chance of making it work.

I reworked the pheasant's back between its wings several times. I developed the flight feathers and the bird's legs in grey and added fine strokes using tints of Venetian Red and some broad patches of yellow to the pheasant's breast. Notice the soft highlight just below the neck ring and observe the difference made by the white highlight on the tail feather.

11–12 The finishing process was mainly a matter of adding delicate highlights in white, cream and yellow and dark patches to the plumage in black, and of restating the brush drawing, also in black. I added a little extra detail and patterning to the background too in order to define the pheasant's relationship with its surroundings. One of the methods I used was to let overfull droplets of wash dry slowly onto the cloth. Again, I based this on an effect I had seen in Crawhall's own work.

In the enlarged details you can see how thinly this piece is actually painted. The weave of the cloth is hardly suppressed at all. You can also see the different qualities of the colouring and the extent to which much of the definition depends on tonal arrangements.

To summarize, this technique begins with a clean brush drawing followed by a skilful use of the ground. Areas of the linen cloth are left untouched or are delicately toned with washes of transparent watercolour. Shadows and half tones are conjured up by these means. Lighter, lustrous half tones are achieved with thin, fluid, translucent passages of body colour, its firm use being reserved for

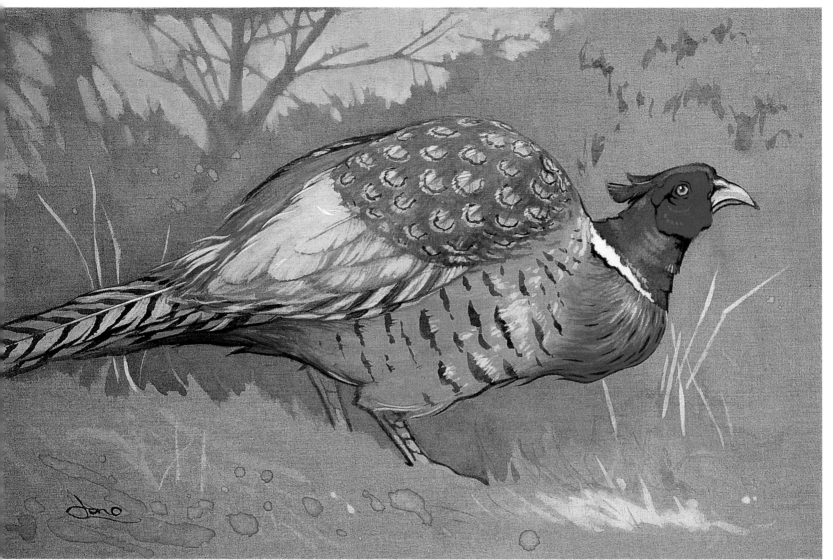

12

highlights and strong definitions. Heavy applications of body colour are kept to a minimum and ideally are not used at all.

Realistically, you should expect each painting to be different because it is so difficult to predict and control the precise outcome of this method. The relative use of the possible effects also varies from painting to painting according to its subject and the successes and difficulties experienced while painting it.

Based on this experience and having used this method again, I think with this technique you reach a point when you know that it is better to stop rather than carry on – the work is then finished whatever its actual state of completion. In one of his letters Crawhall refers to works being 'nearly complete, i.e. out of danger'. It is a sentiment you will recognize when applying his methods. Above all, this technique demands patience and steady nerves.

DEMONSTRATIONS

Ivy leaves and wild flowers with a white jug and cup inspired by Gwen John

MATERIALS

Paper
90lbs (185gsm) Whatman watercolour paper with a rough surface. Size 15" x 11" (38cm x 28cm).

Paint
Half-pan watercolours

Cerulean Blue
Cobalt Blue
Olive Green
Permanent Rose (Quinacridone)
Terre Vert
Viridian
Yellow Ochre

White gouache from a tube (you could also use Chinese White from a watercolour range)

Brushes
A size 10 sable brush was used throughout the painting.

Other items
A graphite pencil, a drawing board and tape to secure the paper around its edges.

Gwen John's (1876–1939) watercolours can be delightfully fluid, sometimes looking as if they have formed miraculously from a chaotic pattern of wetness, rather than having been painted. They are often quite small and may employ translucent body colour rather than transparent wash, but the manner is always loose.

This is not a detailed attempt to reconstruct her methods, but is rather an example inspired by her work. It shows how visually soft and seemingly uncontrolled images can be coaxed from the materials. 'In Brittany at night', she wrote, 'I used to pluck leaves and grasses from the hedges, all dark and misty and when I took them home, I sometimes found my hands were full of flowers.'

1 This painting evolves as the result of a continuous process and cannot, in practice, be separated into stages. It starts with a deliberate lack of control induced by the use of wet paper. I chose a soft-sized watercolour paper for this example because its specification made it very absorbent, allowing wet-in-wet working to continue for some time.

To begin, a very light, loose and simple outline sketch was made onto the dry paper in pencil. Then the paper was wetted thoroughly and taped all around its edges to a board. Painting began immediately with the paper in this sodden state.

At first Cerulean Blue and Permanent Rose were applied separately to background areas. You should use the brush to feed the wash onto the paper in a series of light strokes and touches. The colour runs from it onto the wet surface and spreads. You can and should place colour intentionally, but you will have no exact control over it.

2 With the paper still in this very wet state, I introduced greens, placing them with a delicate touch where leaves were shown in the pencil drawing. The colour, of course, spreads in a random way, but not all of it migrates and newly introduced washes tend to push against the ones that are already there, creating their own softly defined spaces. You should, incidentally, work with your paper flat, so that there is no tendency for the wash to run in any particular direction. This also limits the extent of the colour spread. Some dabs of Cobalt Blue were added at this stage too, together with some stronger touches of rose-coloured wash. You can see the beginnings of the wild flowers.

As you work, the condition of the paper changes from being surface-wet to wet; then, gradually, it becomes semi-dry. As this takes place, the way in which the paper takes the wash and the way the colour spreads alters. Exploitation of these processes provides the element of control in this otherwise uncontrollable method of painting.

3 I continued to paint on the leaves, using different values of green. With each stroke the point of the brush lightly touched the paper, allowing wash to flow and push outwards from the brushstroke, but it no longer ran as far because the paper was not quite so wet. This meant that vague patches of definition emerged. As time went on parts of the paper became merely damp rather than actually wet and began to hold a more definite, though still quite fluid, edge. You can see this beginning to happen on the top right where the ivy leaves and their stems are holding their shape.

Always work with a full brush to avoid making too exact a mark. You can continue working wet-in-wet within areas that you have recently painted, even as the paper dries. For example, some white has been touched into the greens of the ivy leaves and has not spread beyond them. This is because, while the greens are still wet, the surrounding paper has now become dry.

1

2

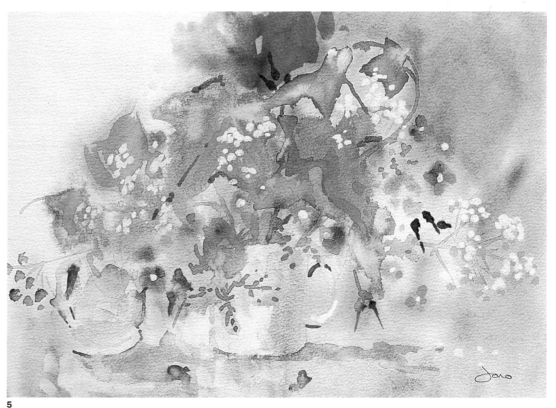

3

A white highlight was also placed on the jug handle beneath the leaves and white was taken over the top left of the painting, covering some of the random spread of green from an earlier stage and cutting shapes out of it – tentatively increasing the definition. Here, the background is white, so white has been used, but you could use an opaque version of any background colour. Dabs of white and a few touches of pink, green and blue were used to complete the work. The paper was by now effectively dry.

This method leaves a great deal to chance – you are attempting to provoke and capture random effects which must then be coaxed together into an image that works without losing its soft ethereal qualities. Knowing when to stop is a matter of fine judgment. I have left this demonstration piece as it is, but it could perhaps be improved by altering its shape and size. Cutting down a watercolour is always an option and with this loose method it may often be worth considering.

4

4–5 As all the paper reaches a semi-dry state, it is possible to place more marks with greater certainty, though they still result in an attractive inexactness. I redefined the ivy leaves on the left at this stage and used darker greens to add drip-like detailing around the centre of the posy. I dabbed petal shapes onto the blue flowers and gave them white centres.

5

Figures in a cornfield
using the methods of Richard Parkes Bonington

MATERIALS

Paper
140lbs (300gsm) not surfaced (cold-pressed) Arches Aquarelle watercolour paper. Size 7½" x 4¾" (19cm x 12cm).

Paint
A pocket box of tube watercolours

Cadmium Red
Cadmium Yellow Deep
French Ultramarine
Ivory Black
Lemon Yellow
Viridian
Yellow Ochre

Zinc White gouache from a tube

Brushes
Sizes 1 and 7 sable brushes.

Other items
Gum arabic solution, a graphite pencil, a small drawing board and masking tape to secure the paper.

1

A small work by Richard Parkes Bonington (1802–28) inspired me to paint this piece. I was intrigued by the number of different techniques that he used naturally and effortlessly in a work no larger than a postcard. My scene, like Bonington's, shows a field of standing corn, with a red roof among trees in the background.

In his best work Bonington used a variety of techniques within a single painting. In *Cliffs near Branscombe* I also applied his methods, but there I did not use the same technical mannerisms or the same paper – hence the difference.

1 This painting is small, which is typical of Bonington. The paper he used often had a surface quality between that of a modern not (cold-pressed) and a hot-pressed paper. There is no exact equivalent today and in this case I opted to use a not surface. You may wish to compare the results with *Cliffs near Branscombe* which is on hot-pressed paper.

I asked my daughters to be the figures in the field, and sat on a bale of straw to make my drawing. My view of the subject is shown in the photograph. I did a quick pencil sketch as a starting-point for

2

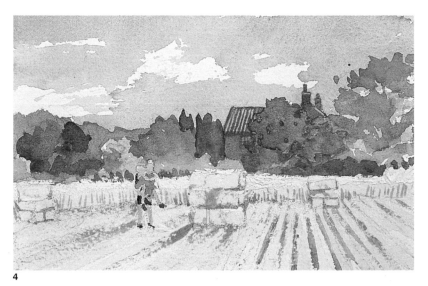

4

the painting. As you can see, it is a light and simple guide for the brush, not a complete and exact drawing. I secured the paper all around its edges with masking tape.

2 Bonington appears to have dragged his brush on its side. This creates scintillating highlights because in places the brush misses the paper as it skims across it. Using a size 7 brush, I applied a wash of French Ultramarine to the sky in this manner. You can see, especially on the extreme left and right,

3

the ragged edges of the clouds that have resulted from this dragging of the brush. In fact, almost everywhere the edge of this wash is rough. This suits the character of the tree line and along the roof it does not matter since a sharper edge can be overpainted with a darker colour. Note the dark run in the top right-hand corner where the blue wash has flowed back onto an already dry area.

Next, I used a Yellow Ochre wash over the cornfield – again I dragged the brush, but this time I pulled it in the direction of the rows of corn, so that the missed areas of paper contributed to the sense of perspective. At this stage, I had left reserved areas – untouched parts of paper – for the house, the background landscape and the figures.

3 I added the trees and hedges with mixed greens derived from various combinations of Yellow Ochre, Viridian and French Ultramarine. Again, the brush was used obliquely to promote roughly broken areas of wash. This suggested clumps of foliage and the gaps between them. Note that each colour has been placed when the adjacent ones were dry – this prevents one colour running into another, but also makes possible the effect that you see immediately in front of the house, where the wash edges overlap.

I used an orange-brown wash with a size 1 sable to flick a few suggestions of detail over the cornfield. The previous wash was dry when this was done. The house was painted with a terracotta-coloured wash to which some extra gum arabic had been added.

This gives the colour a richer quality, but more importantly it slows its drying rate, causing it to become thick and sticky before it is completely dry. At that point, inspired by Bonington, I scored through it with the handle of the brush to reveal the paper underneath and to imply a pantile roof.

4 Bonington had applied a rough white underpainting to his cornfield to give it texture and had then glazed over it with colour. This is really an oil painting technique, daringly translated into

4 (detail)

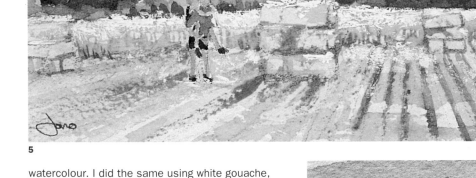

5

6

7

watercolour. I did the same using white gouache, at tube consistency, put on with a slightly damp brush. You can see the effect very clearly in the detail. I applied this highlighting in specific areas and confined it to the cornfield.

5 When the white was perfectly dry, I took a watery wash of Cadmium Yellow Deep over it and let it collect in the surface texture. You must do this at a single touch – otherwise the white will dissolve and spoil the effect. Adding some gum arabic to the superimposed wash may improve its glaze-like quality, but I did not do that here. The same yellow wash was taken over other parts of the cornfield to enrich and unify its colouring. Bonington might have sharpened the figures with some brush-point drawing, but I chose not to and, considering the work complete, I signed it.

6–7 A day later I decided that this painting could be improved upon. I did not like the dark furrows on the right of the cornfield and realized that I had not made full use of Bonington's techniques. To subdue the furrows I repeated the process of using opaque white paint glazed with a wash of colour. Stiff white

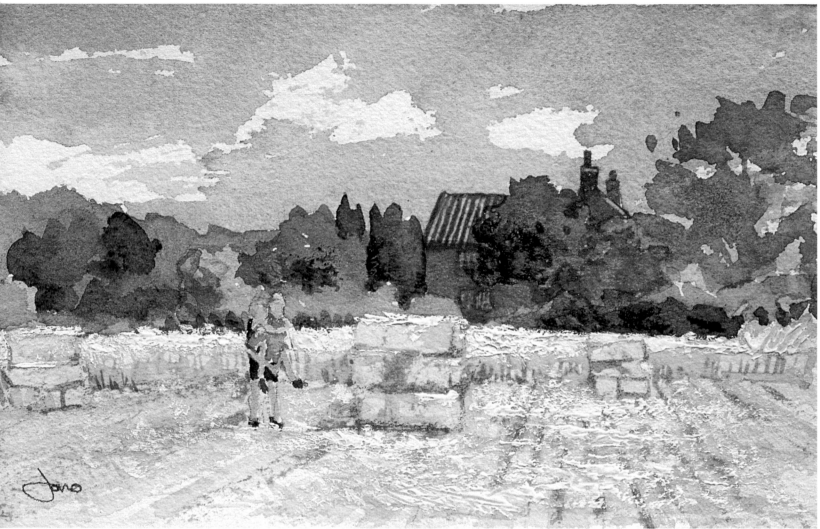

8

gouache was dragged over the foreground and coloured with Cadmium Yellow Deep as before. This suggests a scattering of straw and stubble and detracts from the unwanted lines.

I also decided that the background lacked depth. Bonington had placed a gum-rich shadow on a tree in his painting – not a unique practice – but he had apparently used his finger. I did the same with a sticky dark green wash heavily enriched with gum arabic. A slight manipulation of this on the paper's surface with my finger tip created differential thicknesses and therefore variable

shadow tones. Traces of my fingerprint also added character and detail to the shading – both Bonington and Turner were well aware of the possibilities of this technique.

I also added gum-rich shading from a brush and on the blue-green trees behind the house scraped into this before it dried using the brush handle. The coloured gum coating on the house was softened with clean water and the lower window was scratched into it by the same method. This is visible on the enlarged detail – you may also notice the tiny bubbles that typically occur when gum is used.

8 The finished painting is shown a little bigger than life size. If you look at the top right-hand corner you will see that the dark blue wash line has been removed. I did this by brushing on clean water and then blotting off the excess pigment with tissue. By leaving this until the final stages of completion, I ensured that the more delicate areas of wash that surrounded it had dried into the paper, making them less likely to be removed accidentally.

DEMONSTRATIONS

Children on the sands based on the methods of Laura Knight

MATERIALS

Paper
300lbs (638gsm) not (cold-pressed) surfaced Saunders Waterford watercolour paper. Size 15" x 11" (38cm x 28cm).

Paint
Tube watercolours

Burnt Sienna
Burnt Umber
Cadmium Red
Chinese White
French Ultramarine
Ivory Black
Lemon Yellow
Permanent Rose (Quinacridone)
Viridian
Yellow Ochre

Brushes
Sable watercolour brushes in sizes 10, 7 and 4; the 4 had a very fine point.

Other items
A graphite pencil and a drawing board.

Laura Knight (1887–1970) often painted children on beaches, or in and around seaside villages. I had studied several of her skilful and sketch-like watercolours and worked as I think she would have done, but I was probably slower and more cautious, hence the crispness of the resulting image. If you want a more spontaneous-looking effect, you just need to accelerate the same process. Knight seems to have worked quickly, at least when painting this sort of watercolour, but the subtle simplicity of some of her larger pieces may conceal the effort that went into them.

My daughters did not specifically pose for this painting, but stayed more or less in the same places, although not actually still. Painting a moving subject is not as difficult as you might imagine – the trick is to build a composite image out of numerous momentary observations. It is easier if, as here, the movements are limited in scope or if postures are repeated. Working directly from life, especially where figures are involved, usually promotes a freshness and a truthfulness that conveys a feeling of reality, even if the actual result is far from accurate in its detail. You may find it a challenge to work this way at first, but with practice it is easily mastered.

Knight was a superb draughtswoman, but there is not much evidence of preliminary drawing beneath her brief watercolours. There are some traces of pencil sketches – just a few lines to indicate shape and position, but I did not feel confident about attempting this piece without a guiding drawing, so I did a light outline sketch in pencil. If you also begin with a drawing, keep it simple and try to avoid being heavy handed.

1–3 I started by broadly laying in the essential colours and rendered them as high-key translations

1

2

3

of the actual colours observed – a method that comes originally from Impressionism.

Firstly, I applied a wash of Yellow Ochre to represent the sands, straw hats and mats. To achieve a lighter tone on the hats and mats I diluted it on the brush by picking up clean water. The wash in the background was laid with heavy horizontal strokes, each delivered with a flick of

3 (detail)

4 (detail)

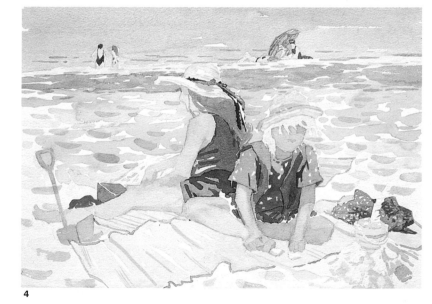

4

the wrist to give it a slight curve. These, combined with the patches of white paper between them, suggest the sand churned by footprints. I also left irregular gaps of white paper between the broad wash strokes of the Yellow Ochre placed on the children's straw hats and their beach mats to help convey the idea of bright sunlight. I did all this very quickly using a size 10 brush.

Next, I placed medium strength washes of blue and red to depict items of clothing. Again, I left patches of white paper, although this time I did so more carefully. I used the paper to represent the pattern on Sophie's red top, the ragged edges of her cut-off denim shorts and the highlights on the folds of Amy's waistcoat. I placed a much more dilute wash of the same French Ultramarine blue that I had used for the clothes over the sea, which appears at the top of this painting. I left white spaces for the figure groups in the background and in a quite random way between the horizontal strokes of blue to imply wave crests. I then flicked a mixed purplish grey wash across the background to show a darker strip of sand.

The basic colouring was completed with a wash of Ivory Black – used dilute to appear grey – with washes of brown and Lemon Yellow for the hair, a dilute earthy orange for the flesh and more washes of red and blue. I applied thin strokes of Viridian from a brush point for the binding at the edges of

the straw mats and used the same colour on the beach umbrella in the background. As it was a warm day the colours dried quickly and I was able to define shapes by means of wash edges. You can see this very plainly in the enlarged detail.

4 The second phase of painting followed immediately after the first. The colours in the two

layers and those put next to each other did not mingle because of the rapid drying. This time I used the same or similar colours, but at a much stronger concentration, making the washes deeper in tone. Most of this shading was done with a size 4 brush.

I used the new washes to shade the original colouring and so developed shapes from it. For example, I restated part of Sophie's t-shirt in a

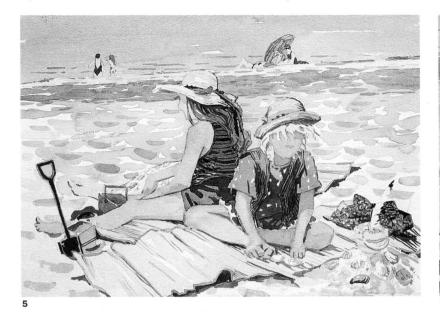

5

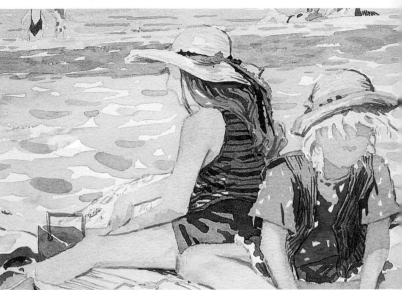

5 (detail)

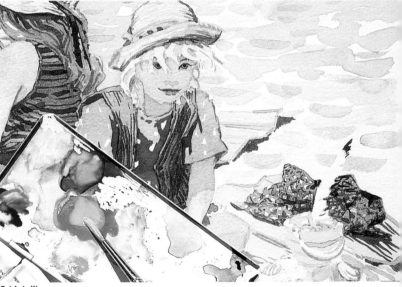

6 (detail)

rich rose red; I added folds on Sophie's shorts and on Amy's blue waistcoat with a deeper tone of blue and placed the shadow and folds of Amy's beach skirt with a dark toned wash of Ivory Black mixed with French Ultramarine. Two tones, one darker than the other, were laid over Sophie's waistcoat for maximum effect. The enlarged detail shows this in progress and in the full view you can see the sequence of shading completed. The original wash, you will realize, now represents the lightest tone – the painting is progressing from light to dark.

During this stage, I scattered some more flicked-down strokes across the background sands, using pink, blue and purple. Note that where they lie over the Yellow Ochre they appear brown, green and grey. In relation to what was already there, they look like gentle shadows that further confirm the idea of much walked on sand.

5 With this technique the last stage is adding suggested detail. I did this with sharp accents of deep-toned wash put down fluently with a fine-pointed brush and used colours that were appropriate to each area of the subject.

Some of the painting I did at this final stage was simply the addition of detail – for instance, the stripes on Amy's top – but the marks I refer to as accents are more complex in their meaning. They are likely to be fragments of outline or small –

sometimes quite tiny – areas of shadow. It is what they imply rather than what they show that matters. For instance, the few lines of brown I added to and around the straw hats make them look both more solid and real and hint at the structure of the interwoven straw. Note how effective the very dark stroke beneath Amy's hat is. I applied the same brown shadow tone

to Amy's hair and used it to suggest the texture of the straw mats. On the hair I added a complex and finely shaped shadow, which suggests the flowing tresses and even the individual hairs, although these are not actually shown. I also used black at this stage to depict the texture of Sophie's waistcoat and to add the black tip to the seagull's feather on the right. The feather is, in

act, just a plain patch of white paper defined by the surrounding washes.

I added a patch of strong French Ultramarine wash to the blue beach bucket on the left to express an interior shadow. This accentuated the form and made the sand in it stand out. I accented the figures with Burnt Sienna and placed the shadows beneath the mat in Burnt Umber.

6 You should not expect a perfect outcome from this sort of watercolour painting. Minor errors and omissions are bound to occur and correcting them is part of the finishing process. In this case, I made a very limited use of body colour – I added the pale blue of Sophie's eyes to obscure the existing flesh tint and used the same mixture of blue and white to improve the highlighting on Amy's waistcoat. I also

painted Sophie's lips in body colour and used an opaque pink tint for the handle of the blue bucket. I used pure white for small, but important, highlights on the hats and for the bucket handle next to the spade and the stick being held by Amy.

I also added a seagull in body colour to the background of the painting. This covered a blemish in the pale blue wash of the sea.

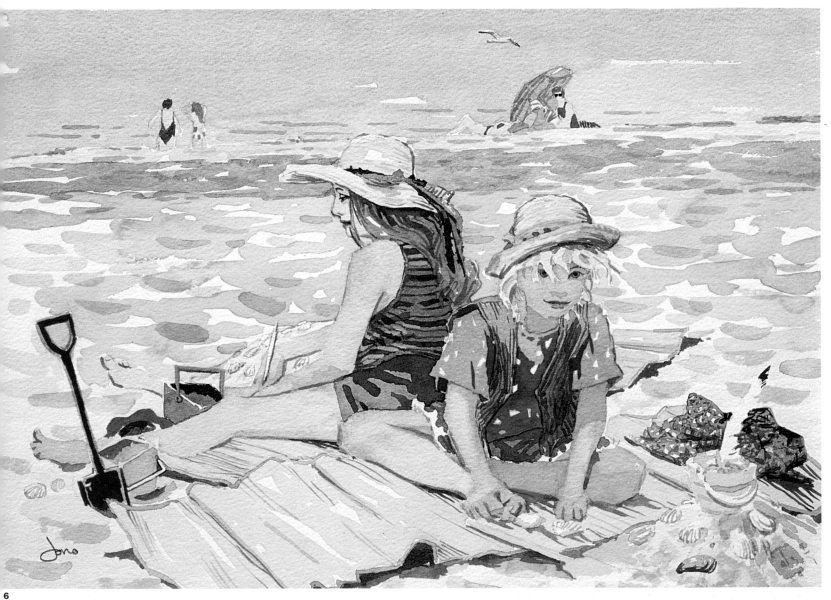

3

DEMONSTRATIONS

Summer apples using the methods of William Henry Hunt

MATERIALS

Paper
140lbs (300gsm) not surface (cold-pressed) Arches Aquarelle watercolour paper. Size of painted area 7½" (19cm) in diameter.

Paint
Tube watercolours

Burnt Sienna
Burnt Umber
Cadmium Red
Cadmium Yellow
Chinese White
Cobalt Blue
Lemon Yellow
Permanent Rose (Quinacridone)
Phthalocyanine Green
Raw Sienna
Venetian Red
Yellow Ochre

Brushes
Three watercolour brushes – a size 6 in sable, a size 4 in a sable-synthetic mix and a size 1 Kolinsky sable, plus a ¾" (19mm) one stroke brush in synthetic hair. Miniature painting brushes are also suited to this technique, but were not used here.

Other items
HB and 2B graphite pencils, a pair of compasses, a small drawing board and studio chinaware for mixing up washes, although the mixing wells and palette area of a good watercolour box should be just as suitable.

1

2

An account of William Henry Hunt's (1790–1864) watercolour method is given in Part 2. His immaculate studies of birds' nests, spring flowers or fruit are almost invariably set against a background of earth – apparently the base of a hedgerow or the bottom of a wayside bank. Hunt's paintings suggest strong outdoor light, implying that they were done directly from nature, but the effort that must have gone into them – the detailed observations, careful composition and time-consuming method suggest that they are essentially studio works. It seems therefore that he must have painted close to home.

I arranged my subject – the apple-tree twigs with their yet to ripen fruitlets – against a clump of earth in my garden. It is likely that Hunt's settings were similarly near to his studio. You can even create a setting for a nature study like this from a clod of earth and a few dead leaves on a tray.

1 I decided to work on a fine-grained not (cold-pressed) surface, but could just as easily have chosen a hot-pressed one. The build up of paint on Hunt's watercolours makes it difficult to assess the paper's surface, but I know from experience that both types are suitable. A smooth paper favours a fine finish, although it can encourage excessive sharpness, while a slight texture seems to assist the build up of colour and helps the potentially thick – by watercolour standards – accumulation of paint to adhere.

I decided to make my painting round as Hunt sometimes did and began by marking out a circular boundary for it using a pair of compasses. I did not stretch my paper as it was reasonably substantial, but later realized that the use of a white margin, as here, may result in the differential shrinkage of the painted and unpainted areas. A moderately effective remedy in such situations is to shrink the blank spaces to match the painted ones with clean water, if necessary taping the edges first.

3

4

2 In Hunt's works the drawing is not visible, but it seems inconceivable that he did not start with one. It is up to you whether you begin with a light positioning sketch, or make a firmer and more detailed drawing as I have done. My drawing had a firm outline and some distinct tone, which anticipated the next stage of this painting.

You must remember that flowers, leaves and fruits do not last long and it makes sense to capture them fully at the outset – the leaves on these branchlets

had, in fact, wilted by the end of my first session of painting. Once the drawing is done, the painting can be completed even if the subject begins to change.

3–4 When your drawing is finished you should cover it with an overall ground of Chinese White (Zinc White). Its covering power is limited, so the drawing remains visible through it and can still be followed carefully as colour is applied. It will be easy to eliminate from view as the painting evolves.

It is reasonable to assume that Hunt began his works in this way, though possibly his initial use of white was more specific. What is significant is that the white is laid first. Here, I put the ground on in two layers to achieve an even covering to the desired degree of opacity. It is very important that this white should be absolutely dry before any further work is undertaken.

5 I decided to start on the background, so I prepared some quantities of wash and began to work up the colouring. For the clay soil I applied Raw Sienna and Burnt Sienna separately. Traditionally, these are regarded as the most transparent of the earth colours. In this instance they also happened to offer an approximate match to the actual values observed.

The essential principle throughout this method is that the colours, in the form of transparent washes, are laid over a brilliantly reflective background of Chinese White. This makes them appear unusually rich and luminous. The colours must remain transparent and so should not mingle with the Chinese White. To achieve this you have to place a dab or a short stroke of pure colour – prepared as a strong wash – at a single touch and lift the brush away immediately so you do not retouch the area just moistened. When perfectly dry, the surface of the Chinese White is not immediately disturbed by a fast and confident stroke. If the brushstroke is too slow, or if the brush agitates the surface too much, or if it is already softened by the moisture of a previous touch, it will give way and the effect will be lost.

My use of separate strokes is very obvious at this first stage of the colouring. They are applied using glancing dabs from the tips of wet, but not overloaded, brushes and are roughly oval in shape. As you can see, they are placed next to each other, often with gaps in between. These gaps are eventually filled by further strokes that

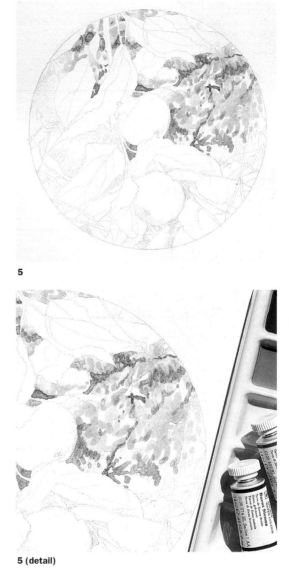

5

5 (detail)

may overlap the already dry adjacent ones. The slight granulation of the colour in places is probably due to the absorbency of the white ground.

It is not possible to lay large broad flat areas of colour using this technique. My opening strokes of Raw Sienna are as large as I dared to make them – I used a size 6 sable brush. The Burnt Sienna was used for preliminary indications of shadow and detail and has been applied in smaller strokes. This was done with a size 4 in a sable-synthetic mix.

3 DEMONSTRATIONS

135

6

6 (detail)

7 Next, I added an intermediate layer of Chinese White. It brought out highlights that would eventually be quite subtle, but at this stage the modelling with white looks stark and strange. To get the right effect for the soil I worked with quick simple touches as before, but this time I dragged the brush in glancing strokes to get rough, scintillating scumbles of white as well. Close inspection of the backgrounds of Hunt's own paintings often reveals the same technique. To do this successfully, the white needs to be fluid enough to paint with, but thick and creamy enough to be opaque, so the use of water has to be judged very carefully.

I also used Chinese White to redefine unpainted areas where colour washes had overlapped contours or partially obscured fine detail. Some extra, exceptionally fine details like fibrous roots sticking out of the soil were added with it too. Correcting and modifying with white like this is a recurrent step in this technique.

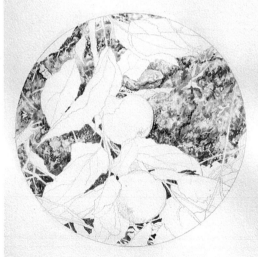

7

7 (detail)

8

6 Little by little I covered all of the areas representing the earth in the background with adjacent and overlapping strokes of the two Siennas. This produced a mottled film of these washes which already contained the beginnings of detail and form. To develop this further, I began using Burnt Umber as well as Raw Sienna and Burnt Sienna in a second layer of colouring that refined the first. The Burnt Umber provided deeper shadow accents, while the overlaying of more

Sienna – Raw and Burnt – enriched and extended the range of tones. Again, swift, single-touch strokes were needed to avoid disturbing the white or the previous colouring. This time the size range was smaller and I placed the washes in dots and dabs that gradually refined the image. You can see this clearly in the enlarged detail. Incidentally, this technique is easier when it is warm since previous touches soon become dry and are less likely to be disturbed.

In the detail you can see thin scumbles of white very clearly to the right of the apple. On the left, Chinese White has been used to reinstate the top of the twig and add a blade of grass between two of the leaves. The fibrous roots that remain visible in the finished background were finalized during a partial repetition of this alternate use of white and colour. The same method was used, but with increasingly minute brushstrokes, to gain the finer finish seen at subsequent stages.

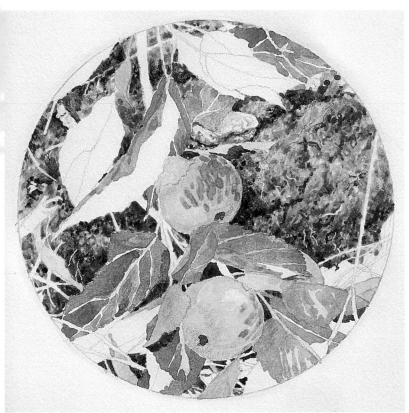

9

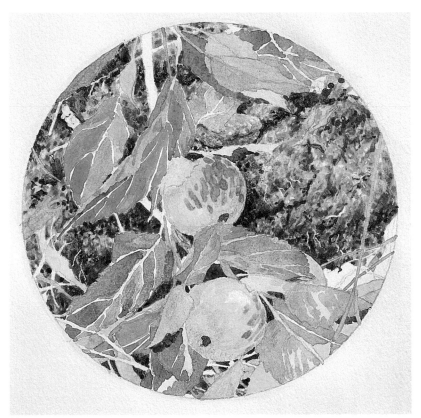

10

8 When the white highlighting and corrections were totally dry, I was able to complete the background by going over it again using the same washes of Raw Sienna, Burnt Sienna and Burnt Umber. This time I placed them with an even quicker and lighter touch than before. It is vital that the lower layers and the interleaved white highlights are not disturbed. The new colouring should sit over either or both transparently, since you want to be able to see through both of them. If you compare the final stage of the background with the quality of its painting before the white highlighting was added, you should be able to recognize the increased subtlety within the tonal range and the delicate modelling that this method produces. Perhaps you will also be aware of the increased sense of texture that it has given to the soil.

Note the stone embedded in the soil above the top apple. This has been worked in the same colours as the soil, but is not yet complete. Its final white highlighting needs to be finished with

a different-coloured wash. Observe also that while the background has been completed, the principal objects in this painting remain as white blanks. This seemed a natural and logical way to work. Hunt must have thought the same because there is at least one unfinished piece of his that exhibits the same pattern of working.

9–10 I used the same basic method for the rest of the painting, but with appropriate colours for the subjects that remained – the apples on their branchlets and the bed of dead leaves and grasses that they were on. My selection of watercolours was expanded accordingly. I mixed a variety of greens for the foundation colours of the leaves and applied them at wash strength over the Chinese White ground in a sequence of preliminary colouring, partly guided by the drawing and partly by referring to the subject.

My method differed slightly from the one I had used in earlier stages – firstly, I varied the wash

strengths by adding more water and intermixed them to achieve different intensities of colour and tone. Secondly, I did not put them on, initially at least, in the same manner. The opening patches of wash on the leaves were done with the brush held at a slight angle so that it set down a wide line of colour when brushed with a sideways stroke. By moving the brush away from its starting point, in a series of parallel strokes, each touching and barely overlapping the edge of the previous one, it is possible to work quickly and cover an area fairly evenly. Brush loading is of paramount importance – there must be enough wash on it to allow a continuous pattern of strokes, but not so much that it floods and loosens the Chinese White. You must not touch, repeat or in any way work over a previous stroke while it is still moist and vulnerable.

By comparing these two illustrations, you will see how the basic colouring was built up. I used different greens in different places and left thin strips of the white ground for the leaf veining. I

11

12

13

14

then used yellows and yellow-greens on the apples along with a few touches of red. I finished the stone above the apple with a wash of Permanent Rose.

11 At this stage I worked on the leaves a little more, but not on the apple. I touched the veins over with a yellow-green wash and developed the greens with superimposed touches. You can see the flickering effect that results from applying the colours in a multitude of small, separate strokes.

12 I now underpainted the same area with white, using a size 1 sable brush, to define the serrated edges, stalks and some of the fine veining of the leaves. For this purpose, I used it quite crisply and fairly heavily. Chinese White was also put over the apple in several thin applications. This rounds out the form and partially obscures much of the original colouring, although it does show through where there are gaps and where the white is at its thinnest. The effect is already quite different.

13 I again added transparent washes of colour on top of the white after it had thoroughly dried. I did a little more work on the leaves, but I mostly painted the apple. I dabbed fresh yellow and yellow-green washes over it in tiny touches from the tip of the size 1 sable. Had this not been such a good-quality brush, a smaller one might have been needed. You may be able to see some of the separate strokes, although many of them are placed as dots by the merest touching of the brush point. The transparency of these colours and the modelling of form and the luminosity of the colouring are dependant on the Chinese White underpainting – this is obvious when you look at the previous illustration. The relative strength of the highlights and even the stroke patterns in them correspond to the previous painting in white.

14 I eventually achieved the degree of refinement seen in the finished apple by repeating the same processes with increasing delicacy. Ever-smaller touches of superimposed wash modified the previous colouring. In this case, I was able to continue doing this with a size 1 Kolinsky sable – partly because the apple was completed with fine, but fluid, strokes that came easily from its point. These are just visible where the apple skin is tinged with red. You may, however, find it easier to use miniature painting brushes – Hunt's paintings are often finished with exceptionally fine dots of colour for which such brushes were designed. Smaller brushes than size 1 are, of course, available, but it is the shape and quality of the point that really matters. At this stage I also worked on the leaves – having added yellows and greens on top of the Chinese White highlighting and original colours.

15 Here you can see the finished painting shown life size. At the very end I slightly sharpened its definition with accents and drawn detail added in strongly coloured washes. You may realize that the apples at the bottom of the painting do not match the original subject, at least in their colouring. This is because I based them on the apple at the top. By the time they were painted, the apple branchlets had wilted and I could no longer refer to them. It is always best to work from life, but such practical difficulties often occur when you do. Painting is a creative process that uses artistic licence to solve these problems.

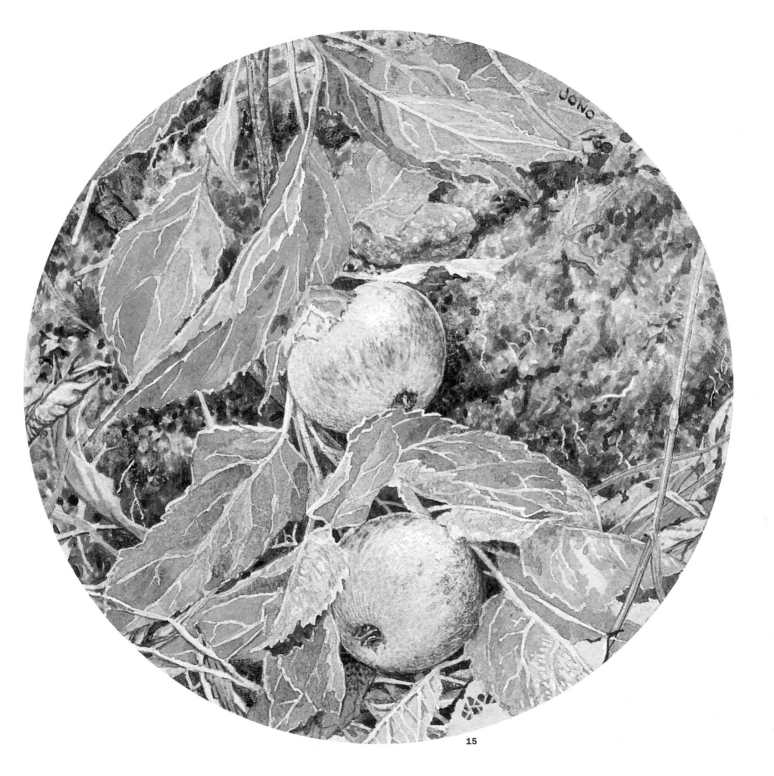

15

DEMONSTRATIONS

Sunset over Barrow Hills
using the methods
of J. M. W. Turner

MATERIALS

Paper
140lbs (300gsm) hot-pressed Winsor
& Newton Artists' watercolour paper.
Size 15" x 11" (38cm x 28cm).

Paint
Half-pan watercolours

Burnt Sienna
Cadmium Red
Cadmium Yellow
Cerulean Blue
Cobalt Blue
French Ultramarine
Permanent Magenta (Quinacridone)
Permanent Rose (Quinacridone)

Brushes
A size 10 sable brush and a large quill and
wire-bound mop brush were used throughout
the painting and a size 1 sable watercolour
brush to a limited extent in the later stages.

Other items
An HB pencil and blotting paper, a drawing
board to rest on, though if this had been on
a sketch-book page the board would not have
been necessary.

1

1 J. M. W. Turner (1775–1851) chose his papers carefully and many of the characteristics that he liked are not matched by today's stock products. This restricts the use of certain aspects of his technique, but does not prevent the adoption of others. In this example I have simply avoided those of Turner's methods that do not usually work well on modern paper. Even so, my choice of paper was quite deliberate – Turner favoured smooth, hard-sized writing papers and this hot-pressed watercolour paper, which is both internally sized and externally sized with gelatine, is similar. Since Turner's watercolour sketch methods are in general less complicated technically than his sample studies or fully finished watercolours, I have made this a demonstration of how Turner might have typically approached a sketch.

I used a piece of paper that was 15" x 11" (38cm x 28cm) – Turner frequently chose a size that was slightly smaller than this. Just out of interest, and not for the sake of authenticity, I fixed the paper loosely to my drawing board so that it was free to behave like a sketch-book page. This worked surprisingly well considering it was not stretched (neither were Turner's) and considering the amount of water put on it. Subsequent pressing in a portfolio restored its flatness almost completely.

Some of Turner's most modest sketches in watercolour were probably done as an immediate response to his observations, but in most cases it is more likely that the colour was added some time after the drawing was made, perhaps on the evening of the same day or maybe a day or two later. Turner, we know, regarded sketching in colour costly in time as this account from 1819 confirms: 'Turner is in the neighbourhood of Naples making rough pencil

sketches to the astonishment of the Fashionables, who wonder of what use these draughts can be – simple souls! At Rome a sucking blade of the brush made the request of going out with pig Turner to colour – he grunted for answer that it would take up too much time to colour in the open air – he could make 15 or 16 pencil sketches to one coloured, and then grunted his way home.'

As a result, the act of colouring takes place under the influences of both memory and imagination, so Turner's effects are often created rather than observed. The same approach was followed here. A quick casual sketch was made in pencil, while looking at the scene, but not, in fact, when the sun was setting. I painted the sunset over it the following day, recalling sunsets and cloud effects during the proceeding few days as the basis of the colouring.

Take note of how slight and sketchy the drawing is and the extent to which it is ignored as the washes are added. It is the skyline, or rather the silhouette of the hill that occupies it, that becomes the focal point of this painting and the rest of the detail is quite literally swept away in pursuit of an overall effect.

2 The first step is to sweep clean water across the page – you should not dampen all of it, but should confine it crudely to those areas that you wish to work on wet. Here, and in many Turner sketches, it is the sky that needs this treatment most. I slopped the water on from a large mop, haphazardly missing patches of the paper. The water was spread in all directions in order to cover the paper quickly, but I particularly used a sweeping arch-shaped stroke that pitched towards the diagonal. There are often traces of such a stroke in Turner's work.

3 Immediately following the wetting of the paper, and while there was still water on its surface, the size 10 brush, fully loaded with Cerulean Blue, was taken over the upper part of the sky in an almost instinctive pattern of dashed, dabbed and swept brushstrokes. Cerulean Blue would not have been used by Turner, I chose it for its colour value and because it is a heavy, slightly granular pigment that tends not to move very much, even on wet paper, unless pushed. Turner would certainly have appreciated and exploited similar qualities in the colours that he used. The brush was reloaded with more of the same colour to achieve the darker area on the right.

4 Here, only seconds have elapsed since the paper was first made wet – Turner's technique was to work continuously at a fast and frantic pace at the opening stage of a work. I took some of the colour away from the right-hand side where the tone is deeper and the brush work is crude. I used crumpled blotting paper to lift out an irregular pattern of highlights, which softens and breaks up the initial effect. Blotting paper works well because it soaks up quickly and very effectively, but it disintegrates as it is used. You may prefer tissue or rag. Turner probably used his handkerchief for this.

2

3

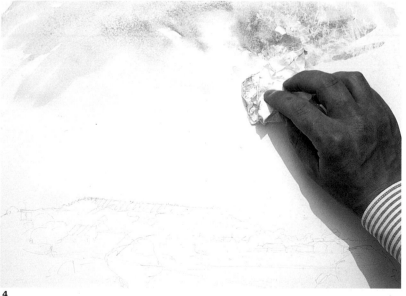

4

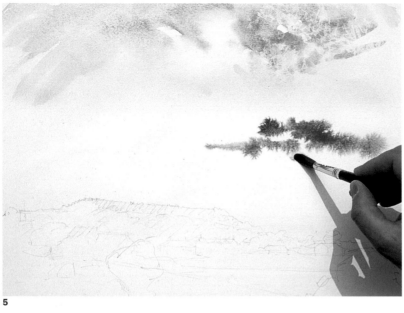

5

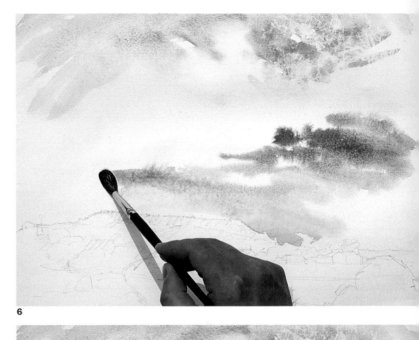

6

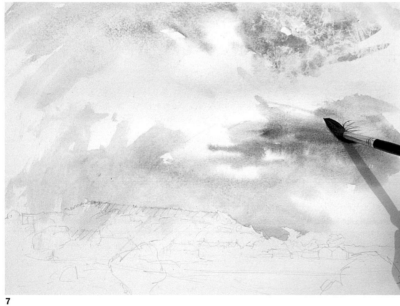

7

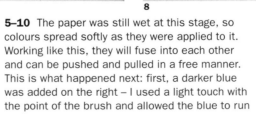

8

5–10 The paper was still wet at this stage, so colours spread softly as they were applied to it. Working like this, they will fuse into each other and can be pushed and pulled in a free manner. This is what happened next: first, a darker blue was added on the right – I used a light touch with the point of the brush and allowed the blue to run onto the paper. I spread and pulled some of this down towards the horizon, where an area of dry paper meant that part of the profile of the skyline could be followed. I then pulled it to the centre, quickly rinsed the brush and recharged it with Magenta. I placed it into the edge of the wet blue, allowing the colours to mingle. Then it was pulled

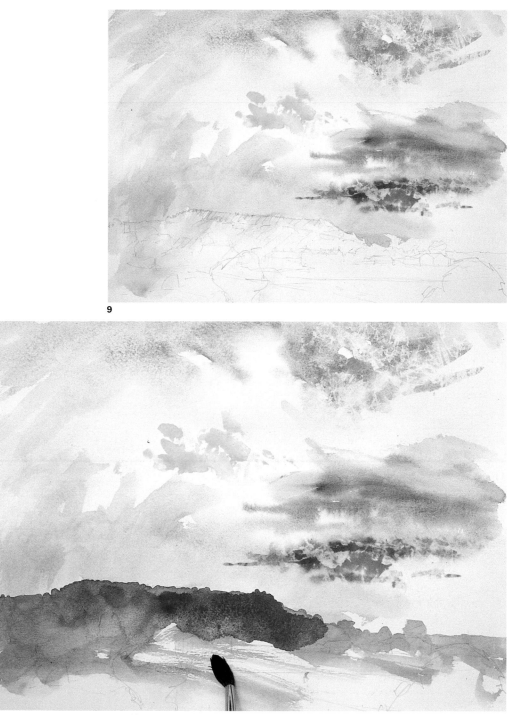

9

0

across to the left, where the sweeping diagonal stroke that I mentioned before was repeated.

As you can see, I have gone straight over the drawing on the left. The top of the Magenta wash carries on to a dry area of the paper – either because it has begun to dry or because it was missed during the initial wetting. This accounts for the firm edges, the harshness of which is detracted from by the random dragged quality of the brushmarks and the paleness of the wash.

Following on from this, the brush was rinsed again and, without adding more colour, was used to manipulate the still-wet blue on the right to achieve a layered effect of different colour intensities and tones. Cadmium Yellow was placed next with bold dabbing strokes into the centre of the sky where the paper was dry. The result, straight from the brush, was too crude and again crumpled blotting paper was used to soften and manipulate the effect.

By now the paper was beginning to dry and had become damp rather than wet on the lower right. Horizontal strokes of Permanent Rose were flooded into it from the brush tip at this stage and a little Cadmium Red was touched back into the middle of those strokes. Again, this was taken up with blotting paper to create the fractured pattern of red clouds which you can see.

To complete this session, I used a mixed blue containing Cobalt Blue and French Ultramarine to paint the skyline and hill – the paper was now dry enough to hold a firm edge to the wash. As you can see, the skyline has been followed in a casual but fairly conscientious manner, although below it the wash was pulled out in an instinctive pattern of dragged marks that lead the eye into the foreground.

Soon afterwards I threw a thin wash of Cadmium Yellow over it, with equal freedom and a total disregard for any plan. You can see this in the finished piece. This dragging of one wash over another is an instinct-led mannerism, but once you know what may happen you can manipulate it to some extent.

You may wonder why I used a yellow wash – I chose it because Turner was very fond of yellow and in his sketches he tended to use a very narrow range of quite bright colours, just as I have here. Their use does not have to be absolutely logical, what matters is that the interaction of the colouring successfully conveys the idea, mood or sensation that is being expressed.

3 DEMONSTRATIONS

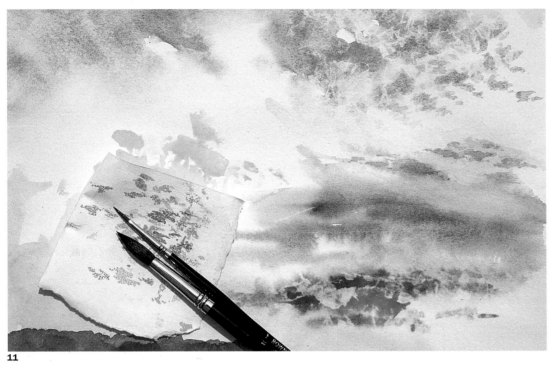

by adding a silhouetted tree or bush – you can interpret it however you wish – in the foreground. A remnant of the original drawing did, in fact, indicate a tree positioned here, though not of this particular shape or size. I pushed a not too heavily loaded brush, in this case a large mop, along its belly towards its point, so that it splayed and gave a ragged mark. This was done first with Burnt Sienna and was then redone over the top with the brush in an even drier state using Burnt Sienna and blue. This completed the watercolour sketch.

Turner may have worked on several sketches at once, moving from one to another with the same colour on the brush and coming back to each one at regular intervals to catch the paper in the right condition for the next stage of its development. There is also reason to believe that he might have scattered his sketches on the floor or ground as he worked, thus allowing him to assess their effects when seen from a distance. As such a sketch must remain flat while wet, this is, in fact, the only practical way of 'standing back' from a work to look at it.

11

11 It is possible to arrive at a satisfactory sketch at the end of a single wet-to-dry session, but many of Turner's sketches show signs of reworking when dry. In this case, I have improved on the sky effects by tidying and extending the cloud patterns that the opening sequence of activity has imperfectly suggested. For this I used a small fine-pointed high-quality brush, as well as the large size 10, and made some of the alterations using a combination of tiny strokes. Carefully worked-up Turner watercolours are sometimes handled with minute precision in the final layers. He actually used miniature painters' techniques on top of a much broader and looser beginning.

To ensure the delicacy of any fine reworking, blot it before it dries and then, if necessary, repeat and blot again until you have a good result. This is what I did here.

12–13 You can greatly improve the sense of space and distance in a loosely handled sketch like this by introducing a foreground object, however slightly indicated, that contrasts strongly against its background. Not surprisingly it is a device that Turner frequently uses. I have employed it here

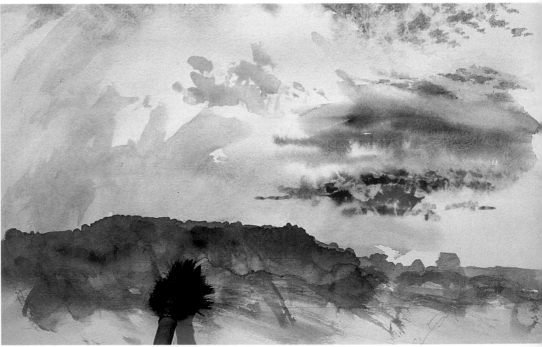

12

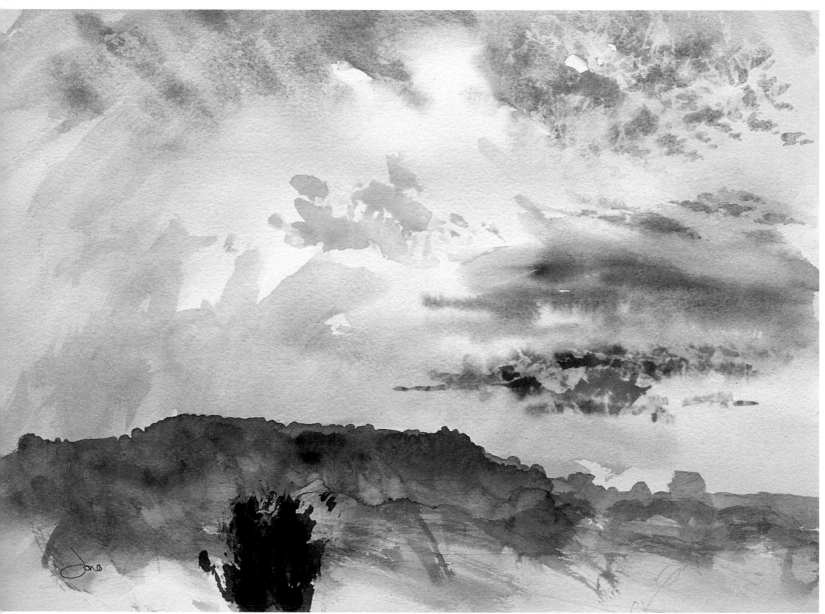

DEMONSTRATIONS

Two tulips using methods derived from Jacob Marrell

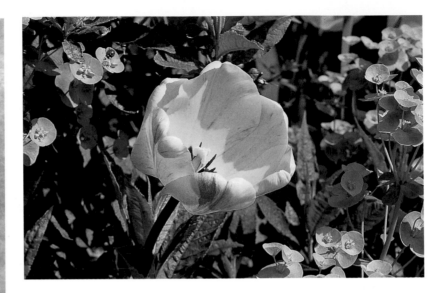

MATERIALS

Paper
Cream Bockingford Tinted watercolour paper.
Size of sheet 11" x 15" (28cm x 38cm).

Paint
Watercolours and gouache in tubes

Cadmium Lemon
Cadmium Red
Cadmium Yellow Deep
Emerald Green
French Ultramarine
Ivory Black
Lemon Yellow
Phthalocyanine Blue
Phthalocyanine Green
Red Ochre
Trichrome Black
Yellow Ochre
Zinc White

Brushes
A size 10 mixed sable and synthetic
hair watercolour brush and sizes 2 and 1
watercolour brushes in pure sable.

Other items
A graphite pencil, a calligraphy dip pen,
a china mixing tile and a drawing board.

Jacob Marrell (1614–81) was a botanical artist who compiled a catalogue of tulips at a time when they were immensely popular in Holland. His best-known paintings often show four tulips across two pages and are perhaps from this catalogue. My painting only shows two tulips – the equivalent of a single page.

Marrell used parchment or vellum, so I decided to use a cream watercolour paper which echoes the warm tone of these materials once they have aged. This, however, was not the only reason – in my experience, even the best white watercolour papers tend to lose their freshness with the passing of time, so where large areas are to remain untouched, a tinted paper is much more suitable. The tint of the paper must, of course, offer a high standard of permanence as this one does. I also chose a coloured paper as this technique involves the use of gouache paint and body colours – opaque not transparent watercolour. These work well against a background colour since their values can be judged in relation to it.

A smooth-surfaced, hot-pressed, watercolour paper would be the more usual choice for a botanical drawing. My paper had a not (cold-pressed) surface, but since opaque watercolour is applied more heavily than transparent washes that did not affect the outcome.

My subject matter and the general principles that I followed were certainly derived from the manner of Marrell, but I also wanted to show

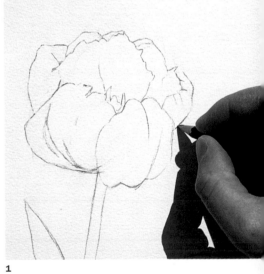

1

the use of present-day materials in an appropriate context, so this is not an exact reconstruction of his methods.

1 I began my painting with an outline pencil drawing done from life. With this type of botanical art it is important to be scientifically accurate. You should study a specimen plant and ideally continue referring to it throughout the painting's progress, but flowers in particular may not last as long as it takes to paint them. For a botanical study, a clean simple

and accurate use of line is generally best, with shading kept to a minimum.

As you can see, in my drawing variations of intensity allow the pencil lines to record the tulips' shape accurately but neatly. You should soften the drawing with an eraser if it is too firm and tidy any errors before painting over it, since while it guides and controls the paint, ultimately you do not want it to show. Sometimes, fine pen drawings are used in botanical work – they have a pencil sketch, which is subsequently erased, as their base. Again, much depends on the quality of the drawing as to whether this intrudes upon or is in harmony with the colouring. If you choose to work in ink, it should be dilute.

I have stressed the need for accuracy, but a botanical drawing should also be a thing of beauty. An elegant layout of the page is a notable feature of Marrell's work and is typical of all the great botanical artists. This is achieved by being exact but not unimaginatively so. In my drawing I have attempted to compose the page and have taken minor liberties with the proportions of the stems and leaves in order to achieve the desired effect. I have also pencilled in some insects – they always appear in Marrell's paintings and are a traditional attribute of botanical art. When thoughtfully placed, insects are a very useful compositional aid.

2–3 The tulip heads would be the most important areas of the painting in terms of detail and colour so this was the logical place to begin. Their basic colour was yellow, but I separated this into three rough areas of tone. Lemon Yellow was used in washes and tints with white for the lightest parts, Cadmium Yellow Deep represented the mid-tones and a shadow tone mixed from white, yellow and black was used for the darkest parts. Today, colours are rarely shaded with black, but in Marrell's time it would have been a common practice. The secret is to use very little of it and to have white present as well, so that the colour being reduced is, in effect, a tint made with grey. I used Ivory Black which is the weakest of the blacks.

When I had tentatively placed each value, I repeated the process to give extra strength and to refine the transition from light to dark. At this stage, the colouring was still just a basic foundation, and as you can see it was not yet dense enough to obscure the drawing.

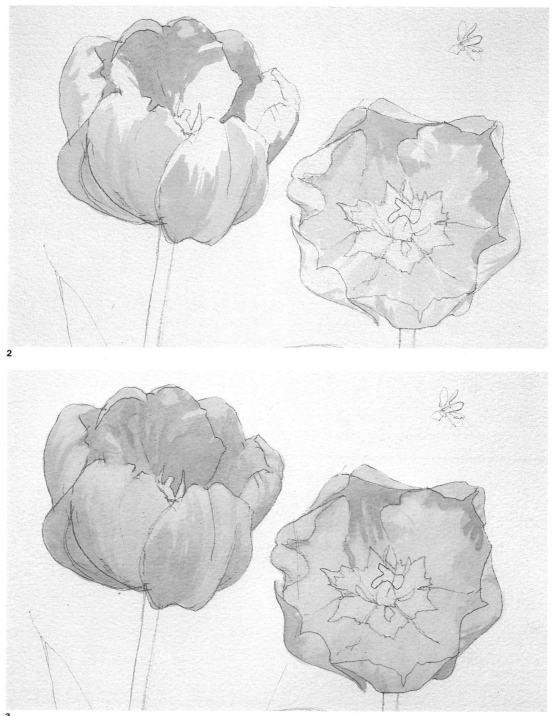

2

3

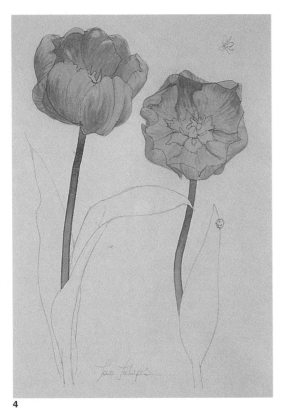

4

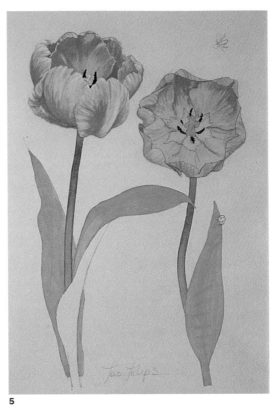

5

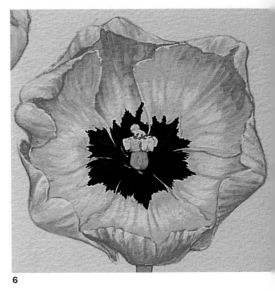

6

4–5 At the next stage you just need to refine what you have already done. Rather than use a large brush to block in colour, I placed smaller strokes with a size 2 pure sable watercolour brush. Again, variant values of yellow were used, ranging from light to dark and with these the colour and surface texture of the petals were more subtly developed. A key point to note is the length and direction of these smaller strokes. They follow the contours of the petals and mimic the texture of the real flower. Similar strokes can be seen in Marrell's paintings.

If you compare the tulip on the left in illustrations 4 and 5, you will see how this process of refinement proceeds. I now began to use gouache in preference to watercolour because of its greater opacity, but I continued with similar colours. The sequence of light and shade was extended and I tried to express the shiny reflective surface of the tulip petals by adding pure white as a final highlight.

The stems and leaves of the tulips were painted in dull greens – made up from yellow, white, green and black in varying proportions. This was mostly just a flat foundation of colour, but on the stems different tones were run together.

6 I worked on the tulip on the right so that it was at a similar stage of completion to the one on the left. The white highlight was placed with directional strokes to convey the nature of the petals and to confirm the bowl-shaped form of the flower-head. Note also the tiny highlights along the petal edges.

The black centres of these tulips were painted with Trichrome Black, a gouache colour used by illustrators and designers. It was chosen for its matt velvety blackness, and because a black watercolour at an equivalent concentration is likely to be gum rich and sticky. This black is highlighted with fine strokes of grey and, again, these follow the contours of the petals. The stamens are painted with a strong tint of Red Ochre.

7 The tulip heads were completed using Cadmium Red. This was put down in delicate linear strokes using the point of a size 1 brush. As the markings on this modern garden hybrid were less distinct than the boldly striped examples that are often shown in Marrell's work, a series of small strokes was used to express the variable qualities of the pattern. Once more the contours of the petals were followed, giving an even greater confirmation of their shape, but as before this is merely an observation of nature translated into paint. The red streaks on the yellow petals of the real tulips are diffused along them in a similar manner.

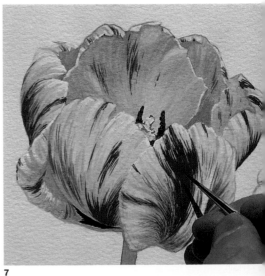

7

8 I finished the tulip leaves by directly observing nature, hence the use of a very blue tint of green – made by overwhelming a mixture of Emerald Green and white with Phthalocyanine Blue – which represents the bloom on the surface of the mid-green foliage. As before, the colour is applied as opaque body colour and, again, you will note that the different greens also represent clearly separate tones.

Marrell also depicted the bluish cast of tulip leaves, but painted it in a more standardized way, using a dark blue-green shaded with earth colours. He, of course, did not have the benefit of a modern colour range. As a token acknowledgment of this, I used some Yellow Ochre – an earth colour – in the shadow tones around the base of the leaves.

The insects were painted in last and the fly on the left was added as an afterthought to balance the composition. All of these insects were seen on or around the tulips at the time of painting.

Delicate additions of text, giving the tulips' names or those of their owners, are a distinctive feature of Marrell's paintings, so I completed this piece with a brief description of what I had painted, added with a calligraphy pen loaded with watercolour instead of ink. This text was placed off centre, around the stem of one tulip, just as Marrell might have done. It adds a final touch to the asymmetrical composition of the page.

8 (detail)

8

DEMONSTRATIONS

Roche Abbey using the methods of Thomas Girtin

MATERIALS

Paper
Two Rivers De Nimes 105lbs (220 gsm) hand-made laid paper in pale green antique fleck. Size approximately 16¾" x 10¼" (42.5cm x 26cm).

Paint
Whole and half-pan watercolours

Burnt Sienna
Burnt Umber
Cadmium Yellow
Indian Red
Lemon Yellow
Permanent Rose (Quinacridone)
Phthalocyanine Blue
Raw Sienna
Yellow Ochre

Chinese White from a tube

Brushes
Sizes 7 and 1 sable watercolour brushes.

Other items
2B and 4B graphite pencils, a slant-well china palette for mixing good quantities of wash, gummed brown tape, gum arabic solution and a drawing board.

are discussed in Part 2. Since this demonstration concentrates on how these techniques were actually used my image is less carefully composed and romanticized than his usually were. My materials were, of course, modern, but I was careful when selecting them, so that they had similar characteristic properties to his – in terms of colour value, appearance and behaviour. The paper was of particular importance – I chose a hand-made laid paper with a very pale tint – nominally a green, but in fact a greyish off-white, with a finely speckled fleck among its fibres.

1

I chose to paint Roche Abbey because I thought it was typical of the places that Thomas Girtin (1775–1802) and his contemporaries painted. This account from 1805 explains its attraction: 'Everything a traveller can wish to render a place delightful will be found concentrated in this most enchanting spot: majestic woods, expansive water, romantic rocks, an agreeable ruin and, withal, most commodious walks, for the convenience of viewing its various beauties. The ruins of this abbey are not extensive; but that is amply compensated by the superior quality of the surrounding scenery.' Girtin's methods

1 Girtin sometimes coloured his sketches on the spot, but most of his watercolours were probably painted in the studio. They would have been based on drawings done directly from nature during sketching trips. The advantage of this process is that since the original drawing will only contain what seemed most important when it was made then any image generated from it will have the same essential simplicity. There is also scope for using your imagination.

I did my drawing in late spring, but did not paint over it until the following autumn. Some

2

3

4

5

hastily scribbled notes – written on the back and copied off before stretching the paper – helped with the colouring. Alternatively, you could write notes lightly on the drawing in appropriate places with pencil and then erase them immediately before applying a wash.

In this instance, since I was afraid of losing the architectural detail of my drawing in the course of painting on it, I drew the principal parts firmly with a 2B pencil and went over it in places with an even darker 4B pencil. Had I not been painting on the original drawing but on an outline copied from it, I could have begun with a much lighter sketch.

2–5 I decided to stretch my drawing in the traditional manner prior to painting on it, both because of the character of the paper and because it was appropriate with this technique. First of all, you should fully immerse the paper in water, either pushing it gently under the surface or immersing it from one edge, as shown. Then, let the paper soak for a minute or two – longer if it is a hard-sized paper like this – and it will relax and expand slightly as it soaks. Next, take it out of the water, let the excess water run off and lay it flat on the drawing board. While it is wet you should thoroughly moisten gummed paper tape in lengths slightly

longer than the dimensions of the paper and tape the paper to the drawing board. The tape should overlap the edges of the sheet by at least ½" (12mm) and you should press it down with your fingertips to ensure a good bond.

As the paper dries it will tighten and should become perfectly flat. You should leave it mounted like this while painting on it, and as it dries after each successive wetting, it will become flat again. Some papers respond better to stretching than others and may give an improved performance or finish because of it. It suited the one used here as it was more lightweight than it looked and like many

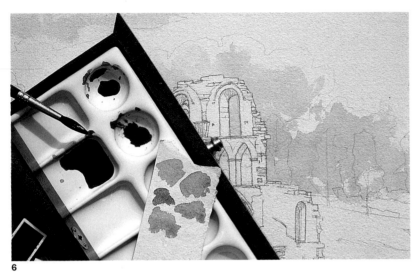

6

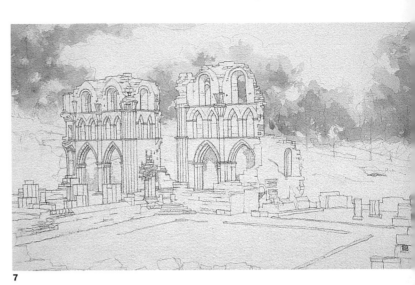

7

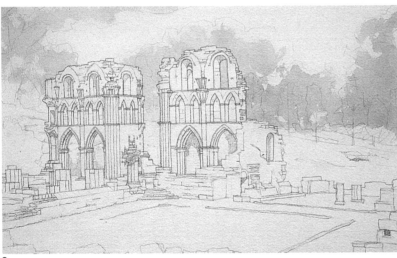

8

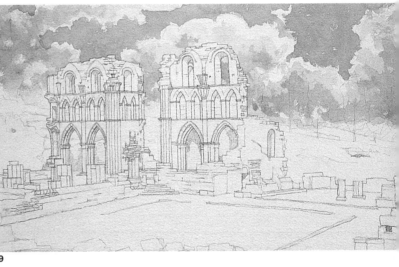

9

hand-made sheets began with slight undulations to its surface – the result of its slow, natural drying during making. These were eliminated by stretching.

6–9 The sky was put in first – this is nearly always the best way to start a watercolour landscape. Girtin probably used Indigo or Prussian Blue, but I used the more up-to-date Phthalocyanine Blue and chose the modern Quinacridone Rose for a reliable Red Lake. Separate washes of both these colours were prepared on the china palette and then a more dilute blue was made by letting down some of the original wash with water. After this I added a tiny

amount of the reddish pink Quinacridone Rose wash to make the colour change from a cool greenish blue towards a warmer, slightly purple, grey-blue.

I tested the value on scrap paper before applying it to the painting – this was the first shadow tint of the clouds. I took it around the important contours of the foreground – the abbey ruins and the distant skyline and from there pulled it across the paper towards the cloud edges lightly indicated in pencil. By gauging the loading of the brush and its touch against the paper, I achieved broken wash edges where the colour was picked up intermittently by the paper's texture.

Then I mixed a deeper shade by adding a greater proportion of the rose wash to a stronger wash of blue. This gave me a darker greyish purple, which I took back across the first sky tone, using the paper's texture to help me drag rough patches of it from the brush. This represented deeper shadow which would give the clouds a more complex and well-rounded appearance.

I completed the sky by painting in the open areas with a plain wash of Phthalocyanine Blue. Strips of untouched paper were left between these patches of colouring and shading for the brightly lit cloud edges. Due to the surrounding colours, these

10

11

12

12 (detail)

look nearer to white than they really are, an effect that you can see most clearly in the finished painting where all but these areas of the paper are covered by wash.

I decided to put in the cloud shadows first and the open sky last because by examining an original Girtin I concluded that this was what he must have done. There is a certain logic to this – as the dragged edges of the shadow washes cannot be placed with perfect precision it makes sense to bring the more controllable washline of the open sky towards them, compensating as necessary for any overrun in the shading and ensuring a sufficient

gap of untouched paper wherever it is needed. Notice that I ignored the presence of the trees when laying the sky.

10–12 For the next stage I used Phthalocyanine Blue mixed this time with Indian Red, which gave a neutral shadow tone, to shade parts of the drawing – specifically the abbey ruins where structural and architectural detail were firmly defined by cast shadow. If you refer back to my original drawing, you will see that these had been observed and pencilled in at the time it was made. I went over them with this blue-grey wash and took a much more dilute

version of the same colour – just some of the original wash let down with more water – across parts of the stone work to indicate vaguely more diffuse shadow and discolouration of the ruins' surface.

This is monochrome shading, an established 18th-century technique, which Girtin supposedly abandoned in his later years. I think, however, that he continued to use it selectively within the process of colouring, as I have here, instead of as a totally separate stage. This preliminary shading is intended to underlie and contribute to the subsequent use of colour.

13–14 Next, I applied washes of Yellow Ochre and Raw Sienna. At first they were very dilute and I placed them broadly, but then I added more concentrated wash in specific places. These values, together with some areas of untouched paper and the blue-grey tones already in place, established the basic shape, colouring and patina of the ruins.

To develop the landscape setting I used a variety of greens and greenish browns. Girtin's Yellow Lake, Gamboge and Brown Pink were replaced by the yellows and yellow earths on my palette. The newly introduced Quinacridone Gold might, incidentally, prove a suitable alternative to Brown Pink – a very transparent greenish yellow brown.

I produced different broken greens by mixing the blue and yellow components of my palette in assorted combinations and also, most importantly, by using Burnt Sienna and Phthalocyanine Blue to make greens. Burnt Sienna is, of course, a reddish brown, but oddly when mixed with a greenish or blackish blue it produces green. These greens are not pure but may appear to be more natural than bright greens. They range from dull grass or leaf green through several versions of olive green until they border upon brown.

Piece by piece, I covered the landscape using flat, evenly applied areas of wash placed adjacent to one another and guided by the drawing. The trees were put in gradually with dark tones of greenish brown – partly because they were being placed over the already painted sky. Note how the trees help to emphasize the foreground subject and give a sense of depth within the pictorial space.

15–17 I modified the colours and tones, wash upon wash, as this stage of the painting progressed. You can see, for example, the introduction of a sweeping shadow that crosses the landscape behind the ruin in a second layer of wash. This was previously indicated in the pale blue shading which showed through the first of these washes and was then followed by the second. At first I indicated the trees in flat patches of colour with some small strokes at the edges to suggest the foliage, but I then worked on these, layer upon layer, with darker washes placed with hatched brushstrokes – a mannerism borrowed from Girtin. I continued this process of working up the colour and developing the detail of the painting until the trees and surrounding landscape seemed complete.

13

14

5

16

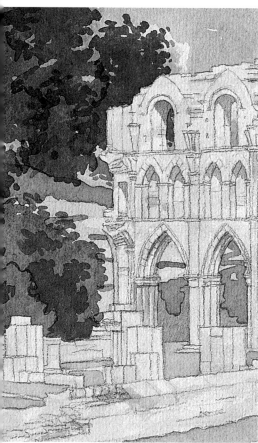

5 (detail)

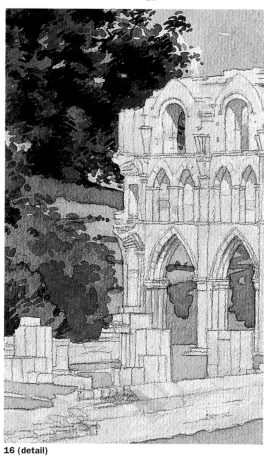

16 (detail)

17

18–20 Girtin usually completed his watercolours – perhaps sometimes with a pen – by overdrawing detail, often in brown. He also used a fine brush point for this, which is what I used here.

I simply restated my pencil drawing – where it still showed through the light washes on the ruined abbey – in a medium strength wash of Burnt Umber. I added the same wash on top of the dark shadows, originally placed as blue-grey monochrome shading, and the two layers combined to give a rich, transparent tone that suggests depth. If you add extra gum arabic to the final wash it will improve this quality, but you should avoid using it excessively. I employed some here, and either Girtin did the same or his dark brown was already prepared in a gum-rich state.

You can see the overdrawing and final toning of the shadow clearly in the finished piece. Note also the hatched brushstrokes on the trees. You may also realize that the trees were not in leaf at the time that I made my original drawing – I simply invented this.

As a watercolour like this advances, each part must be continually assessed in relation to the rest. In the final stages of this painting I decided to darken the foreground and went over the grass areas again with another wash. This was not based on any observation of nature, it was merely an alteration of the tonal relationships that I felt might improve the painting. Girtin, in representing his subjects in a dramatic or romantic way, must have used considerably more artistic licence than this.

A blemish in the final wash forced me to introduce the figures on the left – I had already decided to add the figure on the right to improve the composition. I used a little body colour when painting them to obscure the lower washes. See how the touch of pure white provides a focal highlight – this is due to the use of an off-white paper which makes any reserved highlights, the cloud edges, for example, a fraction lower in tone than they would otherwise be.

Girtin also made late corrective touches and the figures in his watercolours are, at times, quite definitely applied on top of a finished background, suggesting that they were also afterthoughts. The composition of this particular painting, had I given it more thought, might have been improved by cutting off some of the paper on the right-hand side.

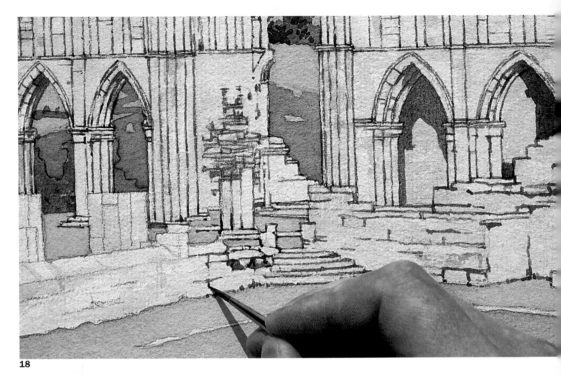

18

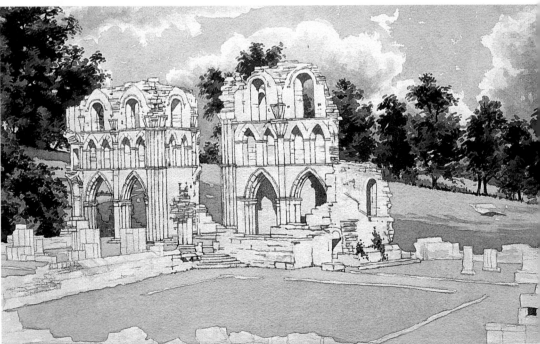

19

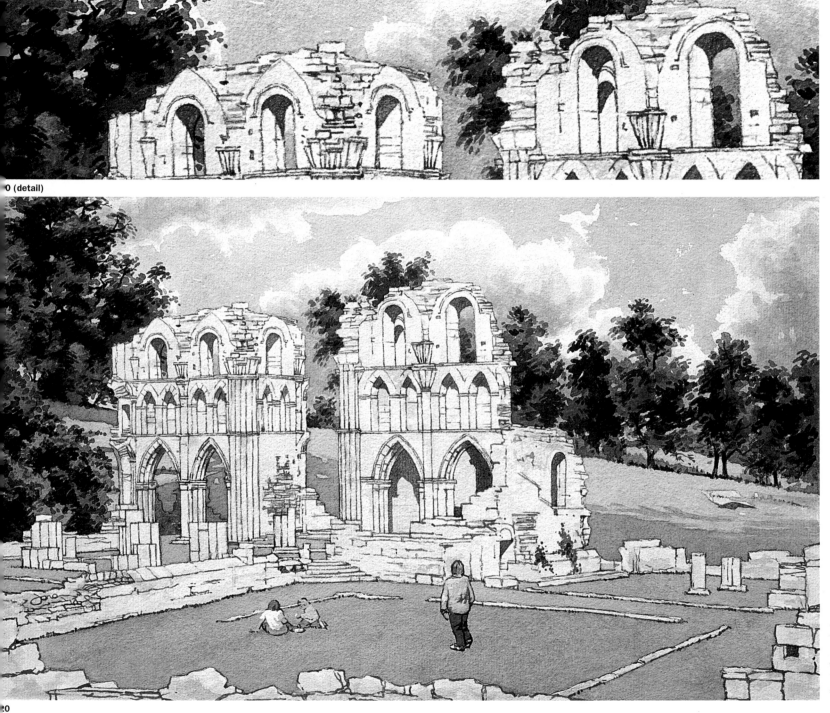

INFORMATION

I should like to thank all the manufacturers and suppliers of art materials who either directly or indirectly helped with this book, especially Winsor & Newton and Daler-Rowney who provided valuable historical information. My thanks are also extended to Ann Hickman who transcribed and typed up my text and to Ed Brickler who helped me gather information on the methods and materials of American watercolourists. I am grateful also for the kind assistance offered by curators, keepers, archivists and librarians during the progress of my researches.

LIST OF ILLUSTRATIONS

57 Joseph Mallord William Turner, *Sunset on Wet Sand*, c. 1845, 22.2 x 30 (8⅞ x 11¾). Whitworth Gallery, Manchester University

58 Joseph Mallord William Turner, *Goldau with the Lake of Zug in the Distance*, 1842–43, 22.8 x 28.8 (9 x 11⅜). The Turner Collection, Tate Gallery, London

59 Joseph Mallord William Turner, *Goldau*, 1843, 30.5 x 47 (12 x 18½). Private Collection, courtesy Richard L. Feigen & Co.

61 Joseph Mallord William Turner, *The First Rate Taking in Stores*, 1818, 28.6 x 39.7 (11¼ x 15⅝). The Trustees, Cecil Higgins Art Gallery, Bedford, England

62 John Sell Cotman, *A Ploughed Field*, c. 1808, 22.8 x 35 (8⅞ x 13¾). Leeds City Art Galleries

63 Richard Parkes Bonington, *The Undercliff*, 1828, 13 x 21.6 (5⅛ x 8½). City of Nottingham Museums; Castle Museum and Art Gallery

64 Richard Parkes Bonington, *The Castelbarco Tomb, Verona*, 1827, 19.1 x 13.3 (7½ x 5⅜). City of Nottingham Museums; Castle Museum and Art Gallery

65 William Henry Hunt, *Plums*, c. 1845, 31 (12¼) diam. City of Nottingham Museums; Castle Museum and Art Gallery

67 Paul Cézanne, *Still Life with Apples, Bottle and Chairback*, c. 1902–06, 44.5 x 59 (17½ x 23¼). Courtauld Institute Galleries, London

68 John Singer Sargent, *Boats at Anchor*, 1917, 40.1 x 52.9 (15¾ x 20⅞). Worcester Art Museum, Worcester, Massachusetts

69 John Singer Sargent, *Derelicts*, 1917, 34.7 x 53.4 (13½ x 21). Worcester Art Museum, Worcester, Massachusetts

70 John Singer Sargent, *Miss Eliza Wedgwood and Miss Sargent Sketching*, c. 1908, 50.2 x 35.6 (19⅞ x 13⅞). Tate Gallery, London

71 Winslow Homer, *Sunset, Prout's Neck*, 1895, 34.5 x 49.5 (13¾ x 19½). Worcester Art Museum, Worcester, Massachusetts

The original photography throughout this book and the original paintings in the step-by-step demonstrations are all by Jonathan Stephenson.

FURTHER READING

The following list acknowledges my principal sources and as several of these contain extracts from primary material, their sources too are acknowledged.

Artists' colourmen's publications

Ackermann, Robert, *A Treatise of Superfine Watercolours*, London, 1801

Scott Taylor, J., *A Descriptive Handbook of Modern Water-colour Pigments*, London and New York, c. 1887

Whiteford, S. T., *A Guide to Porcelain Painting*, London, mid-1870s

Winsor & Newton Limited, *Notes on the Composition and Permanence of Artists' Colours*, Harrow, Middlesex, c. 1979; *The Artists' Colourmen's Story*, Harrow, Middlesex, 1984

Artists' colourmen's catalogues

Daler-Rowney Fine Art and Graphics Materials Catalogue, Bracknell, Berkshire, 1995–96

Grumbacher, *Colors* and *Brushes Catalogues*, Bloomsbury, N.J., 1995–96

C. Roberson & Co Ltd, *Makers of Artists' Colours and Materials 1820–1961*, London, 1961–62

George Rowney & Co, *Retail Catalogue*, London, 1864; *Wholesale Catalogue*, London, 1892

Winsor & Newton Limited, *Catalogue of Materials for Water-colour Painting, and Sketching, Pencil, and Chalk Drawing etc., etc., etc.*, London, 1849; *Trade Catalogue*, London, 1886 and 1888; *The International Catalogue*, Harrow, Middlesex, c. 1995–96

In addition, colour cards, sample cards, leaflets, technical literature and catalogues from around 1935 to 1996 were consulted concerning the following manufacturers' products: Arches, Daler-Rowney, Faber Castell, Fabriano, Grumbacher, Lefranc & Bourgeois, Liquitex, Maimeri, Pébéo, Pro Arte, Raphael, Reeves, Rexel, St Cuthbert's Paper Mill (Inveresk Ltd), Schmincke, Sennelier, Talens, Two Rivers, Winsor & Newton and many others.

Practical manuals, treatises and studies of painters' materials and techniques

Anon., *The Art of Drawing and Painting in Watercolours*, London, 1732

————, *The Complete Drawing Master*, London, 1763

Ayres, James, *The Artist's Craft*, London, 1985

Bower, Peter, *Turner's Papers: A Study of the Manufacture, Selection and Use of his Drawing Papers 1787–1820*, London, 1990

Cennini, Cennino, *Il Libro dell'arte*, *c.* 1390, published in New York, 1932, as *The Craftsman's Handbook*

Cox, David, *A Treatise on Landscape Painting and Effect in Watercolours*, London, 1813

Dayes, Edward, *The Works of the Late Edward Dayes*, which includes his *Essays on Painting; Instructions for Drawing and Colouring Landscapes*, London, 1805

Eastlake, Sir Charles Lock, *Methods and Materials of Painting of the Great Schools and Masters*, 2 vols, London, 1847, reprinted New York, 1960

Hackney, Stephen (ed.), *Completing the Picture: Materials and Techniques of Twenty-six Paintings in the Tate Gallery*, London, 1982

Harding, J. D., *The Early Drawing-Book*, London, *c.* 1855–60

———, *Lessons on Trees*, London, *c.* 1855–60

Harley, R. D., *Artists' Pigments c. 1600–1835*, London, 1970, 2nd edition, 1982

Hilliard, Nicholas, *A Treatise Concerning the Arte of Limning*, *c.* 1600, Manchester, 1981

Kirby Talley, M., *Portrait Painting in England: Studies in the Technical Literature before 1700*, London, 1981

Nicholson, Francis, *The Practice of Drawing and Painting Landscape from Nature, in Watercolours*, London, 1823

Paint and Painting, exhib. cat., London and Harrow, Middlesex, 1982

Prout, Samuel, *Prout's Microcosm*, London, 1841

Pyne, W. H., *Microcosm; or a Picturesque Delineation of the Arts, Agriculture, Manufacturers etc. of Great Britain*, London, pre-1815

———, *Etchings of Rustic Figures for the Embellishment of Landscape*, London, *c.* 1815

Ruskin, John, *Elements of Drawing*, London, 1857

Schmid, F., *The Practice of Painting*, London, 1948

Stephenson, Jonathan, *The Materials and Techniques of Painting*, London and New York, 1989

———, *Paint with the Impressionists*, London and New York, 1995

Techniques of the Great Masters of Art, New Jersey, 1985

Townsend, Joyce, *Turner's Painting Techniques*, London, 1993

Exhibition catalogues, books on specific painters and general works on the history of watercolour painting

The Art of Watercolour, Manchester, 1987

Beam, Philip C., *Winslow Homer Watercolours*, Brunswick, Maine, 1983

Bunt, Cyril G. E., *The Watercolours of Sir Frank Brangwyn, R.A. 1867–1956*, Leigh-on-Sea, 1958

Cikovsky Jr, Nicolai, *Winslow Homer*, New York, 1992

Dubuisson, A., and C. E. Hughes, *Richard Parkes Bonington*, London, 1924

Elgar, Frank, *Cézanne*, London, 1969

Garlick, K., and A. Macintyre (eds), *The Diary of Joseph Farington*, vols 1–6, 1922–28, Newhaven, and vols 7–12, 1978, K. Cave (ed.), Newhaven, 1983

Goldwater, R., and M. Treves (eds), *Artists on Art: From the 14th to the 20th Century*, New York, 1945, reprinted 1974

Hamilton, Vivien, *Joseph Crawhall 1861–1913, One of the Glasgow Boys*, London, 1990

Hardie, Martin, *Water-colour Painting in Britain – Volume I, The Eighteenth Century*, London, 1966, 2nd ed. 1967

———, *Water-colour Painting in Britain – Volume II, The Romantic Period*, London, 1967

———, *Water-colour Painting in Britain – Volume III, The Victorian Period*, London, 1968

Munro, Jane, *Philip Wilson Steer 1860–1942, Paintings and Watercolours*, London, 1986

Peacock, Carlos, *Richard Parkes Bonington*, London, 1979

Pinault, Madeleine, *The Painter as Naturalist – From Dürer to Redouté*, trans. Philip Sturgess, Paris, 1991

Richardson, Sarah, *British Watercolours – Exploring Historic and Modern Pictures from the Laing Art Gallery*, Newcastle-upon-Tyne, 1993

Smiles, Sam, and Michael Pidgley, *The Perfection of England – Artist Visitors to Devon c. 1750–1870*, Plymouth, 1995

Stickler, Susan E. (ed.), *American Traditions in Watercolour – The Worcester Art Museum Collection*, New York, 1987

Thornbury, Walter, *The Life of J. M. W. Turner, R.A.*, 1877, reprinted 1970

Wilkinson, Gerald, *Turner's Early Sketchbooks*, London, 1972

———, *The Sketches of Turner, R.A.*, London, 1974

———, *Turner's Colour Sketches*, London, 1975

Wilton, Andrew, *Turner and the Sublime*, London, 1980

———, *Turner Abroad*, London, 1982

Witt, John, *William Henry Hunt 1790–1864 Life and Work with Catalogue*, London, 1982